Art, Power and Modernity

Contemporary Issues in Museum Culture
Series Editors: Susan M. Pearce and Elaine Heumann Gurian

Other volumes in the series:

Art, Power and Modernity

English Art Institutions, 1750–1950

GORDON FYFE

Leicester University Press
London and New York

Leicester University Press
A Continuum imprint
Wellington House, 125 Strand, London WC2R 0BB
370 Lexington Avenue, New York, NY 10017-6503

First published 2000

British Library Cataloguing-in-Publication Data
A catalogue record for this book is available from the British Library.

ISBN 0-7185-0111-X

Library of Congress Cataloging-in-Publication Data
Fyfe, Gordon.
 Art, power and modernity: English art institutions, 1750–1950/
Gordon Fyfe.
 p. cm. — (Contemporary issues in museum culture)
 Includes bibliographical references and index.
 ISBN 0-7185-0111-X (hc.)
 1. Art and society–England–London–History. 2. Art, English–
England–London. 3. Art, Modern–England–London. I. Title. II. Series.

N72.S6 F94 2000
306.4′7′0942–dc21 99-086882

Typeset by BookEns Ltd., Royston, Herts.
Printed and bound in Great Britain by Biddles Ltd,
Guildford and King's Lynn

Contents

Plates

Figures

Preface and acknowledgements

Art, Power and Modernity is a sociological inquiry into the nineteenth-century English art world. In recent years, under the influences of feminism, cultural studies and sociology, art historians have demonstrated the modernity that is so evident in the fluid and contested character of Victorian art institutions. They have shown that there were winners and losers in the game of original art. The story of art, we have learnt, is partly one of how some people's claims to be creative have been discredited, suppressed and repressed; creative identities have been shown to be simultaneously organized and disorganized by institutions such as academies, exhibitions and museums. My argument is that by examining selected episodes in the story of art institutions (such as the nineteenth-century struggle between painters and engravers) we can bring to the surface identities that were gradually submerged by modernization. These episodes show that the social construction of art was nearer to the surface of things than it is today. In recovering such moments and in listening to people whom modernization separated from originality we may recover something of the collective action that was the making of modern art.

The book contains eight chapters. Chapter 1 does two things. First, it places the story of the artist within its institutional contexts and shows how two sociologists of art (Howard Becker and Pierre Bourdieu) have captured the modernity of art institutions. Second, in bringing a sociological perspective to bear on England, I tackle the vexed question of English traditionalism and show how nineteenth-century art institutions interpreted the modernizing impulses of state and market. Seven further chapters deal with how originality was realized in diverse and contested institutional settings: in art reproduction, at exhibition, at the Royal Academy and at the early Tate Gallery.

Over the years numerous people have listened to me patiently as I picked their brains and rehearsed the arguments contained in this book. Some of them – Peter Crawley, Ronnie Frankenberg, Kevin Hetherington, John Law, Sharon Macdonald, Alan Prout and Mike Savage – were at some time members of what was the Department of Sociology and Social Anthropology at Keele University. Beyond the Department the University has provided interdisciplinary opportunities which are, I think, peculiar to

Keele, and Jim McLaverty, Richard Godden, Charles Swann, Alex Danchev and Chris Wakeling have all been generous with their advice. Beyond Keele I must thank Susan Pearce and Vera Zolberg for responding to unsolicited mail and Bob Witkin for pressing me to completion. Jeremy Tanner, Colin Trodd and Brandon Taylor made me clarify my ideas at crucial moments. The late Colin Ellis patiently explained aspects of print-making and mechanical reproduction and Clive Ashworth helped me to start the project. Keele University generously supported the last stages of writing with a Research Award which released me from departmental duties in the spring semester of 1997.

My greatest debts are to Christine Fyfe and to our young son Alex Fyfe. Alex supported me with his curiosity about the idea of a book and with his patience in accepting that I needed to be left alone to work on it. Christine has been unreserved in giving me her professional help as a university librarian and her personal support as a partner.

Versions of some chapters have appeared as follows: Chapter 2 in Gordon Fyfe and John Law (eds), *Picturing Power*, Routledge & Kegan Paul (1988); Chapter 4 in R.C. Denis and C. Trodd (eds), *Art and the Academy in the Nineteenth Century*, Manchester University Press (2000); Chapter 5 in *Media Culture & Society* (1985), vol. 7, no. 4, 399–425, Chapter 7 in Susan Pearce (ed.), *New Research in Museum Studies* (1995), vol. 5, nos 5–41 and Chapter 8 in *The Journal of Material Culture* (1998), vol. 3, no. 3, 325–354.

I thank the following institutions for allowing me access to their archives: Royal Academy of Arts, Council Minute Books; the Tate Gallery Millbank, the Chantrey Files; the British Library (Oriental and India Office Collections), the Curzon Papers; Keele University (the Sneyd Collection); University College, London, Routledge & Kegan Paul Archive and the Library of the London School of Economics and Political Science (the Webb Trade Union Collection, Printing and Paper Trades, Coll. E Sect. A XXIX). I owe special thanks to D. M. Blake, Jennifer Booth and Helen Burton for their advice on archival sources.

I must also thank the editorial and production teams at Continuum for their generous help, for their constructive suggestions and for their patient, sympathetic understanding.

*In memory of James Alexander Fyfe
and Winifred Fyfe*

1

Introduction: artists and institutions

Introduction

The concept of the artist, that is, of a person endowed with extraordinary gifts and powers of imagination, is of relatively recent currency; it accommodates an historically specific set of attitudes and meanings. These, it is generally agreed, entail notions of difference that matured in the late eighteenth century and were unknown to the medieval world. The idea of the artist was linked to changes in the institutional structures which had regulated the production of images in medieval times, namely the dissolution of guild power, the process of state formation and the evolution of art markets. These changes in the conditions of artistic creation are well established in the sociology and social history of art (Antal, 1948; Martindale, 1972; Wolff, 1981). The following features may be identified as correlates of the weakening of the ties that once bound image-makers to guild-craftsmanship:

- The appearance of a cleavage within the visual arts, between the arts and the crafts, which was unsanctioned by guild authority. Thus by the end of the fourteenth century in Italy: 'doing a panel is really a gentleman's job, for you may do anything you want with velvet on your back' (Cennino Cennini, quoted in Holt, 1957: 148–9).
- The hegemonic role played by painters within a system of production that was increasingly organized through markets, subordinating and marginalizing other image-makers along class and gender lines.
- The elaboration of a philosophical system which was promoted by humanists and established the fine arts, painting, sculpture and architecture as a unified cultural domain (Kristeller, 1951–52). In association with this was the institutionalization of the fine arts in the form of academies, for example, the Accademia del Disegno (Florence, 1562), the Accademia di S. Luca (Rome, 1593), the Académie de Peinture et Sculpture (Paris, 1648) and the Royal Academy of Arts (London, 1768).
- Power struggles between different types of creator: as they jockeyed for social and aesthetic advantage the exponents of humanist art felt justified in denying to others the advantages they secured for

themselves. Goldsmiths, tapestry workers and engravers were among those who were denied the advantages of painters, sculptors and architects.

The rise of the artist is one chapter in a European modernization which gave birth to the modern individual. During the Renaissance, humanist scholars challenged medieval modes of authorizing art, distinguished artists from anonymous craftspeople and sanctioned individualistic ways of being creative. The peculiarly Western notion that human beings are centred subjects possessed of an enduring core identity is nowhere more fully expressed than in the lives of Renaissance artists such as the sixteenth-century goldsmith Benvenuto Cellini (with his celebrated autobiography). The Renaissance (conventionally marked off as the period *c*. 1280–1600) was neither the beginning nor the end of the Western story of the artist; rather it constitutes an accelerated individuation in which some image-makers acquired a heightened awareness of themselves as being creators who were different from other mortals.

States and markets

There are two strands to the story of the artist, which may be summarized as markets and states. To begin with the former, the reputations of Renaissance artists were partly products of a marketization of culture which enlisted new audiences and permitted new cultural identities to emerge. The rise of the artist and the proliferation of intermediaries were two sides of the same collective coin of social action. As Eisenstein (1979) shows, the development of the printed book endorsed the artist in the role of creator. Print spread news of the lives and reputations of celebrated masters along with the humanist ideals that underpinned the claims to creativity. Vasari's celebrated *Lives of the Most Excellent Painters, Sculptors and Architects* was a cultural enterprise which broke new ground in individualizing creation and in promoting the durability of artistic reputations beyond the grave. Eisenstein shows that there was an internal and paradoxical association between the constitution of individual personalities and the impersonal communication that was the printed book.

Printed biography was not the sole means by which reputation was established. By the eighteenth century artistic identities were diversely mediated through the capillaries of a heterogeneous culture industry: an artist might be patronized, employed, commissioned, exhibited, engraved, acquired by museums, promoted by critics and dealers and celebrated as a life in print. He or she might encounter their art in expected and unexpected places. While they created opportunities for expression, say, as exhibitor or printmaker, these centrifugal processes of commercialization also presented problems of pictorial control over images whose situated meanings could escape the authorship of the artist.

Walter Benjamin (1970) was among the first to diagnose the

consequences of these changes when he argued that they transformed artefacts whose uniqueness had been part of the fabric of tradition; for example, in recontextualizing religious paintings, museums, exhibitions and photographic reproductions deprived art of its traditional aura, of its unique presence in time and place, and exposed it to a simultaneous and differentiated appreciation by the masses. More recently, the sociologist Howard Becker (1982) has captured the modernity of art when he argues that there is no such thing as *the* art world; rather there are multiple and disputatious social spaces of art in which diverse creators may co-exist.

Fragmentation is one part of the story; integration is the other face of modernity (Elias, 1982). Modern societies were shaped by centripetal forces which concentrated cultural power in the hands of economic, political and cultural elites. State formation, that is, the consolidation of monopolies over different modalities of power, had a cultural dimension which enhanced the power of courtly painter-artists and accommodated their sense of distinction from craftspeople. The development of the state was deeply implicated in the erosion of guild authority for, during the Renaissance, it was princely competition for the services of painters that allowed some individuals to flout trade restrictions and promote artistic freedom (Hauser, 1962).

By the end of the seventeenth century three types of image-maker existed in Europe as contenders for cultural power: artisan-producers whose guild monopolies were progressively destroyed by princes, states and academies, independent producers such as Dutch artists who serviced the developing market in artefacts, and privileged academicians who were found in Paris and who serviced the pictorial needs of monarchy and state (Pevsner, 1973: 139). In the eighteenth century the academician emerged as the dominant player. Pevsner reckons that in 1790 there were over one hundred European academies or schools of art (Pevsner, 1973: 140–41).

Throughout Western Europe and North America the state was interpreted by official iconographers and pre-eminently so by painter-academicians who specialized in history painting. Renato Poggi's argument that nineteenth-century states pursued strategies of nationing culture and identity may be extended from language and literature to include the visual arts (Poggi, 1978). History painting, which celebrated the nation as a Christian civilization with classical roots, formed the basis of a high art compact with the state; official prizes and commissions were stepping-stones in careers where artistic success meant academic status and consecration at a museum of art. The middle decades of the nineteenth century were the golden age of the living European painter, with successful academicians extending their reputations in partnership with cultural capitalists such as dealers and print publishers (Reitlinger, 1961: 143–74; White and White, 1965; Gillett, 1990).

Not all art worlds are equal. Today, curators of world-class museum collections are beneficiaries of processes that have made their institutions into concentrations of cultural power. They are, as Mouzelis has it (1991:

106–9), macro actors, that is, their decisions stretch across time and space to affect the sensibilities of millions. The cultural state was associated with the emergence of a configuration of hegemonic spaces – academy exhibitions, museums and industrial expositions. These places were sites at which three discourses of modernization were proposed and intersected with each other: discourses of distinction emerging from the status struggles of upper-class formation, nation-building through the consensual rituals of national collections of art and discipline through industrial training in design.

First, the development of the state was linked to a reordering of the material culture of patriarchal rulers through public display. In Renaissance Europe princely rivalry and the courtification of the state enhanced the power of certain artisans, especially painters and sculptors, transmuting them into artists, establishing patronage and art collections as signs of a ruler's distinction. Expenditure on luxuries such as art collections was a refinement of court life whose mainspring was a struggle for difference within a status consumption ethos (Elias, 1983; Sombart, 1967). The attenuated relations of developing cultural markets spawned institutions of cultural capital – exhibitions, criticism, art dealing, etc. – which mediated the tensions between insiders and outsiders. Bourgeois revolutions of market and politics stigmatized aristocratic conspicuous consumption so that taste was privatized, interiorized and transformed into cultural capital. From the eighteenth century museums developed as accumulations of cultural capital; they nationalized artefacts whose appreciation depended on socially distributed codes of connoisseurship and art history.

Second, there was the museum's role in nationalizing art. The making of museums was marked by the organization of trust on behalf of citizen and nation, for example, through trustee museums or state-bureaucratic control. A common denominator was transformation of princely and aristocratic collections (by means of public exposure, expropriation, donation and purchase) into national collections. Expropriation through revolution was the most dramatic mode of change in the relationship between culture and power – change which had nudged academic exhibitions into the public sphere by the mid-eighteenth century. Louis XIV's officials were anticipating the Louvre's function as a national museum a generation before 1789 and registering the growing *cultural* interdependence of states and populations. This interdependence was expressed in discourses of national art and international rivalry as well as anxieties about loss of patrimony through wars and the market.

Third, national museums and exhibitions interpreted the dependence of dominant classes on the cultural capacities of subordinate classes: on their national allegiance, on their skills and compliance as labour and (paradoxically) on their cultural incompetence or lack of distinction. Whereas princely display had illuminated a centred power, that of the sovereign, the state-as-museum or national academy proposed a strong

classification which illuminated and ordered the population, for example, as national artists, citizen visitors and female amateurs. In this way the museum emerged as an agency of social control; it defined creativity and ordered the population. A recurring theme in nineteenth-century exhibition reports is the orderliness of the crowd and the behaviour of working-class visitors. The museum and public exhibition were places at which the Victorians reflected on the meanings of the crowd and the making of an urban society (Altick, 1978).

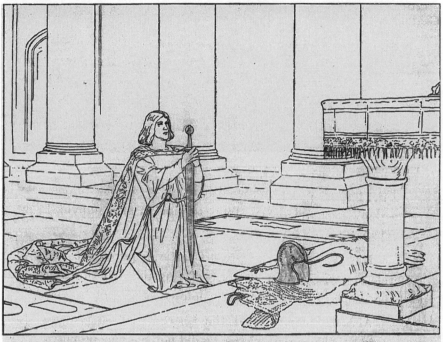

THE VIGIL.

After the picture by John Pettie, R.A., in the National Gallery, British Art, London.

SUGGESTIONS FOR COLOURING LIKE THE ORIGINAL PICTURE.

Knight's robe, slightly shaded with **pale greenish-yellow—White.**

Knight's cloak—**Maroon.**

Upper part of altar ; the part of floor where knight is kneeling—**Very pale yellowish-white.**

Altar pillar, also fringe ; knight's shield ; pillar nearest altar ; knight's hair, hands, and face—**Light greenish-brown.**

Floor below altar and patches on floor ; the other two pillars and wall space near them ; a lighter tone for armour in front of altar—**Dark blackish-brown.**

Knight's sword, sleeves, stockings, and girdle—**Black.**

The last two spaces between pillars and the door in the distance ; the rest of floor ; a darker tone for space behind the altar and space beyond first pillar—**Dull bluish-green.**

Plate 1 Line reproduction with colouring instructions of *The Vigil* by John Pettie RA. Reproduced in the elementary history book of *c.* 1920, *Visual History: A Practical Method of Teaching Introductory History* by A. Nightingale, published by A&C Black Ltd.

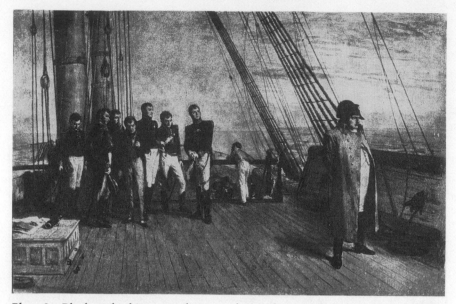

Plate 2 Black-and-white reproduction of *Napoleon on Board the 'Bellerophon'* by W. Q. Orchardson RA. Reproduced in the school history book of *c.* 1910, Book VII of the *High Roads of History* series, *High Roads of British History*, published by Thomas Nelson and Sons.

An illustration: in the twentieth century generations of British children learned their school history as they gazed upon textbook illustrations of historical events. These depictions were sometimes derived from narrative paintings at the National Gallery of British Art (i.e. the Tate Gallery). Their selection often began, as we shall see (Chapter 7), with a small group of male artists who controlled acquisitions at the Gallery. Their decisions rippled across the social structure, through the decisions of publishers and purchasing officers, through the medium of mass education and the mass production of illustrated history, to be appropriated by elementary schoolchildren. Children might literally colour in the course of British history (Plates 1 and 2).

The Academy

It is a commonplace that nineteenth-century modernists challenged the academy. A growing body of research (Boime, 1971; Bourdieu, 1993; Haskell, 1976; Mainardi, 1993; Morgan, 1969; Sherman, 1987; White and White, 1965) has illuminated the factors that undermined belief in the academy, exposed it to the tumult of the market and admitted new conceptions of the creative life into the public sphere. Academic instransigence and elitism were the stuff out of which new conceptions of what it meant to be an artist were forged. However, academic decline, especially after the 1870s, gave a radical twist to individuality when

reputations began to be effectively and officially sustained outside the academy and at new kinds of institutions. A pioneering analysis of this process is *Canvases and Careers* (1965) by Harrison and Cynthia White.

Canvases and Careers chronicles the collapse of the nineteenth-century French academy and the origins of twentieth-century art institutions. The academy presided over a school of art (the Ecole des Beaux-Arts) and a public exhibition (the Salon). The former put students through the hoops of a curriculum grounded in classical models of truth and representation. At the Salon thousands of canvases were submitted and a hybrid jury of state/ academy appointees determined which of these were to be exhibited. Academy students and exhibitors competed for prizes and for the critical acclaim which brought official recognition, a sale, or both. The Whites show how critics and dealers had once serviced an alliance of academy and state which determined the rules of art. However, some artists forged alliances with these agents and (unwittingly) built a rival to the beleaguered academy. The Whites dub the new system the *dealer-critic system*; among the artists who collaborated with it were dissidents (including the Impressionists) whose careers were making little headway under the old order.

The dynamic was a tension between market and state. In raising the status of the artist the academy had so enlarged the number of aspiring artists that a growing majority failed to collect the glittering prizes. The Salon was now choking on a stream of canvases which could not be properly evaluated by a hard-pressed jury, still less adequately displayed. Disappointment translated to protests which irrupted into the state as the academy proved increasingly unable to deliver careers to the majority. If young artists dreamed of joining the immortals of classicism in the museum, reality dictated that a living was more likely to come from decorating bourgeois and middle-class homes with pictures whose anecdotal and genre subjects debased the high art tradition of history painting. However, change went deeper than subjects and into the very mode of apprehending art.

Drawing on Sloane (1961), the Whites argue that in the late nineteenth century the masterpiece mutated; the relationships between the artist, the canvas and the world altered. An academic masterpiece was distinguished from other canvases in terms of a received tradition that gave moral precedence to elevated or high art subjects, and which presupposed that art had subjects – transactions with the world of nature, morality, the past and so forth. However, the wholeness that was the rare and remarkable achievement of the classical master in a great work of art is to be contrasted with the wholeness that is the *oeuvre* of the modern artist. The canvas became 'a piece of meaning' (White and White, 1965: 117–18); the critical reference points became the artist's *oeuvre* or style and not the world.

The Whites uncovered the processes that generated this radical individualism for a few nineteenth-century artists and drew some spectators to engage with the artist's own universe of forms (e.g. Monet's haystacks, waterlilies, cathedrals). They exposed the institutional forces

which subtended two competing discourses of creativity: the canvas of modernism and the academic canvas. The dysfunctional work of the academy with its failure to deliver careers intersected with the activity of dealers who invested in artists, differentiated their styles through so-called one-man exhibitions and marketed unknowns such as the Impressionists. The Whites showed that institutional barriers had, in isolating some artists from success, been a forcing-house for creative subjects who were authors of their own universe of meaning.

Decentring the artist

The past twenty-five years or so have seen a widespread concern in cultural analysis with decentring the artist, with the death of the artist and so forth. Decentring is a critical or theoretical strategy in which it is proposed that the artist is a chimera. It also refers to an historical process, a struggle within the artistic field, in which critics and others have challenged hegemonic, Western and male definitions of creativity. I take the concept to mean that the centred authority of the artist requires explaining rather than assuming, for both centring and decentring are social processes.

The lives and conduct of people such as the sixteenth-century goldsmith Cellini give dramatic edge to the puzzle that late nineteenth-century social scientists such as Emile Durkheim tried to unravel. How was it that the more individualized people became, the more they seemed to depend on others for the realization of their abilities? In his masterpiece, *The Division of Labor in Society* (1893/1933), Durkheim criticized those of his contemporaries who thought that individuals were real while society was nominal, and who took it for granted that human capacities were best ordered through the market.

It is perhaps in the arts that the matter of which is real, the individual or society, has been most fiercely debated. The conventional, romantic resolution has tended to be that art and society are opposites and that the artist is an essential subject whose social context is the negative one of constraint on creativity. At best society is the context in which art arises, at worst it is that which the artist must reject in order to carry through her intellectual project. Popular ideas about art and artist have long been informed by these assumptions, and by the notion that the artist is the wholesome individual who transcends the divisions of modernity with creative projects of universal significance.

Such notions have come under attack from contemporary cultural theory and research. For one thing the social history of art and artists shows how gendered are the reputations that have survived and how selective the canon has been in excluding some artists. For another we are beginning more fully to see that the 'rise of the artist' is a local story with a Western provenance. And in theoretical terms it is becoming clear that identity is never fixed; it is perennially made and remade through the medium of social intercourse, and the artist is no exception to this.

Sociologists and art historians have come to see the invention of the artist as, in some sense, a collective achievement (Albrecht *et al.*, 1970; Baxandall, 1972; Becker, 1982; Hennion, 1995; Wolff, 1981). Moreover, there has been a disciplinary *rapprochement* between history and sociology in which scholars sift accumulating historical facts about the rise of the artist according to the regularities of art worlds (Alpers, 1983; Becker, 1982; Bourdieu, 1993; Brewer, 1997). To adapt the historical sociology of Norbert Elias, there is a substantial body of facts about the rise of the artist: the problem is to identify the regularities of social intercourse that brought about the compulsions of artistic conduct and which drew Western peoples to depend on the services of artists and to believe in creators (Elias, 1982: 288–89).

In judging whether or not to pronounce the death of the artist Frederic Jameson (1991) identifies two ontologies of the creative subject: the historicist and the postmodern. He observes that to adopt the first of these is to say that twentieth-century modernization dissolved the subjects of high modernity; impersonal modes of organizing the world, it might be argued, no longer accommodate the artist-as-creator. To adopt the post-structuralist or postmodern position is to say that the centred subject was always a fiction, that there never was a fixed point from which the artist strode out to make representations in the world and of the world.

Jameson, a humanist-Marxist engaging with postmodernism, indicates that he is closer to the first position than to the second. However, his critical but heuristic engagement with postmodern thought leads him to the contingencies that permitted the birth of the sovereign unitary individual. Jameson suggests that a postmodern perspective tempered by historical specificity may transform our view of the nineteenth-century painter-as-creator. We may come to recognize that centring was an historical process. This is not say that history released the artist from the shackles of society, but that collective action constituted new kinds of creators. It was not the individual but a mode of ordering which empowered creators to be high modern subjects; postmodern revision of the past leads us to consider the institutional and therefore conditional properties of genius.

This is where sociologist Howard Becker's account of plural art worlds of invasion, aesthetic domination and contested meaning which yield multiple narratives of art is pertinent. Becker's key concept is *art world*. Art world denotes 'the network of people whose cooperative activity, organized through the medium of their joint knowledge of conventional means of doing things, produces the kind of art works that art world is noted for' (Becker, 1982: x). Works of art are not the creations of artists so much as the 'joint products of all those people who co-operate via an art world's characteristic conventions' (Becker, 1982: 39). Becker rejects approaches to art which endorse a particular aesthetic; rather he seeks to illuminate the ways in which judgements about art are objects for social analysis – i.e. 'characteristic phenomena of collective activity' (*ibid.*).

The pluralism of this approach converges with new developments in British art historical studies. Until recently, art history was informed by an underlying sense of cultural deprivation; British art did not pass muster as modern. Nineteenth-century British artists were at their worst 'Victorian' and at their best sanitized versions of the European moderns. However, new scholarly research (e.g. Corbett, 1997; Harrison, 1981; Tillyard, 1988) has indicated the need for a more generous formulation of problems in the history of British art. The point is not to establish new modernist priorities but to explore the wider and deeper modernity of the Victorian art world (Corbett, 1997). Even if few British artists fit the bill as modernists, their world was modern in that it was characterized by new forms of cultural participation and ownership and by struggles between different kinds of producers to capture the definition of art.

Four aspects of Becker's approach claim our attention as contributions to a sociology of modernity and art. He emphasizes the co-existence, not necessarily peaceful, of different aesthetics (e.g. arts and crafts) and of different image-makers (e.g. academic artists, folk artists, artisans, etc.). This is important because much of what has passed as sociological writing on art has projected an abstract, timeless and universal agent, the artist, on to an institutional backcloth. Second, in the style of the Chicago School of Sociology, there is the insight that artists are no different from other occupational groupings in that they too pass their 'dirty' work, their less artistic work, on to others such as sound engineers or lithographers and printers. His inquiry into the Victorian art world would embrace not only the stars of the academy, not only the outsider-artists who sought recognition, but also the eighteen anonymous metropolitan female engravers over 20 years of age who were registered by the Census of 1841.[1] Third, creators are not fixed in their identities, for hybrids like artist-craftsmen may emerge which cut across received classifications such as art and artefact. The artist's identity is provisional, and creative possibilities are constituted through conventions concerning media. Finally, he alerts us to the possibility that the artist-as-creator found him or herself through the medium of institutions that contained the potential for decentring the subject.

Becker tilts against those sociologists who have tidied up art as the reflection of some pre-existing (and reified) social entity such as the economic base, class, social structure or the social system. Art is where the action is: art worlds are where the (collective) actions that go to make the distinction between art and mere artefact are experienced in all their uncertainty. Becker provides a phenomenological insight into the artist on the edge of things as his or her work is edited by others or passes through reproductive technologies. He conveys the breathless anticipation of the moment when the artist stands by as the printer pulls prints from the press or a sound recording is played back to the performer and engineer after editing.

However, Becker does not map the interconnections between art worlds and other worlds; he tells us little about how the distinction

between art and mere artefact might be mobilized in struggles for power and privilege within the wider society. In eschewing crude determinism he amputates art worlds from other social processes. How, we might ask, is the world of the artist interwoven with those of the entrepreneur, the politician or the shop assistant? Some writers, among them Bourdieu (1984), Clark (1985) and Goblot (1973), have argued that the appreciation of art is no innocent and universal pastime. Bourdieu (1984; Bourdieu and Darbel, 1991) identifies complicities between art institutions and inequality. In an influential study he shows that an art museum visit may be testing for working-class visitors who, fearing they will fail the test, silently devalue their own taste in a misrecognition of power as culture (Bourdieu and Darbel, 1991: 51). Bourdieu's argument is that museums institutionalize an arbitrary definition of cultural worth. In this way museums are sites of *symbolic violence*, by which he means to say that subordinate groups collude with dominant groups in devaluing their own taste against the measure of an arbitrary definition of art (Bourdieu and Wacquant, 1992: 167–68). The claims of the art museum to disseminate the message of universal genius to all are, it transpires, interwoven with cultural inequalities which the museum implicitly endorses.

Bourdieu focuses on the most authoritative art museums and among them those that are sponsored by nation states. Extending Norbert Elias' historical sociology he argues that modern states emerged as monopolies over diverse modalities of power (e.g. the means of physical violence, tax collecting). However, in building centralized cultural institutions, states also claim the monopoly over symbolic violence for they have established the measure of an individual's worth as a human being, recognized certain differences as paramount and proposed particular identities as normal or even superior to others. Throughout the nineteenth and twentieth centuries definitions of morality, taste, proper speech, the good parent, the normal child and so on were increasingly matters of interest for a central agency. Thus the authority of state was interwoven with the ways in which people classified the world and, for example, distinguished between good art and bad art.

Dominant classifications are resolutions of conflicts; Bourdieu observes that struggles over the definition of taste have been going on since the seventeenth century (Bourdieu, 1984). One moment in this struggle was the battle that was waged by the modernists when they challenged the art of the academy in the late nineteenth century. Edouard Manet and the Impressionists were symbolic revolutionaries in that their art proposed a way of seeing that was at odds with official academic categories of appreciation in art. Their way of seeing – Bourdieu calls it the pure gaze – was alert to the difference between art and pictures of things. Where academic art was a scholastic art grounded in the priority of a content over form, modern art granted form an autonomy from subject that was not permitted for the academician. The duty of the learned academician was to paint the grand narratives of nation and state that were the most

appropriate subjects for art and which affirmed the dignity of art; the modern painter eschewed the literary and historical culture of the academy in favour of a pure intention and form.

For those with an academy eye, art was a finished celebration of a literary, historical or moral truth. For the modernist eye true art resided in the mode of representation and not in the thing represented; it apprehended the formalism of, say, a post-Impressionist painting as opposed to the content of a Victorian narrative painting. An illustration may help at this point. In nineteenth-century England, W. P. Frith's *Railway Station* (1862) was appreciated for its finish and workmanship and was the pictorial realization of an everyday bourgeois experience. The railway station fell short of the academic ideal of an elevated subject but it occupied a legitimate place within the academic hierarchy of subjects and conformed to the notion that all paintings have a subject. By contrast, Claude Monet's railway station, *Gare Saint-Lazare* (1877), presupposes the collapse of hierarchy for, however mundane the subject, the artist has emancipated the form from the content that is this place. This kind of painting has a new kind of artist, as different in his or her way of seeing from the academician as the academician was from the artisan and a new kind of connoisseur who can see this image as a work of art.

Writing on twentieth-century French taste, Bourdieu (1984) argued that aesthetic distinctions (such as that between high and low art) are not so innocent as they may appear to be, for they underwrite the power of the bourgeoisie. Here Bourdieu connects power and classification by way of a contrast between a Kantian aesthetic and a popular aesthetic. The former is disinterested and universal in its aspirations; it promotes the formal qualities of, say, a post-Impressionist painting against the content of a Victorian narrative painting. A popular aesthetic is rooted in the life-worlds of those who experience economic domination. It is the disposition of those who consume images in terms of their functions or pictorial content. A Kantian or pure aesthetic is a refusal of a popular aesthetic: the consumption of art through the habitus of a pure aesthetic is a relational act which mobilizes the advantages of cultural capital. Bourdieu's point is that the relationship is misrecognized as the natural and innate taste of individuals who have the eye to see. There are, let us say, two railway stations, Frith's and Monet's, through which travellers pass carrying different kinds of cultural baggage and where the baggage itself enters into the experience of travel.[2]

Historical scope and the social construction of the artist

Bourdieu is widely applauded for his analysis of how class is accomplished through the medium of culture, of how taste is interwoven with inequality, of how elite culture practices contribute to the social reproduction of inequalities. However, his *oeuvre* has attracted a sustained, often sympathetic but critical response that it amounts to no

more than a bleak covert determinism (Alexander, 1995; Layder, 1994). In the case of his cultural analyses it has been argued that an over-emphasis on symbolic domination has obscured the critical vitality of popular art and underestimated the autonomy of the culture of subordinate, marginal and peripheral groups in capitalist societies (Fowler, 1997).

I think there is some substance to these criticisms and that they relate to the historical scope of his emphasis on the market as the basis for domination in modern societies. Bauman (1987) is among those who have argued that Bourdieu's vision of social order is 'curiously narrowed' in overlooking the marginal poor who are excluded by the market and who must inhabit a world ordered not through seduction but through repression. This has a bearing on the historical sociology of the visual arts because it alerts us to people and things that tend to fall out of Bourdieu's study of French art.

The struggle for professional distinction in art was a contested and long-term process which marginalized and submerged those who were unable to forge fully fledged market identities in the public spaces of art. Thus, eighteenth-century conflicts over the management of metropolitan exhibitions, the nineteenth-century problems of the water-colour societies, the difficulties of the mid-nineteenth-century etching clubs, were charged with the gendered and class politics which submerged collective identities in the market. What enraged the nineteenth-century engraver John Pye was that the Royal Academy, which seemed to have its origins in an act of expropriation, had steered a course away from the need for *collective* security on the part of artists (Pye, 1845).

In defining his historical perspective Bourdieu emphasizes critical breaks in authority of the kind that marked the collapse of the academy. In comparing his perspective with that of Norbert Elias, he suggests that the latter is the more sensitive to continuity while he, Bourdieu, is more sensitive to discontinuity (Bourdieu and Wacquant, 1992: 93). Bourdieu emphasizes conjunctural moments of change when a concatenation of processes gives birth to an historical event such as May 1968 or the birth of modernism. By contrast, Elias acknowledges the significance of revolutionary transformations but insists that, as a violent outburst, revolution will be adequately explained as the denouement of long-term changes in the distribution of power.

The effect of Bourdieu's conjunctural emphasis is that he focuses too narrowly on academician-painters, on those painters who aspired to be academicians and on the modernist victors. In nineteenth-century England, for example, we find a web of cultural identities composing the academic system of foreign old masters, of native English oil painters, of water-colourists and miniaturists and of reproductive engravers. Academy oil painters claimed pre-eminence, but they did so within an estate mode of cultural stratification which admitted the subordinate claims of other kinds of creators such as reproductive engravers.

A characteristic of the Victorian art world was the contested

completeness of the artist-as-creator; issues of authorship were nearer the surface of things in art in 1850 than they were in 1900. There was an incompleteness to the authorship of the academician and a subversiveness to the cultural politics of the Victorian period when it comes to artistic identities. As I argue in this book, mid-nineteenth-century women, water-colourists, miniaturists and engravers challenged both the singularity and the completeness of the English academicians' (male) claim to authorship. If, as Bourdieu argues, the authority of the artist-as-creator has tended to underwrite the authority of the bourgeoisie, the cracks and interstices of the Victorian art world may bear closer examination as sites of protest against and subversion of the power of the male creator.

Fowler shows that Bourdieu's acccount of modernism's gestation is partial in its neglect of modern art's engagement with the culture industry, an engagement evident in the Impressionists' celebration of the urban spaces of popular consumer culture. She argues that Bourdieu overdraws the distinction between modern and commercial artists in the period 1850 to 1880, which he reads through the lens of later classifications between highbrow and lowbrow. Drawing on Clarke (1985), Dimaggio (1982), Levine (1988) and others, she shows that modernism was born out of the relaxed classifications of Parisian urban culture and the strong classification of the pure gaze was a later nineteenth-century appropriation of modern art. Significantly, writing in the 1920s, Goblot traced the connection between cultural closure and art in the 1880s (Goblot, 1973).

This suggests that the story of modernism is a longer, more complex and punctuated one than Bourdieu reports in *The Field of Cultural Production*. The implication of Bourdieu's work on twentieth-century taste is that the art museum emerged, at some point, as the guarantor of distinction. This leaves us with a question: What was the connection between the revolution described in *The Field of Cultural Production* and the symbolic violence that Bourdieu finds at the museum in *The Love of Art* and *Distinction*?

How might an historical sociology of art institutions make the connection between the arguments of *Distinction* and *The Field of Cultural Production*? Bourdieu focuses on an explosive shift in the locus of cultural power but he does so through the lens of a formalist museum art. But how was the selective museum tradition of modernism constituted out of the cultural changes of the late nineteenth century? This was a more complex institutional reconfiguration than Bourdieu's empirical research suggests; it entailed the eviction of academicians from the museum, the rise of the art dealer and the art historian as cultural interpreters and the last gasps of craftspeople who had serviced the academic stars. These are matters to which I return in chapters 7 and 8.

Going down

Drawing on the social history of art and on the sociological interventions of Becker and Bourdieu, we can see that Jameson's centred subject of

creation, though no fiction, was a social construction grounded in the interdependencies of social actors. The rise of the artist is a Durkheimian paradox: an individuation of creativity (accelerated by the Renaissance) was attended by an intensification of the division of labour which increased the dependence of artists on others, for example, through commercial production of artists' materials, through the mediations of art critics, dealers, art historians, museum curators and so forth. The more the artist became a singular creator the more he or she became enmeshed in a network of specialists whose activities constituted a developing and increasingly autonomous cultural field; the individuation of the artist presupposed the specialized actions of a network of others stretched across time and space. There is therefore an association between the coherence of the artist's pictorial meaning and the fragmentation of meaning that is implied by the divided task of communication.

The freedom of the artist was linked to the marginalization of some creators and to their exploitation. The centring of the artist permitted some creators and creations to take their places in the public sphere to the exclusion of others. The obverse of the privileging of the artist-as-creator was humbling, and even humiliating for some producers (reproductive engravers, female artists, academic painters) or else a self-abnegation of the kind that art dealers and museum curators practise in their work of bringing the artist into view as a creative subject. There was a cost to the artist as creator, for it presupposed the conversion of others to intermediaries. The process of entering the public sphere was productive of the artist's creativity. Furthermore, as I show in later chapters, the monad of high modernity was grounded in a heterogeneity which the politics of nineteenth-century art could not quite conceal.

In assessing Bourdieu we should keep in mind his critique of the romantic idealism of the artist-as-creator and his responses to criticism. The relative autonomy of art is what is specified when Bourdieu substitutes his genetic structuralist approach for romanticism's emphasis on the estrangement of the artist from society. Bourdieu has his critics within his sociological sights when he observes that dispositions to resist are socially constituted and that a romantic commitment to people's native resistance is no substitute for analysis of its conditions. He proposes that sociologists talk to the dispossessed and to officials such as social workers who occupy a strategic situation within the social world. By so engaging with suffering and its interpreters, we may, he argues, bring to view the repressed discourse of those who are 'good "historians" of their own disease' and exploit the locational perspectives of those officials 'who are living thesauri of spontaneous knowledge' about society (Bourdieu and Wacquant, 1992: 200–1).

A neglected chapter in the story of the artist concerns the testimonies of those losers who found their opportunities for artistic reputation blocked by modernization. Three unremarked features of English art history have a bearing on this. The first is that the lineage of art's institutional history

stretches back to an antiquarian-artist-engraver, George Vertue (1684–1756). Vertue's *Notebooks*, first published in the early twentieth century, were the point of departure for Horace Walpole's *Anecdotes of Painting in England* (1762) and for W. T. Whitley's indispensable four-volume account of English art institutions in the years 1700–1837. The second is that engravers provide some of the most penetrating writing on the gestation of the modern art world. Half artist half artisan, their creative, commercial and technical situations endowed them with motives and insights that passed by other observers. One such engraver was John Pye, who wrote *Patronage of British Art* (1845). The third concerns the phenomenon of the radical enraver; engravers such as William Blake, Henry Vizetelly[3] and James Linton were vital sources of nineteenth-century English radicalism and social protest.

The works of George Vertue and John Pye along with those of other engravers are measures of the thickness of art history and of the diversity of possible routes into the future. They register lives which are shot through by the divisions of modernity, lives which are patched together through the uncertainties that are the shifting balance between patrimonial favour and market opportunity. Vertue records not only the art collections to which he had access as a patronized engraver but the lives that crossed his along with hearsay, and gossip that came the way of a well-connected antiquarian.

Where Vertue's *Notebooks* are, among other things, a private record of his status anxieties as an engraver, Pye's *Patronage of British Art* is a public protest. *Patronage* forms a discursive alliance between a declining craft tradition and the radical utilitarianism of statistical and documentary data. At its heart is the bitter experience of academic exclusion which Pye shared with so many of his fellow engravers. In Pye's case the experience yields a political economy of art institutions whose target is the Royal Academy and whose argument is that things should have been otherwise. That is the key to the book's infuriating, almost hyper-textual structure with its thin lines of text constantly interrupted by extensive footnotes. In this way Pye gives a sense of stories which are in the making within the inner worlds of institutions. There are other testimonies by engravers: Robert Strange's *Memoirs* (Dennistoun, 1855), John Landseer's Royal Society *Lectures on the Art of Engraving* (1807), Abraham Raimbach's *Memoirs and Recollections* (1843), Henry Vizetelly's *Glances Back Through Seventy Years* (1893) and W. J. Linton's *Memories* (1895).

These works are indications of art worlds in which the hegemony of the artist-as-creator is contested, less then complete. They register the engravers' sense of a world that is at odds with their self-image as artists. More than most creators, engravers were of two worlds. They reproduced the paintings of the great masters as handicraft prints: they had their place in a hierarchy that was sanctioned by a chain of being, the dispositions of patronage, a universe of pre-existing subjects and moral themes. In collaborating to visualize the world, painters and engravers had their

proper roles within the scheme of things. Engravers were a kind of artist; yet they were being drawn into a world which would dissolve hierarchy in the market and measure everything from the singular centre of the artist-as-creator. Engravers (and others) came to be measured by what they lacked, and that lack was originality. None the less, they hung in there, to the 1850s and beyond, feeding their discontents into the public spaces of art and registering their presence.

There are testimonies other than those of engravers and where the experience of erasure, exclusion or discrimination entered into identity, dramatized (perhaps only for a moment) the making of cultural capital and exposed the intimacy of power and knowledge. Sometimes revelation is in the flow of political action, as when the mid-nineteenth-century water-colourists petition the government for official accommodation. In 1860 the artist Laura Herford outwitted the academicians in submitting her perfectly correct application form for admission to the Schools of the RA. The Academy's pathetic appeal to a lack of proper facilities for females, when it realized that 'L' stood for Laura and that there was no constitutional reason for refusing a woman's candidature, is a moment which entered the story of art through female writing of the period. In the twentieth century, just as popular Victorian art is being evicted from the canon, there is the academician Sir Reginald Blomfield's protest over the Chantrey Bequest Inquiries and his exposure of Lord Curzon's refusal to allow the President of the Royal Academy to correct mistaken evidence (Blomfield, 1932).

In diverse ways these people recovered moments in the making of institutions when symbolic power washed back on to the powerful, when power was caught off balance, rendered ridiculous for a moment, not quite sure what it was doing, floundering to find a *post hoc* reason for what it had done, forgetting the rules, rationalizing its way out of trouble.

Karl Marx and Frederick Engels were two Victorians who touched on the exploitative connections between genius and society. In a well-known but undeveloped observation they suggested that modernization brought about an 'exclusive concentration of artistic talent in particular individuals, and its suppression in the broad mass' (Marx and Engels, 1970). Nineteenth-century critics and artists, and especially John Ruskin and William Morris (1936), provided assessments of the Victorian art world that have much to tell us. Both reflected on the exploitation that was internal to art and which could be observed in the commercialization of engraving as a means of mass-producing images.

It was the labour of reproductive engraving that led Ruskin to talk of slavery when he reflected on the amount of cutting required of the engraver to clear the lines of a Punch cartoon (Plate 3) and Morris of the 'literal reproduction of meaningless scrawl'. Consider, said Ruskin, what you have done when you have bought a reproduction of a picture.

> You have paid a man ... to sit at a dirty table, in a dirty room, inhaling the fumes of nitric acid, stooping over a steel plate, on which by help of a

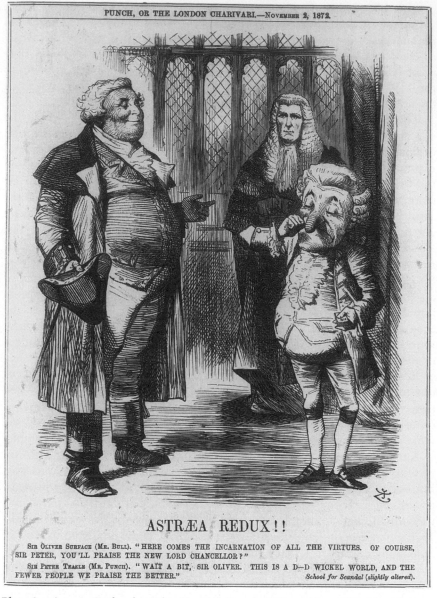

PUNCH, OR THE LONDON CHARIVARI.—November 2, 1872.

ASTRÆA REDUX!!

Sir Oliver Surface (Mr. Bull). "HERE COMES THE INCARNATION OF ALL THE VIRTUES. OF COURSE, SIR PETER, YOU'LL PRAISE THE NEW LORD CHANCELLOR?"

Sir Peter Teazle (Mr. Punch). "WAIT A BIT, SIR OLIVER. THIS IS A D—D WICKED WORLD, AND THE FEWER PEOPLE WE PRAISE THE BETTER." *School for Scandal (slightly altered).*

Plate 3 *Astræa Redux* by John Tenniel, *Punch*, 2 November 1872 (the 'slavery' of cross-hatching). Ruskin noted that the cross-hatching between John Bull and the Lord Chancellor required 1,050 interstices to be cut clear to give two square inches of shadow on the wall. Calculate, he said, how many men are night and day cutting these holes as the occupation of their manly life.

magnifying glass, he is one by one, laboriously cutting out certain notches and scratches, of which the effect is to be a copy of another man's work.
(Ruskin, 1959: 62)

Ruskin's concern about the working conditions of the engraver flows from the sense that beauty cannot be detached from the conditions of art's making. Morris had a profoundly sociological, that is relational, grasp of the conditions of creativity. The writings of both men emphasize the alienating effects of the social division of labour in art. Ruskin and Morris alert us to the complexity of art's relationship to inequality. In the twentieth century Walter Benjamin (1970) was to connect art and exploitation in the remark that a historical materialist viewed cultural treasures with cautious detachment. His point was that art owed its existence both to creators and anonymous toilers. For Benjamin the task was to brush history against the grain, for the transmission of artefacts was tainted with the barbarism of their making and their appropriation.

In this book I take Bourdieu at his theoretical word and look for the repressed discourse of those who were submerged by long-term transformations in the ordering of art. Through the nineteenth and early twentieth centuries we can find spontaneous knowledge of the art world: reminiscences of and by forgotten artists, the memories of female artists, biographies of craftspeople, memoirs of museum officials, the diaries of art dealers, the evidence and deliberations of official inquiries.

On the modernity of British art institutions

I have already noted that in recent years historians have emphasized the modernity of British art institutions (Allen, 1995; Brewer, 1997; Corbett, 1997; Haskell, 1976; Pears, 1988; Prior, 1999; Trodd, 1997). A substantial, though scattered, body of research has explored the formation and development of London's metropolitan fine arts agencies such as the Royal Academy of Arts, the British Museum, the Dulwich Gallery, the National Gallery, the South Kensington Museums and the Tate Gallery. There has been an interest in how provincial and metropolitan concentrations of cultural power took shape as arbiters of taste. Some of this work takes the form of institutional histories that are informed by the principles of the new art history, cultural studies, feminism and social science theory, and shows how the production and consumption of art are social processes.

One reason for attending to this literature is the need to bring to the study of art and power the kind of analysis that has marked the study of economic power. In the case of economic power there is a sophisticated understanding of economic modernization as transition from family or entrepreneurial capitalism to the impersonal modes of control associated with national and global corporations (Scott, 1991). The consequences of impersonal modes of economic possession for the structuration of the upper class are well researched as they yield forms such as the joint stock company and characteristically modern struggles for economic power. However, modernization of cultural power has been less fully explored. There are parallels with the joint-stock company in that modernization entailed separation of cultural ownership from cultural control.

The end of the eighteenth-century rule of taste entailed multi-polar shifts in the balance of cultural power as aristocratic elites lost their grip on the definition of taste and were drawn into collaboration with markets and states. Nineteenth-century art was authorized by institutions which yielded new cultural identities (cultural bureaucrats, trustees, museum directors and so forth). In the agrarian crisis of the last quarter of the nineteenth century, the Settled Lands Act of 1882 led to a rapid commodification of aristocratic art, a flood of aristocratic treasures onto the world market and struggles to contain the flood through the reformation of national collections and new ideologies of ownership. These changes, which were interwoven with the reception of modern art at the museum, accelerated the modernity out of which the English forged new modes of impersonal possession in culture.

Modernization entailed an impersonalization of cultural power which turned cultural institutions into sites of contest. One such institution was the museum of art and it is there, as Bourdieu indicates, that the charismatic authority of the artist-as-creator became most patent; it is there that the art lover was most fully cued to recognize the presence of the artist, to discard references to other authorships and to extra-aesthetic experiences. The museum was one place at which the artist was, so to speak, centred; but the authorship of the nineteenth-century artist was claimed in diverse settings such as studios, art criticism, art reproduction, picture restoration and exhibitions. These spatial contexts were marked by rituals of visiting, gazing and attention which organized the identity of the artist-as-creator while disorganizing other claims to authorship.

Becker's free-wheeling, hybridizing art worlds of collective actions alert us to the untidy and disconnected aspects of cultural production as art circulates through the spatial contexts of studios, exhibitions and museums and as modernity permits new creative possibilities. Becker's Chicago School sociological perspective on modernity accommodates outsiders such as delinquents, hobos and marginal creators such as Sunday painters, folk artists and those craftspeople who service the artist. As Becker shows, art sometimes invades craft; painters may colonize practices that were once artistically intractable or had no obvious artistic application. Thus, new hybrid identities such as artist-craftswoman or painter-etcher may condense on the borders of art worlds; modern art was born out of the maelstrom of modernity rather than from the verities of good taste (Berman, 1983).

The modernity of tradition

It is often said that British modernization was sabotaged by tradition, and Wiener (1985) provides one of the influential formulations of this version of history. An industrial bourgeoisie, so the argument goes, emerged as the motor-force of modernization in the first half of the nineteenth century and was set to accelerate into the future. Then, seduced by the

charms of an aristocratic lifestyle, it failed to fulfil its historic role as a capitalist class. The evidence for a hegemonic culture of traditionalism has long seemed empirically fragile for the one-sidedness of its emphasis on aristocratic survival as the key to British culture, and theoretically flawed for its failure to problematize the meaning of tradition in the modern world.[4] Drawing on the extant critical literature, three preliminary points are made below.

First, there is a need for a more rounded view of the aristocracy's situation as a class caught between two modes of rationality, traditional and modern. One mode was rooted in the need to consume in order to keep one's place in Society, and was realized in the art collecting, country house-building, reconstruction and decoration that continued through the Victorian period until the 1870s (Girouard, 1979). This is part of the reason for the chronic indebtedness of some families and for the long-term decline of the aristocracy (Cannadine, 1995). The other mode was ordered according to the economic calculation of commercialization which turned the aristocracy into a super-rich class capable, among other things, of competing with European princes for the prizes of old masters (Haskell, 1976). Aristocratic power was neither at odds with modernization nor a survival: the aristocracy emerged as a dominant class through the commercialization of land and in close partnership with other forms of capital, both financial and cultural. It is more accurate to speak of the making of the aristocracy through modernization rather than of its persistence as an old order and of its cultural hegemony within a configuration of power that included City interests, commerce and the professions (Rubinstein, 1993).

Second, as Rubinstein demonstrates, Britain 'was *never* fundamentally an industrial and manufacturing economy' (Rubinstein, 1993: 24). It is true that by the 1830s industrial modernization, especially in the North-west, spawned new concentrations of economic power whose holders were outsiders to the old upper class. The cultural dimensions of this development have been well explored by Davidoff and Hall (1987), Smith (1982), Thompson (1978), Wolff and Seed (1988) and others. These reveal the middle-class identities that crystallized in urban institutions, including art institutions; they also establish the cultural weight of the middle class within the class structure of nineteenth-century Britain. In Birmingham, Manchester and Leeds, exhibitions and art societies emerged out of shifting balances of class power and as middle-class challenges to aristocratic cultural categories. However, the traditionalist thesis that after 1850 industrial capitalists ceded their culture in exchange for aristocratic distinction overestimates the power of industrial capitalists in the mid-nineteenth century (Rubinstein, 1993). Manufacturers, as a class, were less wealthy than landowning and commercial capitalists through the period of the nineteenth century.

Third, after 1851 both aristocracy and bourgeoisie were defeated as independent contenders for power. From the 1870s there was a

convergence of the two capitalist groupings that gave rise to a unified capitalist class (Rubinstein, 1993; Scott, 1991). It was not a particular propertied group but a figuration of capitalists, that is of aristocrats, financiers and industrialists, which was the author of modernization. The structuration of the upper class was in part a cultural process which drew land and finance into a closer association but tended, at least until the 1880s, to exclude manufacturers (Stone and Stone, 1984). This is not to gainsay the seductiveness of 'aristocratic' culture for newly rich industrialists who competed for status. Nor is it to deny the existence of an anti-industrial spirit expressed in the English way of life and its rural preferences. It is to suggest the need for a more structural approach that grasps tradition as a selective process of engagement with modernity. It is also to say that a singular emphasis on an anti-industrial culture may obscure the capitalist limits of the state's permissiveness towards tradition.

Tradition was a strand in the dominant ideology of the late nineteenth-century British upper class. Ingham (1984: 241) endorses Wiener in noting the diversity of social and cultural evidence for British traditionalism. In the case of the visual arts we might note the importance of private aristocratic institutions (the British Institution, the Burlington Arts Club, the Grosvenor Gallery) and the aristocratic complexion of public bodies such as the National Gallery. In the second half of the century there are indications that the Royal Academy of Arts was drawn into a closer association with monarchy as it defended itself from the incursions of the bourgeois state (see Chapter 4). And there is the characteristically pragmatic British ordering of the cultural state through Treasury Minutes that tended to juxtapose institutions on the basis of a fiscal convenience and which fought shy of a Ministry of Art.

Ingham observes that while the evidence for traditionalism is not in doubt, a question that remains to be answered is: What material factors permitted this traditional vision to survive and how was traditionalism interwoven with the British state? Ingham focuses attention on the distinctiveness of Britain's economic relationship to the world and on the international role of the City of London as a leading edge of British capitalist development.

While it is not possible to do justice to Ingham's argument here, a number of its features help us to understand the patterning of British official art institutions. Part of Ingham's argument is that non-industrial capitalism was augmented because City wealth permitted aristocratic survival in the face of agrarian decline. A late nineteenth-century 'bankrolling' of gentlemanly lifestyles went hand in hand with a strong classification between banking and industry and with the consolidation, within the state, of a Treasury point of view that favoured the needs of the former over the latter.

This economic power was consonant with traditional liberalism in education and culture. Ingham's argument is that the habitus of the English upper class was one of a pragmatic engagement with world

commerce and one whose transnational and imperial preoccupations did not require the state to organize domestic production. One consequence was an elective affinity between a gentlemanly culture which pervaded Britain's core institutions and a pattern of state formation which favoured a strong City–Treasury relationship.

Treasury dominance within the British state is one of the factors which explains the peculiarity of Britain's arts administration. The visual arts are important because in Britain their ordering was more bourgeois than in some of its European counterparts, for example, in its early containment of royal arts expenditure, in the shaping of the RA itself and in the subordination of official arts expenditure to the Treasury. As Ingham (1984) argues, the Treasury had its sights on aristocratic 'appropriation of the state's revenues'. It was informed by a Benthamite-Ricardian reforming ideology of non-interference which also shaped arts policies, for arts expenditure was particularly susceptible to charges of aristocratic excess (Ingham, 1984: 129). Ingham observes 'that the state set itself against a section of the traditional dominant class, but not at the behest of the emerging industrial bourgeoisie' (Ingham, 1984: 9). A purpose-made National Gallery building (opened in 1838) was sanctioned by a Parliament made wary of voting money to refurbish palaces and for public works by the subterfuge of the Prince Regent (Minihan, 1977: 11). Patronage, collecting and influence over the National Gallery were confirmed as personal rather than official activities of monarchy.

Ingham's contribution to our understanding of the survival of tradition shares something with Wiener in that he leaves the category of tradition untheorized. The culturalist emphasis of Wiener obscures the meaning of tradition by neglecting the structure of modernity and the structuration of the upper class. Thus, aristocratic identities are not residues from the past but are actively created through an engagement with the structures of modernity. Some nineteenth-century art institutions were aristocratic interventions as the old order sought to recover itself on the terrains of the state and the arts. Traditional cultural power in 1750 was different from that of 1950.

It is a commonplace that in the early nineteenth century a new class of patrons, thrown up by industrialization, entered the art scene as collectors of a native English art and with a tendency to eschew an established aristocratic taste for Old Masters. However, to treat them as merely taking up the baton of patronage is to miss the structural changes that accommodated these collectors. New patrons formed their identities through new associations with experts, dealers, critics and the art press, and in doing so they challenged the dominant categories of aristocratic art. The campaigning journalism of Samuel Carter Hall in the *Art Journal* against fraud and forgery of Old Masters was a subversive lesson in the Old Masters and an invitation to buy the worthy English product from living academicians.

The RA was a distinctive and modern blend of cultural power, governmental and royal patronage and institutional self-determination. Its

development conformed to an Anglo-American pattern in which the
professions serviced the state as semi-independent corporations of experts
through strategies of trust-making (Johnson, 1982; Savage *et al.*, 1992: 29;
Torstendahl, 1990: 1–8). There was a symbiosis between the building of
the cultural state and professional autonomy which is evident in the
pragmatic, piecemeal building of apparently traditional institutions: in the
emergence of the RA as an ambiguous, partly private, partly public
corporation servicing the state's artistic requirements, in the evolution of a
National Gallery of British Art or in stalled, delayed, muddled and lost
opportunities. A fateful initiative of this kind was, as I show in Chapter 7,
that of Sir Francis Chantrey.

British official art was subject to two competing principles of
modernization, for the field of the cultural state was itself contested. If
one principle was professionalization, the second of these was a bureau-
cratic mode exemplified in South Kensington in which cultural power was
rooted in a centralizing departmental officialdom with salaried officials and
teachers. South Kensington with its dual functions of museum and teaching
industrial design had emerged out of the radical bourgeois impulse of Select
Committee proposals of 1835 and was funded by the profits from the 1851
Exhibition's celebration of industrial capitalism.

The literature to which I referred in the previous section has an
important bearing on these matters as it establishes that the English art
world was institutionally modern. It includes Corbett (1997), who draws on
Weber (among others) to argue for a relational and sociological view of
modern and traditional discourses of art. His point is that modernity can be
registered in cultural forms that are not modernist in their impulse (Corbett,
1997). I extend this line of thinking by outlining three arguments about
modernity which may lead us out of the frozen categories of tradition and
modern and towards a more sociological view of class, the state and culture
in the period after 1850. Here we need to probe more deeply than does
Ingham into the internal connection between tradition and pragmatism.
Drawing on Bourdieu (1996), I stress the modernity of nineteenth-century
cultural structures which mediated patronage. Drawing on Giddens, I stress
the modernity of traditions which were opened up to discursive
justifications (Giddens, 1994: 105) and which, as I argue in Chapter 4,
probed the *Royal* of Royal Academy. Drawing on Savage *et al.* (1992), I
stress the professions and professional collaboration with the British state.

Bourdieu and the field of art

The key to Bourdieu's sociology of art is that modernization has been a
long-term process of differentiation which transformed societies into
networks of specialist fields of action: economics, politics, sport,
intellectual life, art and so forth. Each field is a social space ordered
according to its distinctive rules and offering its own prizes. You cannot,
as Bourdieu puts it, make the geographer compete for the prizes of a

philosopher. *Modern society* refers to a web of interconnected spaces or areas which together form a field of power. The field of power is where different elites compete with one another for economic, political and cultural assets and for hegemony over subordinate classes. A given state of the field of power is characterized by a particular distribution of assets and by an ordering of the priority among those assets so that, for example, economic capital accumulation may have priority over the accumulation of other kinds of capital (Bourdieu, 1996; cf. Elias, 1987).

A field is a relatively autonomous social space whose structure 'is a state of the power relations among the agents or institutions engaged in the struggle [to define and monopolize authority]' (Bourdieu, 1993: 73). The field of art is marked by internal struggles over the rules of art between established power-holders and newcomers. The former will attempt to conserve their position within the field; outsiders will tend to enter the field subverting the existing rules of art and transforming the definition of art. Thus, the field of art is the space of relations and positions in which artists, critics, dealers and other cultural agents determine legitimate art and compete for the prizes of legitimate art; it is a space of conflict and co-operation between, say, oil painters, water-colourists and engravers.

Bourdieu's approach is at once structural and historical in its emphasis on the differentiation of fields within the field of power. It follows that the coherence of the upper class does not arise automatically from economic assets because the augmentation of economic power is a process of differentiation which yields indeterminacies. To account for upper-class power, we must consider the strategies by which it stitches itself together in the face of the vagaries of modernity. For example, the Good Societies of nineteenth-century Europe, the old-boy network of twentieth-century Britain or the interlocking directorates of modern economies are forms through which the Chinese walls of modernity are hegemonically breached. One aspect of change concerns the means by which upper-class solidarity is secured in the face of modernization's differentiation of power, and in our case this concerns the social position of the artist and, more broadly, that of intellectuals and professionals.

Modernity gives cultural producers greater weight within the overall social structure and is marked by their struggles to augment cultural power *vis-à-vis* economic and political powers. Professionals, intellectuals, artists, scientists and so forth may exercise domination over subordinate classes, but they do so from a situation of structural ambiguity; over time they may be drawn towards political and economic elites or towards subordinate classes. Although Bourdieu dubs them a 'dominated fraction of the dominant class' he signals the possibility that intellectuals might be drawn into an alliance with subordinate groups. The situations of different producers within the field of art flow from combinations of assets in their possession: the most powerful and professional will be economically and culturally well endowed, weaker

groups will be reduced to cultural assets and the weakest will be bereft of cultural authority and money.

Bourdieu is concerned with the autonomization of the field of art, a process whose origins obviously pre-date the 1800s but which accelerated in the second half of the nineteenth century. The more autonomous the field of art (it can never be absolutely autonomous) the more that patronage will be refracted through rules of art whose determination is monopolized by cultural specialists who in turn mobilize public assent to those rules. Bourdieu's meaning is indicated when he draws on Durkheim's distinction between mechanical and organic solidarity (Bourdieu, 1996: 386). Power was once incarnate in particular institutions or even in persons. The patron once commissioned a work of art according to rules which tended to illuminate the power of patrons. However, the development of fields corresponds to a long-term impersonalization of power which entails a 'division of labour of domination' (Bourdieu, interviewed in Wacquant, 1993: 19–44). With this formulation he dissents from the conventional sociological view that dominant categories are imposed on subordinate classes by the economically powerful. Rather, he maps dominant institutions as emergent properties of fields, or figurations of power, which are shaped by struggles over the priority of different assets. In modern societies effective domination flows from success in simultaneously managing different forms of domination (Wacquant, 1993: 25). For example, in Britain subordination of arts expenditure to a Treasury point of view is one aspect of a structuration of the field of art in relation to the field of power.

Giddens and reflexivity

Irrespective of who might be said to apprehend and direct modernization, the Wiener thesis elides the *reflexive* character of tradition under modernity. Reflexivity refers to modernization as it institutionalizes knowledge which flows from a continual examination of social practices; what is distinctive in modernity is its 'presumption of a wholesale reflexivity' (Giddens, 1990: 36–45). Giddens argues that modern people are engaged in a constant review of their social practices, and that such recursive actions are characteristically modern in their subversion of certainty. For example, the 'traditions' of the British state are not traditional in the sense of being clones of earlier social, cultural and political forms. The authority of tradition lies in its capacity to re-invent itself, thus to form new connections in the modern world. Bagehot's assessment of monarchical power in an age of bureaucratic efficiency is entirely to the point in its emphasis on the role played by royal custom in re-enchanting the machinery of government (Bagehot, 1867/1963).

The development of governmental systems of information-gathering (in the form of commissions, reports and inquiries serviced by 'experts') is one expression of the Victorian state's reflexivity. Matters of art and state

were well represented by the official discourse of Select Committees and Royal Commissions. Official discourse provides access to a wealth of historical data. However, as I argue in Chapter 4, it is not a transparent medium through which the truths of witnesses' experiences are articulated or remembered. Official discourse, materializing relations of power, permitted some identities to flourish and others to wither. Official inquiry into art is an initiative for determining the relationship between the field of power and the field of art; it is a moment at which the state, or some sector of the state, recognizes and seeks to organize, control or calibrate the human capacities through which modernization is enacted.

Savage *et al.* on the professions

Reflexivity was an aspect of the internal relationships between knowledge, the professional classes and the Victorian state. A partnership between reformed semi-independent professions and the state accentuated the modernity of the latter through forms of regulation in which professions, such as the law, medicine, the Civil Service and the fine arts were deeply implicated. The hallmark of these occupations was that they articulated an ideology of public service. The making of the modern state was a process involving, among other things, a professionalization of knowledge about society.

Savage and his co-authors (1992) argue that the terms of the debate about British modernization have been drawn too narrowly. They emphasize the role of cultural assets in the struggle for power and privilege, suggesting that the debate about class and British modernization has been preoccupied with divisions within the propertied class. Opposing those who stress aristocratic survival as the key to British institutions, they demonstrate the evolution of a relatively cohesive, male metropolitan professional class as an essential element in modern state formation. They argue that the protagonists in the traditionalism debate have failed to detect the complex networks of upper-class power that progressively characterized domination in the nineteenth century. Modernization was linked to a spurt in professionalization as specialists serviced the particular requirements of power yet traded on the universalism of expertise. A credentialist attack on patronage was a means by which the state, after 1848, sought to fireproof itself against revolution by purging 'Old Corruption'. By addressing these material processes of professionalization, Savage and his associates provide a more complete picture of upper-class structuration as the interweaving of economic, political *and* cultural processes.

Thus while the propertied class played a dominant role as patrons and collectors, professional people had, since the early eighteenth century, been significant players in the development of the metropolitan art world. In the eighteenth century the doctors of the Foundling Hospital and the officers of the Royal Society of Arts facilitated the first public exhibitions

of art. Richard Mead (1673–1754) and Thomas Monro (1759–1833) are among those medical people who were significant collectors of pictures (Pears, 1988: 110). London's first public art gallery, established at Dulwich in 1817, was the outcome of association between an artist and a college. Francis Seymour Haden, a surgeon, campaigned for etching as an art and instituted the Royal Society of Painter-Etchers in 1868. An architect, George Godwin (1813–1888), promoted the influential art unions which were lotteries that offered subscribers an engraving and the chance of winning a work of art. Lawyers figure large in the story of British art institutions: as founder editor of the powerful and long-lived *Art Journal* (1839–1911) (Samuel Carter Hall), as successor at the *Art Journal* to Hall (Marcus Huish), as founder of the New English Art Club (W. J. Laidlay), as donor–founder of the Slade School of Art (Felix Slade). An ex-colonial civil servant, Henry Blackburn, created a journalistic genre with his *Grosvenor Notes, Royal Academy Notes, Art of The Year* and so on. It is not the absolute numbers or even proportion of such figures that is so important but their critical role in pioneering institutional developments.

Conclusion

Art is collective action: the rise of the artist was an historical process which enlisted others through an intensification of the division of artistic labour. The artist-as-creator presupposed a socialization of artistic production that concentrated cultural power in the hands of monopolies such as academies and museums. The problems of academies and exhibitions were bound up with longer-term changes in cultural power that emancipated art from ritual contexts. The fate of academies was interwoven with the creative possibilities opened up by modernity's proliferation of images and by their increasingly rapid circulation, via exhibitions, mass production and with the commercialization of art. Art flowed out of the legislative settings of elites and academies into the diverse contexts of books, prints, domestic easel paintings, exhibitions, reproductions, advertising and commerce.

While commercialization was a necessary condition for the rise of the artist, it brought problems of authorial control insofar as images could circulate beyond the control of patrons and artists and outside the authority of professional institutions. Problems of art classification, of regulating copies, reproductions and exhibitions and of defining the artist were part and parcel of nineteenth-century art politics. These changes were linked to the decline of a 'rule of taste' with its belief in a fixed classical tradition (Ames, 1967; Haskell, 1976; Steegman, 1936). The master narrative that ties the arguments of this book together is that the dominant classifications of art broke down when the socialization of art created a web of interaction which could no longer be contained by aristocratic and professional monopolies.

In Chapters 7 and 8 I build on Basil Bernstein's argument that cultural

classification reflects both the distribution of power in society and the principles of social control (Bernstein, 1971). Bernstein shows how cultural agencies, such as schools, organize identities by selectively transmitting worlds of knowledge. It will be recalled that Howard Becker recovers collective action from prevailing romantic notions of the artist, and Pierre Bourdieu alerts us to the transfiguration of collective action into the charismatic singularity of the artist-as-creator. Bernstein's work on classification advances these arguments because it shows how power is discursively organized by cultural institutions.

Following Bernstein we can see how selective features and moments of art's collective action are reassembled as exhibitions, reproductions, museum displays, etc. Bernstein's concept of code helps us to see that museums and their exhibitions (like schools and their curricula) are encodings of power in that they select and edit elements from art worlds: even the museum without walls will leave some things outside. For example, as I try to show in Chapter 5, the problem with prints being original art was to do with the fact that the social relations of printmaking were refracted through the strong classification of artist and artisan and through strict boundaries between fine and applied art.

The social production of pictorial meaning cannot be separated from the histories of institutions such as exhibitions, reproductions and museums. When we look into these institutional histories we see moments when the production of the artist's authority is discursively incomplete and resisted. The spaces of nineteenth-century art (exhibitions, museums) were spaces of cultural classification where the authority of the artist was registered but where multiple, fugitive and sometimes subversive identities lurked, sometimes suppressed and sometimes bubbling up to the surface of cultural politics.

These matters, I argue in Chapter 8, are most properly assessed in terms of a theory of social change which specifies the conditions of declassification. Nearly fifty years ago David Lockwood observed that change was generated not randomly but systematically according to 'the balance of indulgence and deprivation among different social groups' (Lockwood, 1964: 141). He specified two general dimensions in the ordering of social relations: the normative structures which defined what was possible for people to achieve, and the division of labour which distributed opportunities for people to achieve their aspirations. In the following chapters I try to show how the division of labour in art was both factual (in its distribution of opportunities to be creative) and normative (in its definition of what was possible). In art, as in other enterprises, creative aspirations may be trapped by normative expectations of what is possible for whom (or, to put it put it another way, what is discursively possible for subjects). Lockwood's argument was that people are not necessarily condemned to be trapped in a classification, for the institutional contradictions of social life may create opportunities for action that challenge a given classification of people and things.

Art, Power and Modernity considers aspects of London's art world in the years 1750 to 1950 and has three aims.

- To provide a sociological map of fine art institutions in their relations to power and privilege.
- To show how the gestation of creative subject and the development of art institutions were two sides of the same coin of modernization.
- To show how the authorship of the artist materialized in diverse settings.

This book is organized around related topics: photographic art reproduction, art exhibitions and the profession of the artist, modernity and the Royal Academy of Arts, the plight of reproductive engravers, the resurgence of etching and the problem of the Chantrey Bequest. Each chapter deals with a space or spaces of authorship. I argue that these spaces are media through which the artist-as-creator is constructed; they are not conduits through which an author passes on his or her way to meet the art lover. Thus Chapter 1, in reviewing Ivins' *Prints and Visual Communication*, argues that art reproduction was an argument about the meaning of images and that Ivins unwittingly gives that argument a radical twist. The counter to this position is that class projector slides and half-tones of art works are no substitute for the original which is in the museum of art. Yet as Prior (1999) has argued, museum spaces are purged places which have emancipated historical images from their 'original' religious, domestic and decorative contexts.

If the museum constructs a viewing point and a spectator for art then so does the chapel, the artist's studio, the mixed exhibition, the reproduction, the art documentary, the web-site and the CD-ROM. In these diverse settings viewers may encounter traces of other authorships than those of the artist as creator. A collector's donorship may be inscribed in the fabric of the museum, the technician's skill may leave its traces in the craft of reproduction or the exhibition of male masters may accommodate females as amateurs.

Notes

1 Census of Great Britain: Occupations, 1844 (587) (xxvii).
2 Shaw's fictional artist in *Immaturity* flirts with the housekeeper's daughter, but they are separated by more than class, for the painter cannot conceal his disdain for the daughter's taste in art: 'Mr Frith is undoubtedly a very clever man...[who has] found in a railway station a very suitable field for the expression of his genius' (Shaw, 1931: 136).
3 Vizetelly records that the most democratic opinions circulated in Bonner's workshop where he served his time as an engraver (Vizetelly, 1893: 121).
4 The relevant literature includes Cannadine (1995); Johnson (1982); Rubinstein (1993); Savage *et al*. (1992); Wiener (1985); Wolff and Seed (1988).

2

Fugitive authorship: William Ivins and the reproduction of art

The Spartan Boy

The collection of the National Gallery of Ireland contains two *trompe-l'œil* paintings of prints, *Lowry* and *The Spartan Boy* (Plates 4 and 5), painted about 1800. These images deceive the eye in a game with reality. Surface textures are effaced in favour of a perfect depiction which persuades a spectator to address the paintings as engravings. There are tell-tale plate marks that distinguish intaglio images from other prints and from drawings or paintings. The paintings convey the rich tonality that is the hallmark of the mezzotint.[1] Signs of wear and tear are symptomatic of casual display, perhaps in an artist's studio. The key and the tacks, along with the curling and furling of paper against wood grain, provide depth cues that these images are made from ink on paper attached to wooden panels and not from oil on canvas. The engravings bear the signs of use and of their making.

Within *The Spartan Boy*'s plate mark there is the conventional information concerning authorship of engraved reproductions, evidence that we are looking at a reproduction by W. Humphrey of a painting executed by Nathaniel Hone. The artist's skill brings the print so fully and frankly into our presence that the existence of another image, a second painting, is signified. Hone (1717–1784) exhibited a painting called *The Spartan Boy* (now in a private collection) at the London Royal Academy of Arts (RA) in 1775, and this is known to have been engraved by W. Humphrey.[2] The subject of the painting is not only a Spartan boy, not merely a mezzotint but a mezzotint reproduction of a painting. As a reproduction of a mezzotint the painting reverses the usual relationship, whereby engraving reproduced the effects of oil painting. Qualities that distinguish mezzotint as a medium for reproducing oils are now captured in oils.

The painting depicts the qualities of a mezzotint, but, in a world without photomechanical reproduction, the mezzotint engraving would usually have conveyed those of a painting. There are three levels of authorship: the anonymous *trompe-l'œil* painting, Humphrey's engraving and the original painting by Hone. The mezzotint reproduces a painting

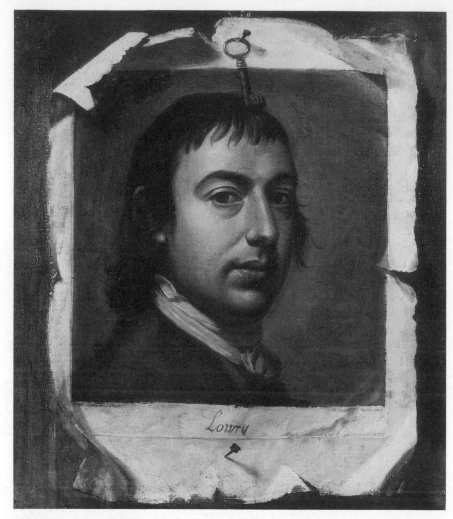

Plate 4 Anonymous *trompe-l'œil* painting of an engraving of Lowry, *c.* 1800. Courtesy of the National Gallery of Ireland.

by Hone. The anonymous painter repossesses, as it were, the engraved image for painting. The *trompe-l'œil* has no signature, which is appropriate, for an indication of authorship would threaten the conceit that the spectator confronts a reproduction of a painting. The anonymity of the painting's artist is a part of the illusion that we have the real thing – a real reproduction! If the graven image is repossessed by painting then the authorship of our painting is concealed through the transparent effects wrought by the anonymous painter.

It is impossible to appreciate the image and not to register the ambiguity that surrounds this fugitive authorship. Signifiers and signifieds are always on the point of being reshuffled. Appreciation gives chase as the

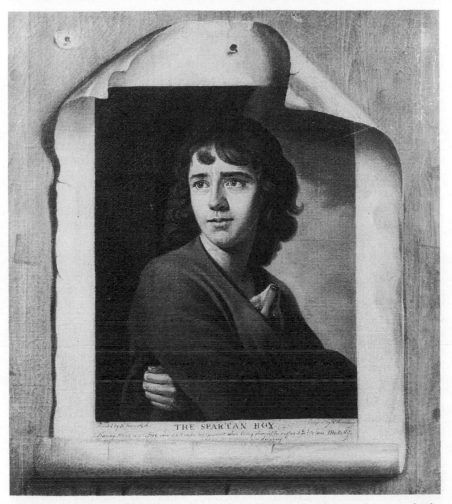

Plate 5 Anonymous *trompe-l'œil* painting of an engraved reproduction of *The Spartan Boy*, *c*. 1800. The legend reads: 'Having stolen a Fox conceals it under his Garment, when being observ'd he suffers it to bite him Mortally.' Courtesy of the National Gallery of Ireland.

eye momentarily captures one image, acknowledges one authorship, while the others are concealed from sight. The sky behind the boy will be a mezzotint only while it cannot be one of two oil paintings. As the curling of the paper suggests, and as the partly obscured legend reveals, concealment is at the heart of the picture. Its subject is the Spartan boy's failure to hide a stolen fox which is suffered to bite the thief mortally, when he realizes that he has been observed. Spartan subjects had currency at RA Exhibitions in this period, and the story of the boy and the fox was widely known.[3]

The allusions to authorship and concealment would have been

appreciated by contemporaries familiar with the print trade. Photography did not inaugurate the age of art reproduction which was a component of European visual culture as early as the sixteenth century. Throughout the eighteenth and nineteenth centuries reproductions ideally took the form of line engravings. In a pre-photographic age, works of art might be known as reproductions engraved in line: 'pictures interpreted by engraving, had become engravings' (Malraux, 1967: 11–12). The reputations and fortunes of successful artists, particularly those of painters, were heavily dependent on a lucrative trade in engraved reproductions of their works. A print collection was an important and accepted working library for any artist, and forays into print shops inevitably featured in the formation of an artist's knowledge and sensibility.

By Hone's time the trade employed a variety of skilled and semi-skilled craftsmen and women whose cultural identity was ambiguous: not fine artists but not without a publicly acknowledged claim to creativity. Technical innovation perfected the means of reproducing paintings but was linked to a fragmentation and submerging of the engravers' occupation that was also an aspect of the making of the profession of the fine artist. Fine artists succeeded in containing the ambitions of engravers through an ideology that interiorized creativity as originality. The Arts were distinguished by their 'intellectual qualities of Invention & Composition, which Painting, Sculpture & Architecture so eminently possess, but of which Engraving is wholly devoid' (Pronouncement of the Royal Academy of Arts, quoted in Hutchison, 1968: 90). None the less, reproductive engravings were accepted as exhibits by the RA which admitted engravers as junior members.

Capital accumulation within cultural production endorsed and accentuated the difference between the artist and the craftsman that had been ushered in by the Renaissance. Consumption of art prints increasingly presupposed a division between mental and manual labour that was internal to pictorial production. While it is true that there were artists such as Hone who straddled painting and engraving, the dominant ideology of creativity and the structure of the market made this a difficult position to sustain after Hogarth (1697–1764). As a successful artist a person was unlikely to have a public reputation for printmaking.

Reproductive engraving was the site of the aesthetic tension between the authorship of the painter and the translation of the reproductive engraver. Engraving was associated with an occupational ideology which asserted the creativity of reproduction as translation. Handicraft reproduction threatened to challenge and obscure the pictorial intentions of artists. While printmaking extended artists' powers of communication it brought problems of aesthetic control and dependency that were perennial sources of conflict and gossip in the art world to which Hone and Humphry belonged. Who had executed the plate? Had assistants been employed? The answers to such questions sometimes suggest deception

and fraud; see e.g. William Blake's 'Public Address' (Keynes, 1966: 594) and Farington's Diary for 18 July 1816 and 10 January 1818 (Greig, 1922–28).

Connoisseurship was sensitive to ambiguities that attended the meaning of reproductive prints: 'we want to forget that they are Engravings; and this sort of Engraver [Desnoyers] who glories in the freedom of his stroke, is ... continually trying to remind us of its power, freedom and elegance' (Cumberland, 1827: 8). Anxieties about the effects of reproduction on art were not born with the photograph. What is surprising is that authorship of reproductive engravings might be granted an artistry of its own; one that might enhance, even improve on, the original and which co-existed with that of painting. The legitimacy of this claim to creativity, promoted by engravers, was an issue in a profession that was tending to marginalize engravers as artists. The metaphor of poetic translation recurs as a contested claim to creativity (Blake, 1810; Landseer, 1807: 177–8; Pye, 1845: 208; Strutt, 1785: 5). Exploitation of the print trade went hand in hand with a connoisseurship that sought to determine the meaning of originality in relation to the authority of painting, but which could not wholly deprive reproduction of its own claim to originality (Richardson, 1773: 165).

It seems likely that *The Spartan Boy* was conceived as more than an exercise in *trompe-l'œil* virtuosity. It may have constituted a reflection on the ambiguities that attended art reproduction prior to the introduction of photomechanical methods. It must have articulated the experiences of painters and engravers where the fine arts were in the business of capturing engraving as reproduction. That the subject is a mezzotint, rather than a line engraving, is also connected with the meaning of the painting. Commonly used for the reproduction of portraits, mezzotint was more aesthetically subordinate to painting than other methods and particularly vulnerable to deskilling. (It was also commonly hybridized with line engraving and etching.) The mezzotinter's art was concealed that painting might be witnessed; there was not 'the line engraver's opportunity of asserting autographic mannerisms' (Godfrey, 1978: 28). This is the cultural context of the *trompe-l'œil*'s ambiguity. In what medium does the spectator witness the truth of the Spartan Boy's act: in the anonymous oil paintings in mezzotint reproduction or in Hone's original painting? If *trompe-l'œil* typically depicts minor cultural signs (Baudrillard, 1988) then just how minor is this image?

Anyone familiar with Hone's career would know that in the year in which he exhibited *The Spartan Boy* (1775), he was at the centre of a scandal. This involved a libellous painting, submitted by Hone to the RA Summer Exhibition, which the Academy forced him to withdraw and which he subsequently exhibited independently. Called *The Pictorial Conjurer, Displaying the Whole Art of Optical Deception*, it depicted Joshua Reynolds, pre-eminent in the profession and President of the RA, in the act of conjuring a painting from a cascade of reproductive

engravings after the works of the Old Masters. The libel amounted to a
charge of plagiarism against Reynolds. It was also a comment on a
problem that exercised Reynolds, Blake and other artists: how to
distinguish originality from plagiarism in a profession which recognized
the Masters as the point of creative departure. However, what is
important here is the uncommon and explicit reference, in painting, to the
role of reproductions in the gestation of art – the pictorial admission to
their presence in the studio. With *The Conjurer*, the art of reproduction
that fine artists were in the process of containing bursts through into the
public domain, disclosing the creative life of the studio. The accusation of
artistic theft could not be tolerated at the RA. What remained was *The
Spartan Boy* reference to theft and concealment in a painting that was
later to be a reflection on the meaning of reproduction. What may not
have escaped the attention of exhibition visitors in 1775 was a twist in the
Spartan tale; that stealing might not be dishonourable if it was not
discovered.

Prints and Visual Communication

William M. Ivins, Jr (1881–1961) was a print curator. His ideas about
visual communication had an impact beyond the Metropolitan Museum
of Art in New York where he held a post from 1916 until his retirement
thirty years later. In *Prints and Visual Communication* (1953) (hereafter
PVC) he advanced a seminal thesis concerning the difference that
photographic reproductions had made to art.[4] *PVC* melds a socio-
technical and aesthetic history of art reproduction with Ivins' experiences
as a connoisseur and curator. *PVC* contributes to an understanding of the
meaning of photographic reproduction partly because of its insights into
the marginalization of a connoisseurship associated with handicraft
reproductive prints. The nineteenth-century photographic reproduction
had to meet the visual anomie of those who experienced photographic
distortion rather than truth to originals. Ivins registers this, indexing a
taken-for-granted aesthetic that differs from our own. Footnotes from
long-forgotten treatises, anecdotes from his youth and early career at the
Metropolitan, when the residues of older attitudes to reproductions still
survived, allow us to glance at the making of a photographic way of
seeing art (Ivins, 1953: 90, 174).

Much of *PVC* is dedicated to a phenomenology of reproductive
engraving. Ivins reconstructs the connoisseurship that accompanied pre-
photographic reproductions and argues that the meaning of photographic
reproductions was determined in relation to their merits *vis-à-vis*
reproductions delivered by engraving. In a nutshell, the photograph
magnified a difference that could only be furtively glimpsed under the
regime of the reproductive print. This was the difference between mere
pictures of things and works of art.

Two concepts are central to the thesis, namely the exactly repeatable

pictorial statement and visual syntax. The first identifies the importance of the printed image for science, technology and mass culture as well as for art: 'far from being merely minor works of art, prints are among the most important tools of modern life and thought' (Ivins, 1953: 3). Ivins argues that a culture without exactly repeatable pictorial statements is different from our own. It is bereft of a visual communication that has made possible our sciences, technologies, archaeologies and ethnologies. It is a key to the development of a visual culture that has been a component in the modernization of the world, a world that has, since the Renaissance, been rendered more visual.

Visual syntax conveys the point that visual depictions are of a different order from verbal accounts. Since the Renaissance both science and art have emerged as discourses which are intimately associated with the production and dissemination of illustrated arguments: diagrams, sketches, engravings, handicraft reproductions, photographs, half-tones. Yet these images are always more than mere 'illustrations'. They are not derivative of a privileged and ongoing discourse; as printed images they are marked by syntactical forms, depictive conventions, which realize the scientific or the aesthetic character we assign to scientific reports and art criticism.

Thus Ivins shows that interpretations of reproductive engravers did not emerge *de novo* from craftsmen's encounters with artworks. Early sixteenth-century engravers evolved visual conventions that represented the world evoked by the conventions of painting. The making of a printed image involved one of several possible visual conventions or languages whose qualities were bound up with available or chosen technique. A printmaking hegemonized by painting was charged with solving the problems of representing the distribution of objects in a rational space.

Credit for devising a print that could, in a world without photomechanical methods, substantially express such qualities goes to Marc Antonio (*c.* 1480–1530). He developed a linear system, 'a kind of shading that represented not the play of light across a surface, and not the series of local textures, but the bosses and hollows made in a surface by what is underneath it' (Ivins, 1953: 66). It was as though a net had been cast over the objects represented (Plate 6). Marc Antonio and those who followed him used a language, or engraved syntax, into which works of art and other images could be translated. What the viewer saw was not just a picture, but one composed from a system of lines and dots which translated a painting (Plates 7 and 8).

The expansion of a European trade in printed pictures was linked to a withdrawal by artists as designers from the labour of engraving. By the end of the eighteenth century it was rare for artists to have reputations for carrying out their own engraving and printmaking (Ivins, 1953: 96–7). Innovations associated with line engraving and its hybridization with other techniques went hand in hand with structural changes in the trade.

Plate 6 Depiction of the principle of line engraving from John Evelyn's *Sculptura*, 1662. Courtesy of Leicester University Library. The pictures show the principle by comparing the lines of the engraver with the shadows cast on solid objects by threads stretched onto a frame: 'it is evident, that these Threads, in whatever manner you interpose the said Frame 'twixt the *Bowle* and the *Sun*, that they will perpetually cast their shadows parallel *inter se*, cutting it as it were, into several planes, uniforme and parallel also' (Evelyn, 1662: 121).

Plate 7 Mid-nineteenth-century steel engraving by C. W. Sharpe after *The Newspaper* by Thomas Sword Good (1789–1872), Vernon Gallery. The reproduction appeared in *The Art Journal*, 1852, vol. 4: 94.

Seventeenth-century printmaking passed into a manufacturing phase with houses such as those of Rubens where the labour of engraving was regulated according to a house style:

> [a]ny sketch, no matter how fleeting its indications and any most elaborately detailed oil paintings of the Rubens type, could be tossed into the hopper of the engraving shop, and out of the other end would come a print that had all the familiar trade-marked Rubens look.
>
> (Ivins, 1953: 73)

Technical innovations drove a wedge between design and the labour of reproduction. Execution of plates devolved onto teams of craftspeople with

Plate 8 Detail of C. W. Sharpe's engraving of Thomas Sword Good's *The Newspaper*.

individuals increasingly confined to semi-skilled labour, some specializing in a particular stage of production. For Ivins there is aesthetic scandal here. The world was engulfed in pictures which lacked authenticity: 'second- or third- or fourth-hand accounts, or even badly jumbled accounts by different people, of what things were supposed to look like' (Ivins, 1953: 99). The visual syntax of engraving shops intersected with the economics of the print trade to produce images executed by artisans who might never have seen the originals.

Ivins shows how the use of a linear scheme had consequences for what could be communicated about art. What was admitted was iconography and composition rather than the 'personal characteristics of the original

works of art, their brush strokes and chisel marks' (Ivins, 1953: 166). The meaning of a work of art was refracted through the engraver's language: '[p]ainstakingly as Dürer might copy a real rabbit ... in his own syntax, when it came to copying a print by Mantegna he refused to follow Mantegna's syntax, and retold the story, as he thought, in his own syntax' (Ivins, 1953: 61). What could not be communicated was the authority of the original artist as it related to the quality of the medium. What could be communicated were the differences between the achievements of reproductive engravers, some of whom established reputations as virtuosos. The engraver-as-interpreter occupied and extended a space that was to be closed off by photographic reports, a space between original works of art and reproduction.

In this space flourished an aesthetic. It had two aspects which together yielded an indeterminacy in experiences of works of art. There was a connoisseurship which flowed from the virtuosity of the reproductive engraver in handling the swelling lines, the dots and flicks from which a printed picture was composed: 'the things that counted in public estimation were the brilliant moiré of the damask of the engraved lines' (Ivins, 1953: 172). Engravers 'chose the pictures they were to make or reproduce not for their merits but as vehicles for the exhibition of their particular skills' (Ivins, 1953: 69).

> The laying of lines, swelling and diminishing, the creation of webs of crossed lines, of lozenges with little flicks and dots in their middles, the making of prints in lines that all ran parallel or around and around – one engraver made a great reputation by the way he rendered the fur of a pussy cat, and another made a famous head of Christ that contained but one line, which beginning at the point of the nose, ran around and around itself until it finally got lost in the outer margin.
>
> (*Ibid.*)

Second, the circulation of engraved reproductions accommodated a connoisseurship sensible of authority that resided not in the picture but elsewhere – a hypostasization of something that lay behind the engraved lines, the 'unreachable, the unknowable, *vrai vérité*' (Ivins, 1953: 139). Ivins recites the vocabulary of eighteenth-century neoclassical doctrines – 'harmony, proportion, dignity, nobility, grandeur, sublimity' – to indicate the discursive preoccupations of a connoisseurship that depended on reproductive engravings. Here there was no knowledge obtained of '[t]he wilful theatrical stroke of Ruben's brush' or 'the dominant expressive gouge of Michael Angelo's chisel' (Ivins, 1953: 173).

It was through photographic reproductions that the connection between such medium and the creative intention of the artist could first be widely experienced and demonstrated: the 'traces of the creative dance of the artist's hand and the effects of a deliberate creative will' (Ivins, 1953: 144). They promoted a connoisseurship based on the distinction between pictorial expression and pictures which were statements of fact.

Photographs permitted the transmission of images as works of art and the recognition of the difference between information and art. It enabled us to see 'the choice and manipulation of the paint', the difference between the founders of modernism and the Salon subject painters of the nineteenth century (Ivins, 1953: 144). Meissonier could now be recognized for what he was – a reporter!

Where was the line between art and dross? What is worthy of a place in a museum collection? Ivins' answer presupposes both an ontology of art and a discrimination on the part of the art lover whose sensibilities have been subordinated to the purely visual. True creativity is defined in opposition to culture and convention: 'culture and intelligence are quite different things' (Ivins, 1953: 4). Creativity and convention have become antonyms for 'the greater a work of art is, the more it is a bundle, not of similarities to other things, but of differences from them' (Ivins, 1953: 139). The conventional modes of pre-photographic art reproduction render it unable to grasp images as Art:

> objects can be seen as works of art in so far as they have visible surfaces. The surfaces contain the brush marks, the chisel strokes, and the worked textures, the sum totals of which are actually the works of art.
>
> (Ivins, 1953: 143)

The argument of *PVC* was carried forward by means of the text and through the counterpoint of illustrations. Two images, the *Laocoon* and Rembrandt's *Old Woman Cutting Her Nails*, are crucial. Ivins invites us to compare ten reproductive engravings after the *Laocoon* (made between the 1520s and the 1890s) with one half-tone reproduction after the Rembrandt. The first are evidence for the subjectivity of the old ways of reproducing pictures. The meaning of the *Laocoon* is distorted, fragmented and dispersed as it is refracted through the syntaxes of different engravers. The second, a detail, provides evidence of the disposition and surface of the paintwork, evidence of the things that make this a work of art and which would have been concealed by an engraver.

The photograph gives us the image's presence as a work of art. With photographs, or more precisely the half-tone reproduction, the syntax of reproduction drops below the visual threshold of the viewer who now encounters the work of art in all its immediacy:

> the lines of the process as distinct from the lines of the visual report could be below the threshold of human vision. In the old hand-made processes the lines of the processes and the lines of the report were the same lines, *and the process counted for more than the report in the character of the lines and the statements they made.*
>
> (Ivins, 1953: 177; my emphasis)

The dots produced by the half-tone screen are interpreted as continuous tone. It is the quality of the lens that matters when it comes to photographic reproduction, not the interpreter (Ivins, 1953: 138). The

camera objectively draws art lovers into a communion with the image as a work of art. Those who have communed with art do not expect art to be conflated with anecdote or journalism. They know the difference between reporting and creation.

Critique

Zigrosser, noting Ivins' 'mutation ... as a minor prophet in the pantheon of Marshall McLuhan', doubts if he would have relished this (Zigrosser, 1975: 208). The doubt is well founded. Ivins' thesis is not that photography determines the message of art, but that in photography art has found a medium that is adequate to the reproduction of its meaning. Photographs and half-tones have assisted our escape from the confusions of handicraft engraving to the truth that is the work of art. He reverses the periodization associated with McLuhan and more recently Baudrillard. Far from photographic reproduction proliferating images at the price of authentic meaning, it rescues us from confusion. This is his point concerning engravings after the *Laocoon*, and the instability of pictorial meaning under the regime of handicraft reproduction: 'had they represented butterflies instead of a known single statue, one would have said that they represented different families of the genus Laocoonidae' (Ivins, 1953: 89). However, neither position, either McLuhan's materialism or Ivins' idealism, is adequate to signification as it relates to the reproduction of works of art. Both dissolve the social production of meaning, ignoring the dialectical relationship between 'reproduction' and 'originals' that is the contingent and situated meaning of a work of art. In assessing *PVC* it is necessary to make the following points:

1 Art reproduction is exegesis about an original and it changes the relationship between the artist and the public meaning of the work of art. It should not be judged as posterior to the authorship of the original. Reproduction does not translate or encode a pre-established authorship, it is a medium through which authorship is produced. There are no works of art which are original in the sense that the social is an addition to their meaning (Bryson, 1983). Reproduction is argument about images whose meanings have already been socially transacted. The camera constructs a viewpoint and a spectator as do the chapel, the palace, the exhibition, the museum or the artist's studio. There are differences, but what is at issue is the regulation of relationships between these different viewpoints. Regulation of the meaning of printed images as fine art – as originals and reproductions – has been an aspect of the extension of art markets since the eighteenth century. The production of artistic value has emerged from a dialectic of differentiation and regulation in which a measure of originality is the socially constructed impersonality of reproductive craftsmen.

2 Reproductive engravers' claims to creativity may seem to be of

antiquarian interest but their suppression was part of the making of the modern artist. They were antiquated in favour of the personal gesture of the artist. From the eighteenth century an impersonalization of reproduction went hand in hand with a personalization of the artist. If we are to talk about the social construction of the artist we must also talk about the social construction of impersonal process work. The individuality of the artist has been produced through a struggle to determine the meaning of reproductions. Determining this meaning has been a feature of art politics (e.g. Francis Seymour Haden's campaign for autographic etching, the James Whistler–Joseph Pennell court action of the 1890s to secure the definition of original lithography and the postwar definitions of the original print offered by agencies such as the Print Council of America, the International Association of Plastic Arts or the French National Committee on Engraving). It is this meaning which is most commonly promoted by dealers and print publishers today and it is the ontology which is at the heart of *PVC*.

3 Ivins contributed to our appreciation of what photographic reproductions meant. Yet *PVC* elides the agency that is art reproduction. It stabilizes signification in favour of a unitary creativity that is the touchstone of modernism, the artist-as-creator. Inquiry is closed off at precisely the point where signification escapes the artist and where the social production of pictorial meaning would be revealed. There are frank admissions by Ivins about curators' uses of reproductions; the image of the artist-as-creator flickers for a moment. However, photographic reproductions are not to be taken as substitutes for originals (Ivins, 1953: 94, 138; Ivins, cited in Fawcett, 1982). The camera is judged to be capable of objective and authoritative statements of which the older handicraft modes of reproduction were incapable. Yet, ironically, the truth of the illustrated argument proposed in *PVC* could not be guaranteed by any photographer. It required Ivins' eye to be at the viewfinder.

Freitag (1979) and others draw attention to aesthetic choices that may attend production and consumption of photographic reproductions. Their significance was debated in arguments that divided a fledgling art history profession during the nineteenth century. The outcome of these debates was not a consequence of the camera's technical superiority but of its mobilization in arguments about the nature of creativity. For some, photographic reproduction endorsed a way of seeing that was a corruption of the eye, neglecting 'the shape of ideas' and the truth of art as it might be conveyed by the creative intervention of the reproductive craftsman (Fawcett, 1982; Freitag, 1979). Photographs yielded copies that were not interpretations: 'what interests us is no longer the likeness of the original that has been faithfully poeticized by a gifted intermediary. No! nothing else satisfies us but the absolute physical identity of the reproduction with the original' (Delaborde, quoted in Freitag, 1979:

118). For Delaborde,[5] photography separated experience from authentic art and from aesthetic objects that were presupposed by what the engraver might have to say.

Today there are doubts about the use of reproductions in teaching and research. The contrast between a way of seeing cultivated through the luminosity of the lecture slide or television screen and the apparent unexciting flatness of the original has been noted (see e.g. Freitag, 1979: 123). What is ignored by Ivins is the creativity of art historians who may judge the manner in which an image should be photographed or process workers whose technical knowledge is brought to bear on the requirements of art. Wind argues that the spectator's eye has been alerted to aspects of art that are endorsed by the camera and that effects pursued by artists may be mediated by a vision shaped by photographs: '[t]hat Picasso has consciously adjusted his palette to the crude requirements of the colour process I would not say, but his paintings suffer remarkably little in this singularly coarse form of reproduction. They suit it almost as well as Van Gogh' (Wind, 1963: 76–7).

Ivins says nothing about engravers' reactions to the camera or their resistance to economic and artistic displacement. Photographic reproductions are treated largely in isolation from their production and as products of optical and chemical agents unaffected by human subjectivity and experience. Ivins tends to treat photo-reproduction as a unity whose history has been completed with the advent of the modern half-tone. He omits assessment of the aesthetic/economic possibilities, choices and judgements that attend innovation in art reproduction. Decisions about lenses, location, lighting, exposure and about processing an image are matters that presuppose argument about the meaning of originals. They are also decisions about who should be making the decisions: professional photographers, artists, art historians, curators?

The omission is surprising given that it was not caused by ignorance and considering Ivins' participation in the manufacture of the illustrations for his book. Correspondence with his publishers, and others, shows that Ivins regarded the illustrations to *PVC* as crucial to his argument, that he exercised surveillance and control over their production (Ivins Manuscripts, Routledge & Kegan Paul Archive, University College, London). Many of the photographs were made by the author on the grounds that a standard photographer would not provide illustrations showing what was intended (Ivins Mss: Ivins to Herbert Read, 7 May 1950). Correspondence between Routledge and the plate-makers reveals the role of both these parties in determining the quality of the images at proofing: 'Many of the illustrations show some faults, thickening of the shadows but particularly vanishing or fading detail in the highlights' (Routledge & Kegan Paul to Waterlow & Sons, 19 September 1952). Detail had been lost. Had the plates, Routledge wondered, been printed in black enough ink? They needed assurance from the plate-maker that the detail would be recovered: 'the point about printing in collotype is that it should bear

examination under the glass' (Ivins MSS, Routledge to Waterlow, 19 September 1952). This helps to explain Ivins' remarks in the Preface concerning the publisher's generosity and his choice of three kinds of reproduction: line cuts, half-tones and collotypes. Given the trouble and expense, he had reason to thank them. Out of a total of eighty-four illustrations, fifty are collotypes. Collotype, an expensive, tricky method of photographic reproduction, gives a limited run (about 1,500 impressions) and is capable of producing continuous tone (no intervening screen). Particularly suitable for the reproduction of delicate line work and washes, it was considered by Ivins to have virtues that were necessary for his book. At mid-century he knew that most readers would be unfamiliar with the linear qualities and textures of handicraft reproductions and determined that collotype rather than half-tone was appropriate for conveying them.

PVC is about the effects of photographs, more particularly half-tones, yet the majority of its illustrations are collotypes. The inescapable conclusion is that collotypes tell readers something about prints that half-tones could not. Moreover, a collotype was used to reproduce a half-tone! Ivins' book is a composition with a counterpoint of half-tones and collotypes. This turns out to be an unwitting admission of the limitations of half-tone reproductions. It seems that the reader was to look at the illustrations in a way that half-tones do not invite – to take the glass and recover something of the old connoisseur's sense of line, something that would have exposed the dots of a half-tone screen (Ivins Mss, Ivins to Jennett, 23 February 1951). Collotypes were to serve as a 'meta-language' for the visual syntax of the prints (Ivins Mss, Ivins to Read, 7 April 1950; Ivins to Read, 10 May 1950). The depictions in *PVC* are an unintended challenge to the notion that photography is a thing, a unity, that completes itself. The illustrations convey the heterogeneity of photographic art reproduction, unconsciously subverting the text's argument concerning photography's revelation of the unity that is art. Ivins used collotypes, but the economic and technical problems of their production had made it an unusual venture by the mid-twentieth century. *PVC* did not arrest the development of art reproduction. By the 1970s offset lithography (used for the 1969 reprint of *PVC*) had displaced letterpress (used in the first edition of *PVC*) as the most common means of reproduction.

The histories of reproduction and printmaking are neither aesthetically nor technically complete. The verities of the original print are sometimes challenged in a world that is more complex and potentially open in its meanings than that definition. In the 1960s some artists crossed the boundaries of fine art and commerce, reflected on their relationship, blurred the distinction between art and process work and challenged the ideology of the artist-as-creator with admissions that creativity might not be unitary.[6] Ivins could see only exhibitionism in the art of the old line engravers where others have discerned a distinct aesthetic, one with

different possibilities from a painterly aesthetic based on revelation of self (Gilmour, 1978: 48–50). What was not entertained in *PVC* was the possibility that art might reflect on the meaning of reproduction.

Reproductive engravers were eliminated from the canon but so too were Salon painters who had traded in mimesis and whom engravers had served – those nineteenth-century subject and narrative painters whose copyrighted popular works were academy draws. Ivins argues that it was photographs which enabled us to see differences pertinent to art. *PVC* gives part of the story of the institutionalization of a modernist aesthetic in the early twentieth century – one that eschewed kitsch, the merely popular, the gaudy and the sentimental. Outside the museum, photographs rendered the difference between art and convention visible. The eye of art lover was captured and brought under the thrall of the singular artist's charismatic authority. I now turn to the question of what that difference meant.

The circulation of photomechanical reproductions has prompted questions concerning the sovereignty of originals. How are the meanings of art affected by reproductions? What is the difference between originals and reproductions? Can works of art be reproduced? Are reproductions duplicates or merely imitations of originals? Reproductions have been experienced as ambiguous. They have seemed to threaten the authority of originals, substituting medium for message, displacing authentic encounters with works of art with experiences of inauthentic copies.

The most perceptive accounts of art's relationship with photography have been those identifying a normalizing of aesthetic judgements that attend the camera (Berger, 1972; Freitag, 1979; Wind, 1963). But normalizing in relation to what? An innocent, unmediated and authentic encounter with original works of art? No. The difference made by the earliest photographic reproductions was to eyes schooled in art through engravings. Moreover, the merits of photographic reproductions were not evident to all who encountered them.

Ivins argues that modern reproduction is part of the making of new ways of writing and knowing about art in the wake of the disintegration of a nineteenth-century cultural apparatus hegemonized by the academy. This was related to the formation of the art historians' profession (Freitag, 1979). It was also related to a separation of art academies from the means of determining art history. These were discursive changes in which the relationship between art and power disappeared from sight to be re-presented as an apparently fortuitous association between discrimination, discovery and the artist-as-creator. They were also changes in state forms which placed at issue the links between professional art academies, the state and national art institutions.

During the nineteenth century, academies, royal and aristocratic collections were sites of struggles for cultural power and legitimacy by the bourgeois state. Aspects of this concern academies' exploitation of cultural markets through strategies which defined and defended the

meaning of art. Transformation of the means of reproduction was always in the process of fragmenting pictorial meaning, sometimes yielding printmaking techniques that had no obvious artistic purpose (lithographs, chromolithographs, woodcuts). The market was a site of struggles for cultural capital which shaped a public sense of which differences between images were pertinent to art. Fragmentation was contained through hierarchy and through a system of art reproduction (whose ideal form was the line engraving) that was hegemonized by academies of painting and sculpture.

Shifts in the locus of cultural power were mediated by changes in the rules governing aesthetic judgements, including judgements about the reproducibility of art. Printmaking became a means of pictorial distanciation in which a transcendent power or ideology might be made palpable, for example, glorifying monarchy as patronage through reproductions of the king's image and works. Prints might be visible signs of the patron's power, establishing the connection between art and his or her authority – prints of pictures which reside in the patron's collection, prints of pictures which society had endorsed at Salon or exhibition and which were sanctioned by the presence of patrons.

The linear syntax of engraving could be cultivated for itself, yet it placed spectators at a distance from the truth of art, except insofar as the reproduction was treated as a work of art in its own right. This distance nurtured a vocabulary of the unreachable and unknowable (Ivins) and registered the aura of the artwork (Benjamin, 1970). Here was a language which spoke of the existence of originals which were located elsewhere (for example, in the palace) and referred the art lover to the existence of a painted canon, ownership of which is beyond the means of those who did not wield economic and social power. Art reproduction explicitly indexed aesthetic difference as social difference, as hierarchy.

Print entrepreneurship involved a subtle interplay between authorship, accessibility, technical innovation and substitution, quality and morality. Taste in reproductions formed a hierarchy which knew certain materials as intrinsically artistic before an artist said anything. Insofar as the RA presided over the qualified status of engraving, this cultural system was sanctioned as one of aesthetic hierarchy. In America:

> there was a strongly and generally held opinion that etching was more artistic than line engraving, that both were more artistic than wood engraving and that all were more artistic than lithography. Lowest of all and utterly contemptible, were photography and any medium that bore the name of some process.
>
> (Ivins, 1953: 114)

Ivins the curator was seeing off the old school, disposing of the hierarchies and orthodoxies of the academy and the notion of 'beauty with a capital B' through curatorial innovations in the new Department of Prints at the Metropolitan. We learn of his encounters with an older connoisseurship.

Its authority is transmuted into the eccentric preferences of gentlemen who scolded Ivins for purchasing 'horrid rough old woodcuts by such artists as Dürer and Cranach when I could have bought the ... white line reproductive engravings of such modern masters as Timothy Cole and Elbridge Kingsley' (Ivins, 1953: 114). In 1916–17 there was 'much talk and argument about what the character of [the collection] should be' (Ivins, 1953: 1). New rules of cultural classification were being instituted. For Ivins it was necessary to exclude the vast majority of the ' "ana", topography, sporting and theatrical prints, costume, portraits, and reproductive work as such' (Ivins, 1927: 5). In the main, 'prints gathered for a museum collection shall be of importance for the manner in which they represent things, and not for the things they represent' (*ibid.*; cf. Bourdieu, 1984).

Ivins' account of the photographic reproduction portrays a relationship in which the meaning of the image has become purely visual. It is no longer trammelled by the codes of engravers. His assessment of this meaning and his activities at the Met are part of the story of how in the early twentieth century some art museums began to authorize a modernist aesthetic which eschewed mimesis – one that secured the difference between art and mere pictures as the *sine qua non* of an authentic aesthetic. From the mid-nineteenth century museum directors increasingly engaged problems of space and display through policies that acknowledged the existence of a fissured audience (Dimaggio, 1982). The production and transmission of this difference were naturalized through acts of cultural classification which informed acquisition and display, acts which were in turn related to a transformation of museums and progressively differentiated the curator as a professional from older patrimonial-aristocratic principles of cultural domination (Zolberg, 1981).

Photographic reproduction ushered in aesthetic objects that were encountered as strange by eyes that had experienced art as reproductive engraving and which knew mimesis as the norm of artistic appearance. Ivins' account contributes to our understanding of the camera's role in endorsing a taken-for-granted assumption of modernism – that art is the artist's search for an absolute originality. The camera provided a knowledge of art that could be conveyed neither by verbal communication nor by the visual syntax of handicraft reproductive printmaking. Before, it was impossible to mass-produce the difference between, say, the achievements of an academic artist such as Bouguereau and Manet: '[i]f Manet and Bouguereau had painted the same model, in the same light, with the same accessories, and the same iconographical composition, any engravings made from them by the same engraver would have been remarkably alike' (Ivins, 1953: 150 and 144).

The significance of photographic art reproduction for Ivins is 'that it is communication without syntax': 'the actual surfaces of the objects reproduced are made visible' (Ivins, 1953: xxv). It is not that. Photographic reproduction mediated a change in the relationship between

spectator and print. Prior to photographs, reproductions reproduced an aesthetic distance between the art work and the art lover or connoisseur – an unapproachability which was the aura of the art work. For Ivins, the photograph conveys a sense of the visibility of the work of art – enhancing the image's sensuous presence and securing a necessary primacy for the artist as the creative subject. In the modern half-tone there is pictorial communication apparently without exegesis; the babble of voices is silenced in favour of mute, ascetic contemplation:

> [i]t is interesting to note how dry and tongue tied so many of the people are who have had a long and intimate first hand acquaintance with works of art as compared with the volubility in abstractions of the persons who know about art through words and verbalist doctrines.
>
> (Ivins, 1953: 139)

Works of art are not things in themselves. Images gain admission to the realm of art through the medium of discursive rules that are knowledge-ably applied by experts and art lovers. Art discourse does not float free of power, interests and the social contexts in which art lovers come to know art objects, although their meanings may be constructed around a denial of such contexts (Bourdieu, 1980). The experience of photographs was linked to a revision of the idea of a masterpiece. Until the nineteenth century the truly great work of art was one that was 'most perfectly in accord with a tradition', it was 'the most complete, the most "finished" work'. The masterpiece has become 'the one in which the artist, in relation only to himself, has touched the pinnacle of his style and stripped away everything that is not uniquely his own' (Malraux, 1967: 80). It is in part the photographic reproduction that allows us to know this as the difference that an artist has made to art. It enables us to know style as deviation from what has gone before. If the dots and flicks of the engraver's burin have disappeared, it may be that our visual syntax is composed from the paintings themselves.

What reproductions meant was contested in the eighteenth and nineteenth centuries as it is today. Ivins wanted to make the eye the locus of an aesthetic discipline where art was separated from mere pictures of objects, from description, from illustration, from journalism, in favour of a universal and autonomous narrative. This was the story of art as it was accomplished by the heroes of modernism and as it was institutionalized by the modern state in the twentieth century.

Conclusion

Ivins (1953) has it that with photography the ambiguity which attended art reproduction was resolved. To know art by means of modern reproductions is to be given access to pictorial effects denied to those who depended on handicraft reproductions. What is at stake here is the pictorial authority of artists and the centring of the artist through the

medium of art reproduction. However, if *The Spartan Boy* invites us to reflect on the ambiguity of reproductions it was not the camera which clarified or confused things. Modernization is partly a visual process involving a rationalization of the means of representation that has unleashed new powers of depiction. *The Conjurer* posed the question: What does it mean to be an original artist in the age of reproduction? To be an artist in the modern world has been to be offered the possibility of answering this question. Here, as in other cultural contexts, simplification has been attended by complication and emancipation by constraint. Ambiguity has been experienced by generations of artists, connoisseurs and cultural agents who have been winning and losing the struggle to determine the meaning of reproductions and to keep up with the game of art. The matter of who won and who lost aesthetically has not been innocent in relation to the production of power and privilege in the modern world.

Ivins' history of art reproduction is less objective than it seems. His camera appears to give us visual communication without convention, without syntax, without exegesis. The art lover knows the difference that an artist has made to Art and can now celebrate Art as difference. There is a price to pay and it is paid by someone. No room for a Norman Rockwell here, but there is for a Van Gogh. Creativity can now be experienced for what it is, deviation from convention. We have visual deadlock: where art is, the social is not. *PVC* is an argument about reproduction which resolves the ambiguity, indeterminacy and noise that attend the difference between reproductions and originals in favour of the artist-as-creator.

No book by a print curator can have gained such a wide currency in the field of cultural analysis as *PVC*. Nearly fifty years on the book is to be judged a classic. It continues to inform critical debate about technical change in the making of pictures and reproductions (Jussim, 1983; Freitag, 1979; Walker, 1983). Sociologists have harnessed Ivins' ideas on representation, arguing that the notion of visual syntax sharpens understanding of the social determination of knowledge and art (Barnes, 1977; Becker, 1982). This is curious because the denouement of the story of art reproduction as retailed in *PVC* is a separation of art from life and the hypostatization of the creator. We should learn from Ivins but beware that an uncritical reading does not seduce us into underwriting cultural power that we need to understand.

Notes

1 The first prints appeared in Europe in the fifteenth century. Between the eighteenth and the twentieth centuries the dominant tradition of fine art prints was as reproductive printmaking after painting and sculpture. The mezzotint plate, first publicized by Evelyn in *Sculptura* (1905), is made by a graduated smoothing out of its roughened surface (which if unworked would print black) to produce tonal values that are appropriate to oil painting. Intaglio, where the

ink is held within the grooves and recesses of the plate, is usually contrasted with relief printing (remember school linocuts?) and with planographic printmaking (e.g. lithography). Ivins' half-tones, in the 1953 edition, were printed letterpress, that is, relief.

2 See *Dictionary of National Biography* entries under Hone, Humphrey and Lowry as well as Lister (1984: 261). It is possible (Crookshank and The Knight of Glin, 1978: 157–8) that Lowry is a self-portrait of Stickland Lowry (*c.* 1737–1785). His son, Wilson Lowry (1762–1824), was one of many eighteenth- and nineteenth-century engravers who pioneered technical innovations in reproduction. *The Spartan Boy* is a portrait of Hone's son John Camillus.

3 Rawson (1969: 355) explains: 'Many people in these years got their knowledge of Greece from the histories of Rollin.... To this, not to any English obsession with foxes, is perhaps largely due the primacy that the Spartan boy and the fox begins to gain over the hundreds of ancient anecdotes of similar type. The prologue to Mrs Cowley's tragedy *The Fate of Sparta or the Rival Kings* (1787) shows that what the public is now expected to know about Sparta is the fox story.' Goldsmith, citing the authority of Plutarch, reports that 'in order to prepare them for strategems and sudden incursions, the [Spartan] boys were permitted to steal from each other; but if they were caught in the act, they were punished for their want of dexterity' (Goldsmith, 1809: 27–8).

4 Photographs of themselves did not yield mass-production capable of delivering the tonal values of a painting. The first steps to the modern half-tone were taken in the 1850s and perfected in the 1880s. The principle of the half-tone (half, because half the image is lost) is a breaking down of continuous tone into dots. This is accomplished by means of a cross-line screen interposed between the image and a light-sensitive printing surface. The effect is to translate tone into a pattern of dots which (with the exception of cruder newspaper pictures) normally appear as continuous tone.

5 Delaborde was Print Curator at the Bibliothèque National in Paris.

6 Joe Tilson, the artist, comments on his printmaking at the Kelpra studio run by Chris Prater: 'Chris often uses the analogy of Composer-Conductor-Orchestra for the Artist-Chris-and the Team, but although the analogy is quite a good one I think it underestimates Chris's role. Because, without a conductor music can exist at least in manuscript, but without Chris Prater none of the work in this exhibition [Arts Council exhibition of Kelpra prints] would exist' (Tilson, 1970). See *Studio International*, December 1967, vol. 174 (895): 293. For Roy Lichtenstein in the 1960s the mass-produced newspaper cartoon strip was a point of departure for investigating the gestural quality of abstract expressionism: 'I was very interested in characterizing or caricaturing a brush stroke. The very nature of a brush stroke is anathema to outlining and filling in as used in cartoons' (Lichtenstein, 1968: 1).

3

Art exhibitions and power during the nineteenth century

Introduction

This chapter is concerned with the exhibition as a site of cultural production and as a medium through which the authority of the artist was constituted. In the eighteenth century the exhibition was a place at which painters articulated their claim to be original artists. Towards the end of the nineteenth century there was a preoccupation among artists, exhibition directors and others with gallery arrangements that would secure the public's recognition of the pictorial authority of the artist. This concern was expressed in the claim that art was most satisfactorily displayed when the works of a single artist were grouped together.

These claims were interwoven with the fortunes of the London Royal Academy of Arts (RA). During the nineteenth century the RA, with its prestigious annual Exhibition, was the focus for politico-cultural power plays which had profound consequences for art institutions, for example, in relation to industrial design, reproductive engraving, national art collections and professional art exhibitions. Such matters were the very stuff of art politics, a politics whose possibilities were mediated through the extension of state cultural power, the commodification of art and the growing weight of cultural agents such as critics, art dealers and art officials. In what follows I assess the link between the situation to the RA and the social production of the fine artist's authorship.

The difficulties encountered by some nineteenth-century artists in relation to exhibitions have, of course, passed into twentieth-century myth of what it means to be an artist. From the late eighteenth century European Romantic artists had been expressing their antipathy to the rules and the universalism of the academic system (Pevsner, 1973: 190–242). The growth of the fine art market placed strain on a centralized, congested and successful exhibition that was controlled by a privileged professional elite. By the second half of the nineteenth century the conditions of public exhibition had become the focus of artistic concern and discontent. From the 1830s the London Royal Academy was the subject of numerous official inquiries concerning its public accountability and the organization of its annual Exhibition. What was at stake was the

autonomy of the RA in relation to the bourgeois state, and it was a relative autonomy whose political significance was partly worked out in relation to fissures within the art profession.

The development of exhibitions was related to new forms of authorial intervention and experience for artists. I stress experience because there is evidence that artists could, as it were, be caught by surprise (is this what I'm saying?) – evidence that the exhibition, and the process of organizing it, was a medium through which artist, gallery-owner and visitor collaborated in the production of author as original artist. I stress intervention because the exhibition also related to questions of control over the organization and transmission of aesthetic principles – those governing the inclusion and exclusion of art-objects, their naturalization as Art, as well as the way in which the visitor's attention was captured, engaged and focused on the art. This is a matter of power in that the agency of the fine artist was constituted through exhibitionary encounters with visitors.

Exhibitions

In London, art exhibitions first took place in the mid-eighteenth century – somewhat later than in the cases of other European cities. Their appearance was associated with a nascent art profession which exploited the advantages of a consumer society. The functional ties between the augmentation of agrarian capitalism and the legal and financial institutions of a metropolis which was the centre of the land market spawned the distinct cultural style of the English landed gentleman (programmes of house-building, decoration, the Grand Tour, etc.) along with the expansion of the cultural/entertainment world in response to the consumer needs of seasonal migrants and a growing urban gentry (Fisher, 1947; Lippincot, 1983; McKendrick *et al.*, 1982).

Entrepreneurs such as Wedgwood made novel use of artists' pictorial skills. The projects of people like William Hogarth, Arthur Pond, J. B. Jackson, John Boydell and others were symptoms of the shift away from old patronage to a nexus of urban institutions that were the bases for new creative possibilities and opportunities of professional contact: coffee houses, taverns, clubs, learned societies and, of course, printmaking, academies and exhibiting societies. Art exhibitions were being held from the mid-eighteenth century, at the Foundling Hospital, at the Society of Arts, the Free Society of Artists and the Society of Artists of Great Britain.

From the 1600s there are traces of short-lived institutions which failed to contain internal dissension. One project collapsed in the 1750s when connoisseurs and professional artists could not agree on the constitution of an academy. The artists, and this is a sign of their growing autonomy, refused to accept governance by the gentleman amateurs of the Dilettante Society. During the last decades of the century the balance of power shifted away from connoisseurs and towards patronized artists and

market-dependent producers generating conflicts and deadlock between all three: connoisseurs, patronized artists and artisans, each struggling to consecrate an identity by inventing new institutions. They were, as Elias would put it, locked into a clinch from which no one could escape; each had some investment in the world as it was; no one was able to steer it to their exclusive advantage.

The Society of Artists became a focus for these struggles; its politics were marked by the institution's differentiation into a controlling elite and rank and file members who were excluded from the decision-making process. The incorporation of the Society of Artists in 1765 created two types of member – fellows and directors. In the 1760s there was a sudden realignment within the field of art when the king entered the fray to resolve the disputes centred on the Incorporated Society. In 1768 the fellows made an attempt, through the attorney-general, to contain the power of the directors. They were successful, but the manoeuvring of court artists drew George III into the affair, shifting the centre of gravity of the power struggle away from the market and towards patronage. The establishment of the Royal Academy of Arts (RA) in 1768 resolved the power struggle between patronized and court artists and the larger body of the profession in favour of the former.

The RA was a self-elected artistic oligarchy and was composed of two strata. There were forty full members who, with the exception of the first generation, were elected from among a subordinate body of associates (a maximum of twenty). The associates were in turn elected from the body of exhibitors at the annual Exhibition to which all artists were invited to submit their work. Control over selection for the Exhibition was in the hands of the RA's governing Council (a rotating body of eight RAs plus the President) and the hanging of works was executed by five RAs who made up the hanging committee. The uncertainties of submission, selection and hanging became facets of an artist's career and subjects of discussion and controversy in the art press. The RA's association with the monarchy was of enormous importance. George III provided a location at Somerset House and gave the new institution much-needed financial support in its early years. In competition with the RA the financial situation of other exhibiting societies weakened as they lost revenue, the support of talented artists and were marginalized. In due course the Exhibition, firmly embedded in the ritual cycle of the Season, took on a singular meaning that was only lost with the Great Exhibition of 1851.

By the eighteenth century, connoisseurs and amateurs were unable to make art institutions as they saw fit. Together with professionals and artisans they formed a configuration of interdependent agents with competing interests in the building of institutions. Some aristocrats proposed themselves as guardians of a public taste and as people whose cultivation of art flowed naturally from their identities as men of property who were therefore fit to be a governing class, namely landed gentlemen. Their taste in high art, in the art of antiquity, was an accomplishment that

naturalized the political and economic dominance of a landed oligarchy; connoisseurship in the Old Masters was part and parcel of a patriarchal authority that was augmented through cultural practices such as collecting and the Grand Tour.

The demands of taste went beyond mere collecting. Brewer observes that eighteenth-century collectors distinguished themselves as connoisseurs rather than as virtuosi by domesticating the emotions of wonder and delight. Where the virtuoso had been 'impulsively' curious the connoisseur made critical distinctions informed by standards that were internalized through study and by intellectual application to the arts. Following Elias it seems possible to interpret these transformations as moments in a long-term 'civilizing process' that regulated the unbridled display of emotion and pleasure and rationalized taste in the arts (Elias, 1982). An aristocratic interiorization of taste as connoisseurship flowed from competitive status struggles between families and between the aristocracy and outsiders which raised the standards of what Elias called 'affect-control'; struggles for advantage within a field of status competition raised the stakes in matters of taste by giving advantage to the distinction of rational connoisseurship over a more primitive virtuousity.

Brewer (1997) and others also show how the centre of gravity of cultural production shifted towards contemporary native producers and gave hope for a native English or British school of art. The development of the market separated connoisseurship from ownership of art and permitted the emergence of relatively autonomous institutions such as academies and exhibitions. Where aristocrats as amateurs sought to conserve and augment the identity of the Old Master, native artists pursued professionalizing strategies which subverted the orthodoxies of amateur connoisseurs as the basis for a public art. Where the amateurs sought to monopolize connoisseurship (Brewer, 1997: 256), native painters collaborated with print dealers and publishers to promote their art and to extend their reputations as creators. The underlying regularity at the heart of late eighteenth-century cultural battles was 'the contest between those who produced and those who collected art to decide who governed artistic interpretation' (*ibid.*: 276).

These changes were not the effects of singular classes rising and falling in the social scheme of things but of transformations in the whole field of cultural production. The field of cultural power accommodated the competing but interdependent authorships of aristocratic amateur and of professional artist but was increasingly hostile to the claims of the artisan whose identity was gradually submerged. Charged with tensions it was the field of art and not artists, artisans or connoisseurs which was the author of change; each player produced his cultural identity through the medium of the flux that was the shifting power balances of the field as a whole.

Public spaces of art

These developments were bound up with the evolution of a public sphere which weakened status hierarchies and permitted new forms of cultural authority to appear (Habermas, 1989). Habermas argued that in eighteenth-century England a social space emerged between the state and the private interests of a commercial society in which communication was amputated from arbitrary power, where the state's actions might be the subject of rational criticism and where the balance of cultural power shifted from aristocrats to laypeople (Habermas, 1989: 28). Aristocratic status retreated before the force of argument engaged in by members of a public whose inclusiveness was grounded in the commodification of culture associated with the printing press. Habermas argues that the world of letters provided a developmental blueprint for the public sphere; it was a 'training ground' in the skills of critical reasoning. Coffee houses, newspapers, academies and so forth facilitated a reasonable discourse between people who suspended their differences in the interests of rationality and 'a common interest in truth' (Habermas, 1989).

Habermas explores the sociability that permitted rational critique of traditional cultural power. He correctly surmises that conflict about lay judgement was most severe in the case of connoisseurship in painting. In thinking about painting we need not confine the modalities of discourse to the spoken word and the printed text. We might consider art exhibitions as places where people may sustain a critical argument through the terms of their selection and organization. Exhibitions were not transparent media through which artists promoted their art: they were visual arguments about authorship, places at which artists competed for a viewing within the parameters of available space and the rules of display.

The exhibition, *pace* Benjamin (1970), takes us away from the aura of a cult (with a specific religious location), away from the palace where authorship retains the sign of the contract and the preference of princely patronage. Patronage displays art as a 'spectacle of treasures which the public is allowed to invade and marvel at' (Grana, 1971: 100) and locates the eye of the visitor within the ambience of the patron's cultural power. Visitors are presented with the viewpoint of the patron. They are likely to encounter signs of the patron's presence even in his or her absence – the very conditions of access, the patrimony of family portraits, the preoccupations, perhaps the obsessions of the collector, the prince's private study and an architecture which is a tribute to the patron's authority/authorship.

Public exhibition transformed the eye's relationship to art-objects. The more attenuated, impersonal, relationship of artist to exhibition visitor was (like that of patronage) one of power and persuasion, for it was associated with strategies (gallery arrangement, decor, lighting, etc.) for determining the encounter between pictures and the public gaze.

However, the visitor's eye was constituted in relation to the authority of the artist: such an eye was confused when it confronted paintings 'exhibited or stored up like merchandise in a hall' and struggled 'to contemplate each picture separately without having to see at the same time half of four other ones' (Caspar David Friedrich, *c.* 1830, quoted in the Tate Gallery, 1972). At the same time the public exhibition was constitutive of what it was to be an artist, of how works might be judged. This had consequences for the experience of selling art.

 John Constable's response to public exhibition was intimately bound up with his view of himself as an artist and indexes the possibilities opened up by the shift from patronage to bourgeois art market. The world of patronage is a world of 'friends' (Perkins, 1972: 44–8). In its purest form it embodies the artist as a houseman or servant or, perhaps, courtier; it enmeshes the artist in a network of reciprocal ties and obligations and connects the artist's career to the economic and political fates of patrons, to matters of their personal favour, recommendation, etc. Constable had his friends, his patrons, but he records the impact of the contrasting impersonality of the market on his sensibility as an artist: 'I felt flattered that an application should be made to me from an entire stranger without interest or affection or favour, but I am led to hope for the pictures' sake alone' (Beckett, 1966: 98). In 1825 Constable writes with pleasure about the sale of one of his pictures in Paris, 'purchased by a nobleman (a great collector, I know not whom) for twice or three times what I sold it for' (*ibid.*: 99–100).

Identities, exhibitions and social power

Exhibitions were not transparent media through which artists promoted their art; they were silent material arguments about authorship. The problem is to map the connections between exhibitions, identities and social power. In this matter Bourdieu's field analysis offers a way forward. Bourdieu, it will be recalled from Chapter 1, conceives of modernization as leading to an increasingly complex division of labour of domination and an impersonalization of cultural power. In modern societies power is stored as different forms of capital (e.g. economic, religious and artistic assets) whose values are sources of both conflict and co-operation. These capitals correspond to specific worlds or fields in which they are validated and through which social power flows.

 Power is defined and redefined as it flows through impersonal networks of interconnected fields of economics, politics, science, art and so on. A field of art is a domain which functions according to the rules of art. Modernization entails the emergence of a relatively autonomous art world or field which is the site of competition for the prizes of art and of the authority to sanction artefacts as art according to the rules of art. Bourdieu's general approach permits us to see, in the case of England, that the institution of the RA was an indication of the

autonomization of the art field and to observe the story of the RA as a facet of the impersonalization of cultural power.

An art world accommodates different types of producers, possessing different combinations of economic and cultural assets, engaged in diverse transactions with the economically powerful and with different prospects for securing cultural authority. In London (1750–1850) the pattern of shifting, changing, fusing and fissioning art institutions flowed from the interweaving of artists who had different trajectories *vis-à-vis* the field of power. There were the Royal Academicians, those 'gentlemen of the brush' (Gillet, 1990), whose professionalization marked their integration into the elite and whose studio lifestyles became enclaves of Society (Davidoff, 1986). By contrast, miniaturists and reproductive engravers were on a downward trajectory with the latter feeding into radical class politics and both threatened by technical change. Water-colourists, at first a heterogeneous group of marginal artists, followed an upward trajectory that took them towards the centre of cultural power. Fragile engravers' associations of the early 1800s suggest vulnerability and a need to defend working lives against the vagaries of the market (Pye, 1845).

The art battles of the eighteenth century were exhibitionary struggles. This is so in that exhibitions were spaces at which artists competed with each other to sell their art. The sale of fine art was part of a wider impulse which populated the metropolis with displays of artefacts: with shows, fairs, sights, marts and exhibitions whose promoters all jostled for attention and commercial advantage (Altick, 1978). In the fine arts there was a duality, for exhibitions entailed both a commercialization of the power to consecrate artefacts and the consecration of the power to commercialize them. Identifying this duality illuminates art exhibitions as they relate to the ordering of social relations through their policing of the boundaries between private commercial interests and public good and through the melding of art and gentility.

Eighteenth-century studies such as those of Barrell (1992), Pears (1988) and Solkin (1992) have shed much light on the consecration of a lay public taste in art. This is the key to the academic project of high art as enunciated in eighteenth-century London: to legislate for a public art that transcended the particular and was therefore irreducible to merely private commercial interests. The Academicians proposed themselves as a public good rather than a trade association (Brewer, 1997); they were, as their Instrument of Foundation put it, 'eminent Professors of Painting, Sculpture, and Architecture' and their aim was to promote 'the Arts of Design'. Yet there was a contradiction at the heart of the RA; it was the problem of reconciling high art with the commercial and private opportunities of a picture market. High art had its roots in an ideology of public service by a landed oligarchy and materialized in the great aristocratic collections of Old Masters. The difficulty, to which the lives of the artists James Barry, William Hilton and Benjamin Haydon testify,

was that heroic high art was difficult to realize. It was not just that its scale and subject matter made it difficult to sell into the privatized world of a middle class which preferred subject pictures. The academic project presupposed an organic public space in which there was a rule of taste. This was unsustainable in the face of the divisions of modernity: class conflict, the development of occupations, privatization, suburbanization and middle-class domesticity undermined the notion of a public sphere of heroic action on which high art fed.

Exhibitions had ritual functions; they were among the metropolitan spaces at which the solidarity of the upper class was reclaimed in the face of the divisions of modernity. Exhibitions were among the seasonal rituals of power which promoted the authority of a centred Society over commercial competition. The London Season was a period of some six months, beginning in November, when country squires and aristocrats gathered in London to pursue the pleasures of social intercourse, to settle their affairs and to confirm their elite status through acts of display. An annual festival of Society, it drew the boundaries between the established and the outsiders through a civilizing process of cultural pastimes and events such as visiting, dining, dancing, exhibitions and so forth (Davidoff, 1986; Elias, 1983; Stone and Stone, 1984).

Exhibitions did not receive art for display so much as they excluded, selected and combined artefacts in order to instruct the public in looking (Brewer, 1997). Early representations of exhibitions showing them as congested displays with pictures piled up from floor to ceiling may seem to be at odds with the demands of art. To view them as such is to miss what artists had won for themselves and what exhibitions were about. The exhibition was a point of transaction between the classification of the arts and the ordering of Good Society of which the King was the leader. It looked in two directions: towards patronage and towards the hetero-geneity of a marketized art world. To the modern eye the exhibition would appear as an overcrowded miscellany. However, such an eye has already positioned itself beyond the implicit compromises in which the authority of art and the authority of Good Society were melded.

The early RA exploited and contained the tensions between patrimony and the developing cultural field. Its exhibition was a national site of art classification at which Society, rooted in agrarian capitalism, represented itself as a gathering of distinction. The RA enhanced its power by enlisting new commercial techniques (exhibiting and reproducing art) in the service of a contested and increasingly impersonal cultural power and by colonizing the developing cultural state. The gendered professional power of the male creator was established as dominant through exhibitionary strategies which disorganized alternative visions or refused other people a place: the water-colourist, the craftsman, the female artist, the amateur, the critic were members of a cultural estate ordered by RAs.

The politics of hanging were intimately associated with artistic identities. Framing and the process of painting anticipated the effects of

a mixed exhibition and the effects of juxtaposition with the works of competitors. Struggles between different kinds of artists to capture the gaze of visitors were evident in the disputes and rivalries which entered into the exhibitionary process and into the classification of art. Classificatory disputes were a constant process of adjustment to the competitive claims of different creators to have their art admitted and shown at exhibitions in the best light. Framing was crucial to securing the comparative integrity of a work at exhibition (Bayard, 1981). For some such as water-colourists, who although accepted as RA exhibitors were implicitly disqualified from RA membership, the problem was to compete successfully with large framed oil paintings. For miniaturists a way of claiming public attention was the framing of multiple images on large blackboards. In 1791 the RA Council ruled that this practice was getting out of hand and established a new by-law: 'That no single Miniature be allowed more than one inch of Framing; – and when a greater number are contained in One Frame, it is expected they will be arrang'd as close as possible' (Council Minutes, 23 March 1791, vol. 2: 133).

The RA had instituted itself without granting patrons an active membership. They were invited to private views and banquets, a necessary ceremonial fringe to the business of art. None the less, the shadow of monarchy is evident in the rituals of opening and in the deliberations of Council. In 1771, contrary to the rules against showing copies, an enamel after Reynold's portrait of the Marquis of Granby is exhibited, 'His Majesty having signified His intention that it should be exhibited' (Council Minutes, 13 April 1771). And in 1831, having discovered that a portrait of the King's daughter had been 'accidentally placed in an obscure position', it was resolved, contrary to regulation, to allow the picture to be moved (Council Minutes, 25 April 1831, vol. 7: 434).

There was a latent tension between the generalized authority of mixed exhibitions that conjoined art and Good Society and the individual creative projects of artists. A Royal Academy Council Minute of 1775 records a motion proposed by James Barry RA (1741–1806) who was something of a rebel, took the high art aspiration seriously and may have felt the tension more than most. The motion notes the protests that attend hanging decisions and proposes, among other things, that 'every History, Portrait, Landscape or other Painter may chance to have the opportunity of situating himself (if he chuses it) in the neighbourhood of some others in his own Walk, so to afford both to himself and to the publick a fair View of his comparative excellence or deficiency.' No doubt Barry had felt himself badly done by in 1773 when the Hanging Committee moved his picture on the advice of Joshua Reynolds (Whitley, 1928, vol. 1: 291–92).

In their displays of worthy things, exhibitions gave priority to and consecrated a particular version of the social. To anticipate a later part of the argument exhibitions deleted, dislocated and reordered the identities

of the field of art to organize the identity of the artist as professional male painter. The exhibition arrested pictorial meaning and singled out the oil painter for creative freedom. It is in this sense that the exhibition was internal to the process of modernization, for it mediated the differentation of the field of art within the broader space of fields that constituted the field of power. Different authorships (patrons, professional artists) were permitted a public identity through the strong classifications of Society, while others were marginalized.

Exhibitionary strategies

In 1800 the RA had the exhibitionary field to itself and, until the 1870s, though not unchallenged, it remained ahead in the game of art. Losers and dissidents recovered their positions enough to institute, albeit sometimes fractious, fissionary, short-lived, chameleon and shadowy societies which promoted the interests of other producers: the British School (1802), Society of Painters In Watercolours (1805), the British Institution (1806), the Associated Artists in Watercolours (1808), the Society of British Artists (1823), the New Society of Painters in Watercolours (1831), the Fine Arts Club (1856), the Society of Female Artists (1857), the Burlington Fine Arts Club (1866), the Society of Painter Etchers (1880), the Society of Oil Painters (1883), and the New English Art Club (1885). In 1900 *The Year's Art* noted over ninety institutions: professional bodies, art schools, sketching clubs, collectors' clubs and so forth within the metropolis of London.

Each society was effectively a coalition between different producers: between connoisseurs, amateurs, men, women, professionals and market-dependent producers. To go to a show was to see the art world through the exhibitionary lens of producers who were objectively situated in a configuration of cultural power. Each of these situations dictated different exhibitionary strategies and tactics which were not bound to succeed. I have identified a professionalizing strategy which was pursued by the RA and which drew academicians towards the centre of power. However, two other exhibitionary strategies can be identified, each of which was the medium and the outcome of the formation of the field of art.

Aristocratic connoisseurs

As a territorial class the nobility made its mark on the land both economically and culturally. Expenditure on artefacts illuminated the local dynasty, radiating symbolic power from the family's country seat. The patrimony of ancestral portraits by more or less distinguished artists had long indicated the family's place within the local and national networks of power. Status competition was expressed in country house-building, reconstruction, extension, decoration and so forth while the richest aristocrats established a metropolitan presence with their urban

palaces. Collecting might be pursued for its own sake; collections of curios, antiquities, etc. and an amateur cultivation of the arts had long been signs of gentlemanly virtuosity and distinction. In the late eighteenth century there was an escalating and competitive accumulation of European Old Master paintings as English aristocrats exploited the opportunities of war and dynastic struggle with the dividends of agrarian and commercial modernization. Celebrated art collectors acquired continental masterpieces on a large scale, for example, the Duke of Bridgewater, Lord Berwick, Francis Baring, the Marquis of Lansdowne and many others. The breakup of the Orleans Collection, marketed to fund the dynastic ambitions of the Orleans family, is a dramatic episode of collecting history which provided English aristocrats with opportunities to establish world-class collections (Cannadine, 1995; Haskell, 1976).

Attempts by wealthy connoisseurs to extend their power in relation to metropolitan art institutions were features of nineteenth-century art politics. Some producers sought a patrimonial support that would raise their ventures above the vagaries of the market. The short-lived British School showing at Berners Street was established by three artists with the support of the Prince of Wales and wealthy amateurs as well as some RAs who sent in their work. Its constitution suggests a more heterogeneous and frankly commercial remit than the RA, instituted as a continuous exhibition of 'original paintings, sculpture, drawings and engravings, by the most eminent living and departed British artists' (quoted in Whitley, 1928, vol. 1: 46). And the Society of British Artists (1823) was counselled by the Duke of Sussex, a guest at its opening dinner, against jealous competition with the RA (Whitley, 1930: 59).

In 1806 the British Institution, backed by wealthy amateurs and connoisseurs, was founded, and promoted an annual exhibition of living artists' works. The Institution excluded artists from its management; in addition to its Old Master preoccupations it mounted Spring and, from 1825, Summer shows by living artists. It was a threat to the Academy; its Spring exhibitions sold £75,000 worth of paintings in the years up to 1827. Individual artists showed their work there, but they retained a collective anxiety in a period that witnessed 'a barely concealed struggle for power between the Academy, representing the profession, and the main body of connoisseurs and patrons' (Hardie, 1968: 270). The early 1800s had already seen some aristocrats (e.g. the Marquis of Stafford) opening up their London collections to limited public access. The Institution shows connoisseurs adapting to the market, extending their authority into new spaces such as the National Gallery. Lord Farnborough, for example, was a director of the Institution and a trustee at the National while Sir George Beaumont was a key player in both places. There were widely reported loan exhibitions from 1813 to 1867 to which the collector-members regularly contributed, and in 1829 the Institution donated a Reynolds and a Gainsborough to the National Gallery.

Commercial exhibitions

An artist might sell direct through commercial premises such as the European Museum (a mart for curiosities and pictures) or as an independent exhibitor (J. M. W. Turner at Queen Ann Street). James Ward is reported withdrawing pictures from the RA and exhibiting at a private gallery in 1804. Commercial art did more than communicate the identities of British artists: it sponsored them. It was a medium through which new identities were produced and artistic powers expressed. John Boydell (1719–1804) promoted the idea of an English school of art through his activities as a print entrepreneur, turning himself into a wealthy man celebrated by Burke as England's 'Commercial Maecenas' (Santaniello, 1979). Thomas Macklin, a rival of Boydell, launched similar schemes and was said to have sunk £30,000 into his illustrated *Bible* (Whitley, 1928: 9). But the image of the art trader as a middleman who had no obvious productive role and lived off the ignorance of others was far from positive during the first half of the century.

The earliest dealers had episodic relationships with established artists whose works they would normally acquire from authoritative exhibitions. In the early part of the century the dealer was a cosmopolitan and suspicious presence plying a dubious trade in Old Masters that was fraught with problems of fraud. The painter Joshua Reynolds managed to make a fool out of a dealer, and William Seguier's vocation as art dealer was not universally judged to be a qualification for appointment as first Keeper of the National Gallery (Whitley, 1930: 121). Family names (Colnaghi, Gambart, Desenfans, Flatow, Zannetti) indicate the outsider status of people moving along the trade routes of European art and artefact to settle in Britain. Some dealers emerged out of cognate trades, such as the framemaker Charles Tooth who moved into art dealing in the 1840s. By the 1850s 'much of the commerce in modern art is ... in the hands of dealers ... it is certain that they should be narrowly watched' (*Art Journal*, 1854). By 1875, the *Art Journal* is more sanguine in reporting that London is full of exhibitions including twenty collections of modern pictures, a dozen of which are shown by dealers: 'but these are for the most part of great merit and interest' (*Art Journal*, 1875: 158).

The status anxieties of early nineteenth-century artists dictated the need for commercial care. It was not until 1811, in the face of competition from the British Institution, that the RA put in place arrangements for the sale of art at its exhibition (Whitley, 1928: 187). The Academy kept dealers at a distance although, as individuals, artists did more and more business with them. In the late 1850s one RA, Samuel Redgrave, woke up to their presence when he arrived unusually early at the RA: 'I soon found what a business they make out of the Academy' (Redgrave, 1891: 212). From the middle of the century, established artists such as Frith and Hunt were sought out by a small but increasingly powerful group of entrepreneurs: Ernest Gambart, Messrs Lloyds, Louis Flatow and

Agnew's sold engravings and bought paintings from artists. *The Post Office Directory* for 1854 listed eighty-five picture dealers and importers; in 1900 *The Year's Art* listed 146 metropolitan print-sellers and picture-dealers.

The commercial history of Agnew's (Agnew's, 1967) illustrates key changes in the field of nineteenth-century art. Originating in Manchester as a carver and gilder's which also traded in diverse collectibles, including paintings and prints, the firm had two partners by 1817 when Vittore Zanetti brought in Thomas Agnew. By the 1830s the flourishing business had extended its interest in prints, and was engaged in the developing trade in contemporary British art under the sole proprietorship of Agnew. Agnew's was by now part of a network of bourgeois cultural institutions that had emerged in Manchester and other commercial cities of the North and Midlands. Their print- and picture-trading activities promoted the consciousness of northern industrialists of their distinctive and non-aristocratic identity as a class. Some of Agnew's print publishing ventures were a quasi-journalism centred on the great issues of the day, for example, *The Meeting of the Anti-Corn Law League* published in the 1840s. Agnew's fusing of print-selling and picture-dealing is repeated in other firms such as Ernest Gambart: a strategy in which paintings were reproduced as engravings and put on the road for provincial exhibition. As a business strategy it was central to the promotion of British artists, especially of royal academicians: J. R. Herbert, Edwin Landseer, J. E. Millais, Luke Fildes and others.

In 1860 Agnew's opened a London branch to which the main business gravitated as they became progressively international in scope and ultimately developed interests in the USA. Kinship ties integrated Agnew's into the business of Victorian visual culture: marriage brought associations with the proprietors of *Punch*, which employed many up-and-coming artists as illustrators, and with Swain the wood-block engravers, whose cutting took countless images from drawing to print. By the end of the century Agnew's belonged to an elite corps of dealers who were part of polite society and whose business practices had been domesticated through a civility that concealed their function of selling art.

Agnew's were friendly with celebrated Victorian artists and began to cultivate a pattern of dealer–artist relations that dissolved the sealed statuses of artist and dealer in favour of a greater intimacy with the latter bringing new artists forward and, in turn, being consecrated as a kind of patron. Agnew's played a role in discovering Fred Walker in 1864 at the Old Water Colour Society and business turned to friendship. Walker's early death in 1875 confirmed him in the role of Victorian romantic genius. There are parallels with the painter Charles Lawson who was later discovered by the Grosvenor Gallery, and with the fictional Little Billee from George du Maurier's *Trilby* (1896).

Art exhibitions and the artist-as-creator

The 'one-man' show was uncommon during the first three-quarters of the nineteenth century. Its development endorsed the gendered shift from the masterpiece as the object of aesthetic contemplation to the 'master-sequence' of paintings:

> The individuality of the new picture is the individuality of the artist who painted it, but it is less sharply differentiated from the canvases just before and just after it. The more the work is solely the artist's own creation, the more each one will blend into the sequence of what he has done to form the larger whole which is his universe of forms.
>
> (Sloane, 1961: 424)

The opportunity to articulate that universe of forms was not provided by the Academy's annual Exhibition which dealt with thousands of submissions and was always struggling to accommodate the works judged fit for display. This was an increasingly hopeless struggle which, by the 1880s, was losing the Academy its public credibility and was fuelling attempts by disaffected artists to establish an alternative exhibition. For some exhibitors, as we shall see, this crisis was experienced in terms of the question: What does it mean to be an artist and to have one's works publicly displayed?

The Whites (1965), as we have seen, illuminate modernity's shift away from the singular canvas as the locus of institutional transactions (judging the merits of individual paintings, selecting and hanging them in the Salon, awarding prizes). They show how, in France, the dealer–critic system crystallized around the careers of the Impressionists and how the one-artist exhibition took on a decisive role as a basis for validating art and publicly presenting artists' achievements. The individual canvas became a 'piece of a meaning' (White and White, 1965: 117–18); its point of reference was the artist as a creative subject.

Can the Whites' thesis be generalized to include the case of the English art world? Artists along with associated occupations were growing metropolitan presences as recorded by trade and professional directories. For 1833–34 *Pigot's Directory* records, under *artist*, 378 historical painters, landscape artists, portraitists and miniaturists, etc., as well as the most artistic end of the engraving trade. *The Post Office Directory* of 1840 seems more selective in excluding engravers from its list of 179 artists. By 1900 there are 884. *The Year's Art*, a professional directory published from the early 1880s, points to rising numbers of people seeking professional and national recognition as artists. In the ten years from 1881 to 1891 the directory shows numbers exhibiting at thirteen leading exhibitions, six in London, rising from 3,500 to 4,500. By 1899 the figure was 6,000. Writing in 1892, Marcus Huish, editor of the *Art Journal*, estimated that sixty years of government-sponsored education in art and design was rapidly expanding the pool of people who might aspire to be professional artists: 'the grand total of persons

educated in art by this means was in 1880 829,000, and in 1891 1,273,000.'

In the second half of the nineteenth century the Academy was on the defensive with its annual Exhibition becoming an issue of cultural politics. The 1863 Royal Commission enquiring 'into the present position of the Royal Academy in relation to the Fine Arts' judged that 'want of adequate space' was the most 'unanimous' and 'justly founded' subject of complaint about the Academy (Report: xiv). The testimonies of the witnesses (including those of academicians) along with other contemporary evidence – press reports, attacks by disaffected artists and statistics concerning submission/rejection/exhibition at the RA – convey a widely diffused sense of malaise.[1]

In making sense of this it is necessary to locate the RA within the context of class and state formation. The Academy was the site of power plays during the nineteenth century and these were not neutral with respect to the political and economic domains. The exhibition was an aesthetic problem and a problem of art politics coloured both by the Academy's connection with aristocratic patronage and monarchy. Throughout the last century successive official inquiries into the state of the arts probed the affairs of a far from supine RA and threatened to breach the institutional autonomy that (increasingly) seemed to be encoded in the Royal of Royal Academy. The key to these inquisitions is the tension between the ascriptive privileges of aristocratic cultural power (adapting to the terms of metropolitan/professional art institutions) and the ideological weight of the bourgeoisie as a public – corralling art and its institutions into the public domain, preaching the word, and translating art into cultural capital (exhibition visiting, reproductive prints, art journalism, etc.).[2]

The annual Exhibition, with its exclusive dinner[3] and Private View day, was a child of the Season, part of the institutional fabric through which the cohesive identity of Society was reproduced within a developing capitalist society (Davidoff, 1986). However, by the late nineteenth century Society was manifestly being divested of direct political and administrative control (Northcote-Trevelyan reforms) and with the push towards an accountable expertise in art, as elsewhere, the RA's prerogatives were under assault. By the 1880s Society's contours were becoming increasingly difficult to discern: 'English society has grown too large for its representatives to be contained within the limits of a single drawing room' (Escott, 1880). The political power of the salon, with its emphasis on personal invitation and knowledge was, Escott tells us, now replaced by the club (Escott, 1880, vol. 2: 64–5). Through more junior eyes 'London appeared as a shifting mass of miscellaneous and uncertain membership' (Webb, 1929: 46).

> The bulk of the shifting mass of wealthy persons who were conscious of belonging to London Society ... were, in the last quarter of the nineteenth

century, professional profit makers: the old established families of bankers and brewers, often of Quaker descent, coming easily first in social precedence; then one or two great publishers and, at a distance, shipowners, the chairmen of railway and some other great corporations, the largest of the merchant bankers – but as yet no retailers.

(Webb, 1929: 47)

That bulwark of the Academy, agrarian capitalism, was in crisis with the agricultural depression of the 1870s. It has been argued (Morgan, 1969) that by the 1870s the RA had 'lost an opportunity' to retain its earlier dominance in matters of Art. The situation of the RA was profoundly and irreversibly affected by the agrarian crisis of the last quarter-century (with the decline in house-building)[4] and what has been characterized as the increasingly caste-like attributes of the landed aristocracy – 'distancing itself from, and distanced from the newer business magnates' (Rubinstein, 1981: 219).

These changes were interpreted by exclusive exhibitions in the 1870s, 1880s and 1890s which established an alternative to the RA – the Grosvenor (1877), the New Gallery (1888) and the Grafton (1893). The sense of change also shows in observations and anxieties expressed in the literary genre that was late Victorian and Edwardian art memoirs, diaries and reminiscences. These chatty, gossipy and often inconsequential narratives of a life's art were outgrowths of a Society that was under siege, sometimes symptomatic of a cultural occlusion and sometimes articulating an emerging aesthetic.[5] H. S. Marks chronicles the fate of Picture Sunday. Once it had been an intimate affair with painters opening their studios to a few friends (also the odd dealer and potential buyer) immediately prior to the Academy's sending-in day. Now (early 1890s) it 'has degenerated from a simple friendly meeting into a crowded overgrown abuse' (Marks, 1894, vol. 2: 83).

These were contested changes, as is evinced by Lady Butler's response to a private view at the Grosvenor Gallery in 1879 as, 'more and more annoyed', she escapes into 'the honest air of Bond Street' and catches a hansom to her studio: 'There I pinned a seven foot sheet of brown paper on an old canvas and, flung the charge of "The Greys" upon it' (quoted in Clive, 1964: 103). Lady Butler was abandoning a Grosvenor (established in 1877) that was pivotal with respect to the emergence of an artistic opposition to the Academy; the terms of that opposition are aspects of class structuration as it manifested itself on the aesthetic terrain. Contemporary accounts of the Grosvenor give a sense of aristocratic retrenchment and of a habitus that contrasts with the more public aesthetic of the Academy.

Pottery and china, and groups of plants disposed about the rooms, serve to heighten the impression that this is not a public picture exhibition, but rather a patrician's private gallery shown by courtesy of its owner; indeed so studiously are the business arrangements kept out of sight, that but for

the inevitable turnstiles and catalogue-keepers the illusion would be complete.

(The Portfolio, 1877: 98)[6]

This description is not evidence for the proliferation of an aristocratic caste's aesthetic; it should be placed within the context of the reforming and bureaucratizing strategies of an elite professional and administrative stratum, the intellectual aristocracy (Williams, 1980: 79–81). New kinds of exhibitions were sites of the transformation of elite culture and of power struggles through which new cultural fissures were constituted – the production and reproduction of the social difference between a popular aesthetic (as expressed in the Victorian subject painting) and the pure, disinterested aesthetic of the bourgeoisie (Bourdieu, 1984, 1993). Measured in terms of exhibition visitors, the late nineteenth-century Academy was successful, numbering hundreds of thousands per year. Part of the key here is the popularity of sensational narrative works (W. P. Frith: *The Railway Station*; Luke Fildes: *The Doctor*; W. F. Yeames: *And When Did You Last See Your Father?*) whose subjects were so often the process of state formation itself. It was the aesthetic status of such popular successes that was increasingly called into question by an argument about art that directs attention away from the subject and towards the pertinences of style and a universal art history. Indeed, popularity begins to be assimilated into the language of critical opprobrium.[7] The developing cultural apparatus of the bourgeois state and the emergence of international, universalizing bourgeois art locked the RA into a posture that was increasingly particularistic.[8]

Bourdieu argues that the cultivation of art by the bourgeoisie relates to its historical situation as a class. On the one hand, the bourgeoisie cannot legitimate its privilege through an appeal to birth, for this is precisely what it has 'refused to the aristocracy'. On the other hand, it is not possible to invoke Nature because this is 'the ground on which all distinctions are abolished'. This dilemma is resolved as a charismatic ideology which elides and mystifies the relationship between nature and culture:

> the sacralizing of culture fulfils a vital function by contributing to the consecration of the social order. To enable educated men to believe in barbarism and persuade the barbarians within the gates of their own barbarity, all they must and need do is to manage to conceal themselves and to conceal the social conditions which render possible not only culture as second nature in which society recognizes human excellence or 'good form' as the 'realization' in a habitus of the aesthetics of the ruling classes, but also the legitimized predominance (or, if you like, the legitimacy) of a particular definition of culture. Notions of art and artists can be seen as essentialist representations of 'the bipartition of society into barbarians and civilized people'.

> (Bourdieu, 1968: 610)

The ideological (re)presentation or recontextualization of the relationship between nature and culture is secured partly through the institutional practices of modern art worlds (e.g. those associated with the one-artist exhibition and the original print). The creation of these practices is the artist as a creative subject. The problems faced by the late nineteenth-century RA were crucially bound up with the elaboration of this ideology of creation, an ideology that it had nurtured in the early part of the century but whose elaboration now seemed inhibited by the conditions imposed at the annual Exhibition. It is not a question of treating the artist as a kind of label but of uncovering an ideology of creation both as it conceals the social and as it informs the realization of individuated modes of picture-making, of exhibitionary control and cultural authority. It is also a matter of how relations of power in a society are symbolically reworked as the dominant traditions of creativity.

'Van Dyck wasn't in it'

Like the organizers of earlier eighteenth-century exhibitions, Royal Academicians found means for ensuring the exclusion of 'improper Persons' (Hutchison, 1968: 55) and this, along with other evidence, indicates the felt need to secure a distinction between the art exhibition and the popular forms of display with which it co-existed. In 1788 the Academy found itself next door to a display of 'Automaton Figures which move in a great variety of descriptions, by clockwork, with the Diamond Beetle, scarce and valuable paintings, Needlework, Shells, Flies, Water Fall, etc., etc.' (Whitley, 1928, vol. 2: 104; also Altick, 1978: 99). The early records of the Academy show that such things obtruded into its proceedings; the exhibition was a medium for establishing the difference between the aesthetic domain and what Altick identifies as the documentary representations and historical realia of gentlemen's cabinets (p. 100). In 1772 the Academy is refusing application by a Mr Malton to exhibit his 'Perspective Machine' (Council Minutes, vol. 1: 130–1). Ten years later the Academy was approached by a G. P. Towry seeking endorsement for a proposed 'Mart or Court Fair'. The Academy refused to co-operate, replying that the proposed show 'must weaken the Effect of Exhibitions, divert the Attention of the Public from that of the Royal Academy, and by a multiplication of such Shows render them disgusting' (Council Minutes, vol. 1: 317–18).

The exhibition was always a matter of concern to the Royal Academicians; its organization encoded their sense of themselves as original professional fine artists. Some objects were excluded under the laws of the Academy and others (e.g. reproductive engravings and water-colours) were admitted but discriminated against. In January 1769 Council, the governing body of the Academy, ruled that no copies could be admitted: 'No Picture copied from a Picture or Print; a Drawing from a Drawing; a Medal from a Medal; a Chasing from a Chasing; a Model

from a Model, or any other Species of Sculpture, or any Copy' (Council Minutes, vol. 1: 8). From the early 1770s: 'no Needle-Work, artificial Flowers, cut Papers, shell-work, or any such Baubles shall be admitted into the Exhibition' (Council Minutes, vol. 1: 75–6); 'no models in coloured Wax shall be admitted' (Council Minutes, vol. 1: 101).

The long-term historical context of the Academy exhibition is the gestation of a habitus that displaced older and more sanguine attitudes towards copies and even forgeries. The exhibition endorsed the artist in the role of creator. We are a long way from the bourgeois monad of high modernism and the unique style of the artist. Creativity still had transactions with a pre-existing symbolic order (Nature, the Antique, narrative history, literature). Nineteenth-century painting had a marked narrative/subject orientation, trading on a shared iconography – a medium through which the limits of pictorial authorship were constructed ('the artist has recorded an historical event that never occurred, got the technical details of costume wrong, misrepresented the literary account', etc.).[9] By the end of the nineteenth century such limits were seen by some artists as obstacles to a proper individuation of creation and, moreover, as limits that were institutionalized in the Academy and its annual Exhibition. I turn to a consideration of what those limits were perceived to be and the terms within which the Exhibition became a focus of public controversy.

By the 1880s criticism of the Academy and complaints about the Exhibition were becoming shrill.[10] As the correspondence columns of *The Times* suggest, overcrowded exhibition rooms and disappointed artists made up the stock of common knowledge about the fine arts (see *The Times*, Monday, 26 April 1880, p. 8, col. 6). Could room be found at the Horticultural Gardens for the 'great unhung' to show their work (*The Times*, Friday, 23 April 1880, p. 8, col. 2)? And 'Rejected-Dejected-Neglected' writes: 'How many hearts would be glad and crushed hopes revived if the suggestion relative to the opening of a "Supplementary Exhibition" were to assume a practical shape! The wolf is at many a studio door' (*The Times*, Saturday, 24 April 1880, p. 8, col. 3).

The Academy Exhibition was perceived as an unfortunate crowding of canvases, many of which were condemned to comparative obscurity even though they were selected (perhaps accepted but still unhung, or else hung without the advantage of being 'on the line') and perhaps juxtaposed with unsympathetic neighbours. In the last quarter of the nineteenth century what amounted to a crisis in the Exhibition was fuelled by changes in the imagery and vocabulary of creativity as they were determined within a developing fine art market. A central image here is that of the artist's studio and a sense of the studio as the locus of a creative life. Symptomatic is the popularity of such imagery in nineteenth-century paintings and its exploitation by art journalism (illustrated accounts of visits to contemporary artists' homes and studios).

The aesthetic control that the artist might exert in the intimacy of his

or her studio became more widely acknowledged as the basis for judging how artworks ought to be displayed:

> When you go to a painter's studio and ask him to show you a picture, he does not run upstairs with it and hang it out at the window of the third storey and tell you to go out into the street and look up at it; he puts it on an easel, level with your eye, wheels the easel into the best light, and you really see the work. Now in a rationally contrived gallery....'
>
> (Hamerton, 1889: 243)

The studio of the working artist was the site of aesthetic effects that could not be obtained through encountering works that were distributed between collections (public and private) or dispersed within a large mixed exhibition. In the early 1830s Constable comments on the effects to be gained from seeing his pictures at his studio: 'It is much to my advantage that several of my pictures should be seen together, as it displays to advantage their varieties of conception and also of execution' (Beckett, 1966: 129). What Constable was signalling, as Turner had already done at Queen Anne Street, as Delacroix and Ingres were to do at the 1855 Paris World Fair and Manet was to do in 1867, was the importance of the one-man show or exhibition.

In 1877 Sir Coutts Lindsay (the wealthy dilettante) with his wife and C. E. Halle launched the Grosvenor Gallery (satirized by Gilbert and Sullivan as 'greenery yallery') on an aesthetic programme that would avoid the annoyances incidental to exhibition at the Royal Academy as well as 'the juxtaposition and crowding together of ill-assorted canvases' (Halle, 1909: 99). Here the works of individuals were grouped together within a physical setting that was designed to harmonize. M. S. Watts (1912) gives an account of the effects of the Grosvenor's arrangements:

> Afterwards came the consciousness that the work of some English painters of the day was being revealed to the public for the first time ... in the setting of this well conceived building each was being allowed to deliver his message consecutively, and the visitor was not called upon to listen to him between other and conflicting voices, or to hear from him nothing but a broken sentence. The works of each artist, grouped together and divided by blank spaces, allowed the spectator's eye and mind to be absorbed entirely by what the painter had to give them ... those who had cared to search the Academy walls, season after season, for the work of George Frederic Watts stood before the end of the West Gallery wall, and hailed their master. ... It was not too much to say that now to a larger public, beyond the circle of his friends, *the mind of the painter was speaking for the first time.*
>
> (Watts, 1912, vol. 1: 323–4; my emphasis)

Sennett (1976: 205–9) plots the nineteenth-century changes in the theatre that redefine the prerogatives of an audience, constituting it as a silent, self-policing aggregate shrouded in darkness with its attention commanded by the stage. There were parallel developments in the organization of art exhibitions with artists, gallery-owners, directors

and dealers collaborating to produce the physical conditions and arrangements that would guarantee the artist's visibility, presenting her or him as the locus of creation. The requisite techniques were pioneered by Whistler, Halle and others in the 1870s who used lighting, decor and the arrangement of pictures as a means of establishing the pictorial authority of the artist and securing the gaze of the visitor. There are accounts of the strategies and techniques adopted by Whistler: his use of controlled lighting (by means of a velarium) to ensure that the spectators remained in shadow while the pictures were bathed in soft light, the choosing of colours and tones for gallery decoration that would not compete with the pictures for attention, the careful arrangement and spacing of the pictures by the artist and a scrupulous attention to other matters of detail (see Eddy, 1904: 132–9; Menpes, 1904: 104; Pennell and Pennell, 1921: 304–5). The effects that Whistler and others sought were bound up with power: control of the physical environment within which pictures were encountered, securing the artist's point of view, establishing the artist as the single source of pictorial meaning.[11]

The Academy dispersed the artist's art across its walls; the visitor 'heard' a fragmented 'message', a 'broken sentence' whose meaning had to be sorted out from that of 'other and conflicting voices' (Watts, 1912, vol. 1: 32). Insofar as the experience of what it meant to be an artist was mediated by the exhibition, the one-man show was the means by which some artists found themselves, or were encouraged to see themselves, as creators. Although he was persuaded to engage in the project, Millais had considerable misgivings about putting on a one-man show: 'It is the kind of thing that should never be done till a man is dead ... I feel a little as if a line was drawn across my life now and the future won't be the same thing I meant it to be' (Burne-Jones, 1906/1912, vol. 2: 230). Halle (1909) tells how he inveigled Millais into the idea of an exhibition and gives us an account of difficulties that were encountered in arranging the pictures. Having decided that he would arrange them himself, Millais adopted the principle that the most 'popular' and highly priced pictures should be placed prominently. However, 'the result was deplorable' and a disappointed, unhappy Millais came to the conclusion 'that he was not an artist at all'. Halle's response was to organize the rehanging of the pictures himself, this time on the principle of 'their artistic merit alone', giving 'the merely popular pictures less prominent places'. Millais was jubilant at the effect: 'Charlie, my boy, Van Dyck wasn't in it!' His next response was to set about retouching the pictures, 'strengthening the colour in one place, glazing in another, toning in a third' (Halle, 1909: 155–6). Another instance is that of the Alma-Tadema exhibition put on by the Grosvenor Gallery in 1882–83. Against the advice of others, the artist had wanted to hang his pictures, some of which he had not seen in years, in a strict chronological order. However, coming across 'one of his best pictures', he decided, irrespective of chronology, that it warranted hanging in the best light.

'How about chronology?' said Carr. 'The picture's place is in that dark corner.' 'Chronology be d——d!' said Tadema, and we heard no more about chronological arrangements at that or any other exhibitions.

(Hallé, 1909: 133)

Two final illustrations. In 1875, following its exhibition in London (1870) and Manchester (1875), George Frederic Watts' allegorical painting *Love and Death* returned to the artist's studio in London, where it was repainted, shown at the Grosvenor in 1877 and eventually acquired by Bristol Art Gallery. It was not, it seems, unusual for Watts to exhibit unfinished pictures in the expectation that he would learn something from 'seeing them placed in what he usually found to be unfavourable conditions' (Watts, 1912, vol. 1: 283). Watts was among several nineteenth-century artists who found themselves as artists partly through the medium of new modes of exhibition. The sequence of events noted above points to a dialogic association between artist and exhibition in which the effects of the latter are not surplus to the work's gestation in the studio. In Watts' experimentation, as it were, the work flows back from exhibition to studio or, to put it another way, the studio expands to include exhibitions as a mega-studio in which the artist finally completes the work.

Watts was not the first artist to to bring his paint and brushes down to the show. The 'varnishing days' of the Royal Academy of Arts were held immediately prior to the opening of the annual Exhibition of the RA and after the so-called Hanging Committee had arranged the show. The ostensible purpose of these days was to varnish canvases, but until the 1850s academicians, attended by an assistant and sometimes even equipped with scaffolding, had the privilege of touching up their paintings *in situ* and routinely did so. Watts, like other artists, took advantage of this privilege but J. M. W. Turner infamously converted it into an extension of his studio practice. Contemporaries record the theatre of his wholesale reworking of half-finished canvases (even surreptitiously toning down those of adjacent paintings by other exhibitors). One report suggests that Turner held a stock of partially prepared canvases at his studio in anticipation of their future completion on varnishing days (Leslie, 1914: 146–7). These cases are significant for understanding the relationship between institutions, power and creativity. Creativity was about power in the sense that it entailed the subordination of materials and people to the artist's intention.

The exhibition did not translate or encode a pre-established authorship. The anecdotes provide clues as to how the artist's identity as a creator was constructed. The one-man exhibition was a site at which the artist's 'universe of forms' could be explored. It was the site of aesthetic effects that could not be obtained through encountering the works of an artist which were scattered around in different collections or within a large mixed exhibition. The spectator approached pictures whose very arrangement was an argument for the primacy of the creative subject, an

arrangement which broke with the common-sense principles that might have dictated to it – thus neither chronology (Alma-Tadema) nor mere popularity (Millais). The exhibition asked something new of the spectator and denied the relevance of certain kinds of knowledge. Why, asks Whistler, should you be concerned to know that a portrait I exhibit at the Royal Academy is of my mother? This way of seeing was at variance with the central thrust of Victorian art criticism with its literary and narrative emphasis (Roberts, 1973) and there were obstacles to its production and dissemination – not least in the aesthetic effects generated by mass-produced reproductive engravings. None the less, the news was being spread, the key to the cultural code was in the process of transmission. Why not, asked the influential *Art Journal* in 1860, reviewing a posthumous Thomas Faed exhibition, mount a one-man exhibition of the works of a living artist? In 1875, 1876 and 1877 the *Art Journal* was preaching, through a series of illustrated articles on Edwin Landseer, the merits of the original sketch and the possibility of watching 'the growth of the painter's mind as developed in his works' (*Art Journal*, 1875: 1). By 1889 we hear, not altogether favourably, of 'the modern fashion of one-man exhibitions' (*Art Journal*, 1889: 53).[12]

Notes

1 See the partisan John Pye (1845), Thomas Skaife (1854) and W. J. Laidlay (1898). In the 1880s and 1890s there was a growth in the number of works being submitted to the RA Summer Exhibition – 6,415 in 1879, 8,686 in 1887 and 12,408 in 1896 (Hutchison, 1968: 139). At the end of the century there were about 5,000 artists annually submitting works with not more than two-fifths gaining a place in the Exhibition (Hutchison, 1968: 150).

2 In 1871, after years of petitioning, the press was officially given access to the Exhibition. Improved conditions of access were granted in 1892. See M. H. Spielmann, *The Magazine of Art*, 1892: 186–8 and 222–8.

3 Its exclusiveness appears to have been in question in the early 1800s: 'It should never be forgotten that the original intention of this entertainment was calculated to bring together at the opening of the Exhibition the highest orders of Society and the most distinguished characters of the age; but unfortunately, by degrees, the purity of selection has given way to the influence of private friendships and the importunity of acquaintances' (Royal Academy, Council Minutes, 1 April 1809, vol. 4: 111).

4 Girouard (1979: 8–9); Clemenson (1982: 48–50).

5 Halle (1909), Carr (1908) and Carr (1925).

6 Carr (1925): 'Lady Lindsay's Sunday afternoon parties at the Grosvenor were among the social events of the 'eighties.... Admissions by ticket to the private-view days had always been in great demand, but the Sunday afternoon receptions were entirely confined to personal invitations, and Sir Coutts and Lady Lindsay took a certain pride in being the first members of Society to bring the people of their own set into friendly contact with the distinguished folk of art and literature. In these fine rooms hung with crimson damask they certainly gathered together the elite of the great world as well as all the

brilliance of a select Bohemia' (p. 54). It was an illusion. By 1887 the patrician Sir Coutts Lindsay's associates (Charles Halle and J. Comyns Carr) had fallen out with him, resigned their directorships and were establishing the New Gallery – taking with them the star of the Grosvenor, Edward Burne-Jones. Thompson's metaphor (1978: 55) characterizing the aristocracy as presiding, like the staff of an expensive hotel over the comings and goings of guests who may choose to do what they want, is entirely apposite. Worth noting here is the growing importance of the commercial directorship as a mode of aristocratic participation in the affairs of exhibition galleries: see *The Magazine of Art* (1892: 348–50) for a description of the Grafton Gallery and its board of directors.

7 This is noticeable in the case of the assault mounted on the RA's control of the Chantrey Bequest in the years *c*. 1880 to 1915. The Report of the 1904 Select Committee on the Chantrey Trust asserts that the Chantrey selection 'contains too many pictures of a purely popular character, and too few which reach the degree of artistic distinction evidently aimed at by Sir Francis Chantrey' (Report: 498, para 7).

8 On the other hand, there is the emergence of a reforming tendency within the RA in the 1880s and 1890s. See Hutchison (1968: Chapter 13). By 1894 the Academy was being congratulated on its reforms (*The Magazine of Art*, 1894: 217–20).

9 See e.g. 'Some anachronisms of art', *The Magazine of Art* (1880: 39–40). Crucial here is the ideological role of narrative painting in elaborating historical knowledge within the class context of state formation.

10 Disaffected artists, among them French-trained dissidents, were given much publicity in schemes for a broadly based exhibiting society. There was considerable discussion and debate about the principles upon which a new society might be organized, and proposals that universal suffrage – the participation of all British artists – should be the keynote. The major outcome was the foundation of the New English Art Club in 1886: 'the outcome of a movement or feeling expressed at divers little meetings held in Paris and London between the years 1880 and 1886, with a view to protesting against the narrowness of the Royal Academy' (Laidlay, 1907: 3). What particularly distinguished it from the Academy was that the fifteen-strong jury (selecting exhibits) was 'elected by and from members and exhibitors of the previous year' (Laidlay, 1907: 202). Resentment within the profession continued to fuel a campaign for 'a really national exhibition ... conducted by artists on the broadest and fairest lines' (*The Times*, 7 August 1886: 6), but this seems to have disintegrated.

11 See *The Portfolio* (1893: v) for an account of the newly opened Grafton gallery and the problems of its lighting: 'Each wall is ... lighted by the skylight opposite it. The result is that when the pictures are looked at from exactly the right spot they are seen very well. On the other hand, the system limits the choice of point of view, for when the spectator stands too close he is bothered by reflections.'

12 The misgivings that Millais had appear to have persisted. The art dealer Oliver Brown recalls that in the early years of the twentieth century there were many successful artists who had reached the end of their careers without ever having had a one-man show 'and were by no means convinced that they would be of any benefit' (Brown, 1968: 139).

4

Auditing the RA: official discourse and the nineteenth-century Royal Academy

Instituting the Royal Academy of Arts

On that day in 1768 the painter Joshua Kirby (1716–1774) must have been stunned as he digested the news he had just heard. Once a tutor to King George III and now newly elected as President of the Society of Artists of Great Britain, he had been admitted into the presence of the King at Buckingham House. Already received was the court painter Benjamin West whose painting *The Departure of Regulus from Rome* the King was considering. Kirby expressed admiration for the picture and added that he would welcome it to his exhibition at the Society of Artists. The King indicated that the matter had been settled otherwise: 'No, it must go to my exhibition – to the Royal Academy.'[1] So far as Kirby knew no such body existed; not a moment earlier, as he awaited the King's pleasure, he had assured Joshua Reynolds that no plans for a royal academy were afoot. On the one hand proposals for an academy had been circulating for decades and none had come to fruition, and on the other Kirby must have expected to be party to the founding of such an institution.

Kirby may have hoped that his election, in October of 1768, as President of the Society of Artists would draw a line under the disputes that had broken out among metropolitan artists in the 1760s. It was, however, the RA which resolved things; it syphoned off stars such as Gainsborough and ran the exhibitionary ventures of other societies out of business. Like its European cousins, the RA was a teaching body with an exhibitionary function. How it differed from the Continent was in the commercial emphasis that was placed on the Exhibition (Pevsner, 1973: 185). If in the seventeenth century Louis XIV had granted his academy his fame, then George provided a viable exhibition. The RA mission of elevating the status of the artist by teaching and exhibiting art was accompanied by ruthless financial probity: for example, following audit in the late 1790s the Council approved measures to increase the revenues from its exhibition (Council Minutes, 26 August and 14 October 1797,

3 February 1798). Significantly the one RA appointment that was in the King's gift was the post of Treasurer.

What did it mean to say that the Academy was a *Royal* Academy? As we have seen, the RA was no mere extension of royal power. Both monarchy and academy formed a discursive alliance as they converged on the symbolic power of an elevated art. Kirby's shock at the institution of the RA was one moment in the longer story of the shaping of the monarchy as an agency specializing in symbolic power. From the seventeenth century a parliamentarization of political power (Colley, 1996; Elias and Dunning, 1986) transformed the monarchy which yielded up much of its historical power to Parliament. Modern government grew out of the differentiation of functions that were once exercised by the 'private' court and domanial administration of the kings or princes (Elias, 1982: 110). In the case of the visual arts, older functions of courtly patronage, art collecting and so forth were transferred to the bourgeois state which differentiated between those that were of public significance and those that were peculiar to the private inclinations of the monarch. The Civil List dating back to the last years of the seventeenth century is a part of this; it accelerated Parliament's containment of royal power by securing the distinction between the monarch's personal household needs, properties and so forth and the crown estates and by subjecting the monarch to budgetary control. The Civil List was a regular settlement which covered those revenues voted by Parliament to meet the expenses of the royal household and which were distinguished from the costs of government.

Adjustments to the allocation were a means by which Parliament domesticated a monarchy which still disposed over resources of political and cultural patronage and might still augment its power. British monarchy remade itself through the medium of a modernization which offered new possibilities for patronage and symbolic power. Royal expenditure was a source of tension when monarchs made excessive claims, used their revenue to buy favour within Parliament or to extend their patronage. It will be recalled that the King supported the RA with three assets: his symbolic power as the leader of Good Society, the financial support of the royal privy purse and the use of Somerset House in which the affairs of the Academy were to be conducted. The Civil List settlement entailed an exchange in which the King gave up his old palace of Somerset House to the government for rebuilding that would provide government offices. In exchange the King got Buckingham House. In striking the bargain he stipulated that provision be made for some professional societies that were under his patronage, including the Royal Academy, to have apartments. Thus, the Royal Academy was born out of a private initiative by George III and out of a moment in the differentiation of royal power within the field of the state. However, and I return to this point below, this was a fateful moment, for it saddled the bourgeois state with an obligation to find the RA accommodation should it require the space at Somerset House.

While monarchs continued to exercise older-style patronage, the pleasure and rewards of art patronage were progressively mediated by a web of art which enmeshed both monarchy and artists. The pleasures of art were a long way from those of the traditional patron let alone the potentate; their cultivation presupposed a collective action in which artists depended for their powers of expression, fame and fortune on lengthening circuits of cultural power. Occasional anecdotes about exhibition purchasers (for example, Lloyds the art dealers and Charles Galloway the collector) who famously gave up rights of purchase to Queen Victoria are indications of a circuit of value in which it is no longer clear who is ratifying whose taste and who is creating value other than the art world itself. That the two pictures in question (W. P. Frith's *Ramsgate Sands* of 1854 and Lady Elizabeth Butler's *Roll Call* of 1874) were widely reproduced as engravings confirms a sense of the density of the social relations of cultural production.

Modernity, we have seen, entails a division of labour of domination so that an effective dominant class must be capable of wielding different forms of domination concurrently and of recomposing itself in the face of shifting values of diverse forms of capital. Rubinstein showed that prior to 1832 the English elite was a 'harmonious connection between mercantile [and Imperial] wealth, City finance, land, the professions' and official corruption (Rubinstein, 1993: 142). The integrity of this class was secured through a dominant ideology woven out of Anglicanism, patriotism and allegiance to the throne and which found visual expression in what Steegman (1936) dubbed the Rule of Taste, and through whose certainties newcomers to economic power might be assimilated.

Artists depicted the heroic deaths of distinguished British soldiers and sailors such as Peirson, Wolfe, Nelson and Wellington; they promoted the notion of British literature in illustrations of Shakespeare and Milton; they defined British pursuits of hunting, racing, fishing and stock breeding and they serviced the needs for a middle-class domestic visual diet through ventures such as Charles Heath's *Keepsake Annuals*. In the years 1750 to 1830 it was partly through the industry of professional painters and fashionable engravers such as the Boydells, the Heaths and Charles Turner that the British way of life was made palpable and the notion of a coherent national historical past constructed. Painters were increasingly conscious of themselves as a distinct national school that might stand comparison with other European schools of art (West, 1990: 309–10), although they wait until the end of the nineteenth century for a gallery that was dedicated to their art, namely the Tate Gallery.

One newcomer was Robert Vernon, a successful businessman in the carriage trade who serviced the needs of early nineteenth-century London Society. Vernon was memorialized by the Victorians as a new art collector who belonged with John Sheepshanks to a generation of new collectors. Yet there are important differences between the two men and their styles as collector-donors and as new men of art. As Hamlyn (1993) shows,

Vernon's taste and life do not conform to the posthumous portrait of a Smilesean new man who eschewed the dealers and who collected art according to his own taste. Collecting was no doubt a medium through which Vernon, who modelled himself on Wellington (Macleod, 1996), transformed himself into a gentleman donor of art to the nation. Vernon's acts of collecting and donorship surely mark him as a man being drawn into the old elite, while Sheepshanks is quite different in specifying the destination of his gift as a non-trustee museum, namely the middle-class wing of its cultural apparatus at South Kensington.

Sheepshank's gift signifies a fracturing of power; after 1832 the unity of the British elite was disrupted through an industrial modernization which admitted a new centre of cultural power, the national art schools, into competition with the RA. Following a Select Committee of 1835 the government charged the Board of Trade with the task of creating a school of design and a museum that would meet the requirements of British industry. Dogged by doctrinal curricula disputes and subject to periodic reorganization, the Schools of Design had developed, by the 1860s, into a national system that provided teachers for 70,000 pupils and came to be known as The National Art Training School (Bell, 1963: 256). Through the 1840s and 1850s the shape of the curriculum was uncertain, for its future was balanced between the claims of the old and the new orders; between the aspirations of traditional humanists (such as Stafford Northcote), set on improving the taste of the masses, and middle-class reformists (especially Henry Cole) who targeted the requirements of industrial production.

The prize was the definition of art education and the conflict was a multi-polar one over who should know what and who should determine the curriculum of art training. There were industrialists who could not always see the practical relevance of the curriculum, pupils who were mystified by its abstraction, middle-class amateurs who sought access to the cultural capital of high art, women who found the schools prepared to receive them as students, the Royal Academy which was jealous of its teaching monopoly and the parsimonious industrial trainers who thought in terms of limiting the aspirations of pupils to trade. The role of the RA *vis-à-vis* the Schools (its members were recruited as directors and teachers) was a tendentious one, with some vocal RAs (especially Benjamin Haydon) vigorously proposing a full-blown academic training for artisans. By the 1850s, in concert with other outsiders to the establishment and carried along by the unexpected roller-coaster success of the Great Exhibition, Henry Cole had won the day to become General Superintendent of a new reformed department of the Board of Trade: the Department of Practical Art.

What were the limits of bourgeois reform? In the mid-nineteenth century the South Kensington outsiders to the cultural establishment, Henry Cole, Prince Albert and Henry Playfair, imagined an integrated official cultural centre that would embrace the National Gallery, professional societies,

museums and the RA. This the RA successfully resisted and it is this response, no doubt, that Morgan (1969) has in mind when he suggests that the RA 'lost an opportunity', that at some point in the 1870s its fortunes turned and it failed to placate its enemies. However, to focus on lost opportunities is to miss the structural processes that were transforming the field of power and which the RA could no longer contain, at least in the guise of an autonomous professional body. The RA's professionalizing trajectory through the space of the state created ambiguities that invited examination of the RA's role as a body servicing the nation.

In the 1850s one of the most obvious pressing problems was the location of the RA; an ostensibly private body occupied space in a public building that might be more properly allocated to the National Gallery. The problem, as Trodd (1997) shows, was articulated in the language of professions and markets; the ambiguity of the RA emerged discursively as the contested identity of a profession in the business of art. How could the business of art be reconciled with a monopoly which in limiting competition might appear to have its roots in Old Corruption? This situation made the RA a subject of successive public inquiries which were, in part, attempts to determine the historical origins of the RA's privileges and which recovered something of the eighteenth-century collective action that was the making of the profession.

The gestation of the professional artist presupposed a socialization of artistic production which, in the long run, tended to outrun professional control and to empower other commercial producers such as female artists, water-colourists and engravers as cultural critics. Modernization created new valencies between art and manufacturing and invited official examination of the RA's role as a professional body servicing the requirements of the nation. My argument is that from the 1830s the ambiguities of the RA emerged discursively through the strong classifications of a Victorian state which permitted the institution only one of two options: it could either follow the line of professional autonomy or integrate into the bourgeois state. It chose the former, for which strategy the monarchy was a necessary ally. At the beginning of the twentieth century one RA was led to conclude his history of the RA with three chapters identifying the natural enemies of the RA. And who was a friend?

> The Royal Academy happily still enjoys the favour of the Sovereign. The Sovereign is still the Head of the Institution, and to him its chief officers have yet the right of direct personal access.
>
> (Leslie, 1914: 281)

Mapping the Royal Academy

Reflexiveness is one of the keys to the subtle association between professional autonomy and the power of the modern British state. I shall demonstrate this relationship by examining a significant nineteenth-

century moment in the reproduction of the power of the *Royal* Academy.

One locus of professionalization was the Royal Academy of Arts (henceforth RA), an exhibiting and teaching body, which was instituted in 1768 (see Chapter 3). We have seen that George III provided accommodation at Somerset House and gave financial aid to the RA in its early years. Though not without its dangers,[2] this connection allowed the RA, especially from the 1830s, to escape direct control by the agencies of the bourgeois state. Indeed, Shee's response to those parliamentary radicals for whom the RA was a sign of 'Old Corruption' was both terse and pointed: 'The Royal Academicians, my Lord [John Russell], owe much to their sovereign, but nothing to their country.'[3]

The power of the RA developed in three respects. With its rituals of dining and private viewing, the RA and its Exhibition translated the status struggles of Victorian Society into the hierarchies of art. It was a strand in the institutional fabric of the Season through which the aristocratic identity of the upper class was secured within a developing capitalist society. With visitor numbers steadily climbing, the Exhibition proved a necessary professional hurdle for aspiring artists. Success provoked anxieties about the safety of exhibits when in 1822 and 1858 railings were installed to protect pictures. By 1885 they were more or less permanent features of an exhibition which had captured the interest of the middle class (Altick, 1978; Hutchison, 1968). The making of the middle class was dramatized by sensationally popular RA pictures. These were the so-called subject pictures which interpreted the modernity of Victorian life as the triumphs and anxieties of new worlds of public spaces and private domesticity, of enfranchisement and imperialism and of the crowd itself. Spectators flocked to see historical and narrative works at the RA, for example, Wilkie's *Chelsea Pensioners* (1822), *Derby Day* (W. P. Frith, 1858), and *The Roll Call* (Elizabeth Butler, 1874).

Second, the Academicians arrived as a British school worthy of collectors. Where the prevailing aristocratic taste had been for Old Masters there was now an emerging interest in British pictures. Gustave Waagen, Director of the Royal Gallery Berlin, made snapshot surveys of English collections in the 1830s and 1850s which show an aristocratic canon that is being challenged and a middle-class identity in the making. Following a first tour of Britain in the 1830s he had recorded the extensive holdings of Old Masters in country and metropolitan houses. In the 1850s he reports a growing catholicity as taste diversified beyond a restricted canon of Italian Old Masters. Some collectors had continued to cultivate the taste of the 'preceding period'; others had moved on to new tastes. Most significantly there was the growing recognition of the English School: 'among the larger and smaller collections of this kind which have been formed since 1835, I need only mention the following: That presented to the nation by Mr. Vernon, that of Mr. Sheepshanks, of Mr. Baring, of Lord Lansdowne, of Messrs Bicknell, Young, and Gibbons' (Waagen, 1854, vol. 1: 36). Through the bequests of Sheepshanks, Vernon

and others, an embryonic British art found its place among the acquisitions of the Science and Art Department at Marlborough House, a precursor to the South Kensington Museum.

The wealthy distinguished academician was a creature of Victorian social mobility. It was not just individuals but an occupational group that was recomposing itself and sloughing off its trade and craft associations. Diverse presidential styles are indicative of a trajectory that took PRAs into exalted circles: Sir Charles Eastlake, the official connoisseur at the National Gallery, Sir Frederick Grant, the country gentleman, and the patrician Lord Leighton who would hardly deign to deal with the print-seller. By the late nineteenth century the PRA was 'not only an artist but a courtier, not only an authority in the studio but a personable figure in society, a good public speaker, a man of urbane address and of general information and culture' (Escott, 1885: 309).

Third, the RAs were recruited to the officialdom that regulated public artworks, museums and art galleries and to state-sponsored schools of industrial design. As President, Charles Eastlake had four official positions: trustee of the National Gallery, trustee of the British Museum, trustee of the Soane Museum and trustee of the Atheneum Club. Other, personal appointments were Commissioner of the International Exhibition, member of the Portrait Gallery Commission and of the Committee for the Prince Consort Memorial. No other institution could challenge its authority. For a stormy period (1838–68) the RA shared premises with the National Gallery.

High art was central to a professionalization which engaged with the state and developed the RA's identity as a public institution. While RAs might advise the government on the status of the Elgin Marbles (Brewer, 1997) some looked for a less episodic association with officialdom. The Preface to *The Elements of Art* (1809), a poem by Martin Archer Shee RA, pleads the case for state patronage of historical art in the absence of private support. The earlier *Rhymes of Art*, in a third edition by 1809, directs the reader's gaze to the *Royal* Academy and the Exhibition's contribution to public taste.

> In yonder pile, by royal bounty plac'd
> The Graphic Muse maintains the throne of Taste
> Surveys again reviv'd, her ancient powers,
> And smiles as genius there unfolds her flowers.
> Though public favour still but feebly glows,
> And no fond care th' incumbered state bestows;
> Surprised she views in vigorous verdure rise,
> Th' exotic blooms that bless'd serener skies;
> And lays exulting, as the fruits refine,
> Her annual offering at the public shrine.
> Disdain it not, ye critics!
>
> (Shee, 1809: 12–13)

Nineteenth-century academicians were donor-contributers to public art; for example, the Chantrey Bequest and the Turner Bequest. Dulwich College Gallery was one such development. Dulwich, the first British public collection of art, was established when Francis Bourgeois RA (1756–1811), who had received an Old Master collection as a legacy from the art dealer Noel Desanfans (1745–1807), donated the works to Dulwich College where he had friends among the Fellows. The Gallery, opened in 1817, was closely associated with the RA, whose members had access to the pictures and borrowed them for study and shared convivial professional interests with the College (Waterfield, 1988).

Along with galleries, museums, industrial expositions and other artists' societies, the RA formed an exhibitionary complex of official and semi-official spaces (Bennett, 1995: 59–88). The story of how the RA moved from Somerset House to Trafalgar Square demonstrates the relationship between governmental rule and royal culture within the nation-state (Colley, 1996: 208–50).[4] The RA's first proper home at Somerset House resulted from the parliamentary deal that was struck over Crown lands and the income for George III's political and household expenses. It was from this arrangement that a government obligation to find premises for the RA arose. The relationship to monarchy was personal, labyrinthine and subtle; it required detailed explanation from Lord Farnborough that the post was not in his gift when, in 1830, George IV was all set to install his own noble president. One academic position, that of Treasurer, was made by the monarch, who, in addition to approving all other appointments, was referred to for consent in all important management matters.[5]

By the 1850s RA power ran deep into the developing cultural state. Academic authority was part of a distinctive pattern of class and state formation in Britain, where professionals, including artists, found legitimation through collaboration with state agencies. Along with other institutions, such as the aristocratic British Institution and the Old Watercolour Society, the RA was located within a web or *field* of interdependencies, conflicts and institutional associations that composed the art world.

The nineteenth-century field of art was configured and reconfigured through the medium of struggles for the prize of the monopoly of the power to define the categories of art and artist. The prize was consecration as the English School of Art, and it was this identity that the academicians, who were primarily oil painters, sought to monopolize through the privileges of royal association, fashionable social intercourse and the command of the growing middle-class art market. As the century progressed there were some doubts and uncertainties concerning academic privileges and especially so in relation to the management of the Exhibition. Other groups, such as water-colourists, asserted that their capacity to embody a tradition of 'national' art was ignored by the RA (Roget, 1891/1972: 125–31).

It is clearly the case that the RA wanted to 'speak' a national discourse as it looked to the monarchy for its privileges. National academies were concentrations of cultural power which triumphed within the field of art and through transactions with the field of power. The RA regulated the relationship between these different fields in order to generate, authenticate and monopolize cultural capital; but it was caught between the congealed traditions of aristocratic culture and the fluidity of commercial society. A hybrid institution, the RA looked in two directions: towards a field of power whose orderings permitted a residual estate habitus, where artistic identity was forged in the bonds of face-to-face relationships to patrons; and towards the heterogeneity of a marketized art world, where artistic identities proliferated in the impersonal spaces of free competition between individual economic agents. In the early nineteenth century the RA resolved these tensions through the authority of its annual Summer Exhibition.

Gender, water-colourists and the field of art

In recent years feminist research has deepened our understanding of the social construction of the artist by establishing the historical links between professionalization, sexual inequality and the visual arts (Chadwick, 1996; Cherry, 1993; Nunn, 1986, 1987). The identity of the artist-as-creator was partly produced through the aesthetic subordination of women who were excluded from or had only a partial access to the opportunities of metropolitan exhibiting societies. The categories which constituted the academic project, high art/low art, presupposed the exclusion of women from art's public spaces. Sexual inequality does not, of course, make its aesthetic debut in 1800 but it is clear that discourses of art and gender acquired a new intimacy, and that new priorities were established from the late eighteenth century (Parker and Pollock, 1981).

Subordination of women was intimately associated with the transition from a social order based on estates to one based on class, and this had profound consquences for discourses of creativity. Where, historically, the categories of high art had illuminated the power of patrons, they were now recontextualized and finessed to illuminate differences within the populations of nation-states (ethnicity, gender, age, class). In the case of women their creativity was increasingly normalized through a network of exhibitions and other public art institutions from which they were patently absent except as lady members or as amateurs.

Art had a contradictory relationship to this process in that it carried connotations of aristocratic and courtly excess whose regulation was at the heart of bourgeois identity (Elias, 1983). On the one hand there is the embourgeoisement of the aristocracy as it adopted middle-class mores of privacy and domesticity that gave priority to the regulation of consumption. In the eighteenth century William Hogarth had interpreted this impulse with his prints. On the other, through a diffusion and

finessing of aristocratic cultural codes of gentility, Good Society defined and hegemonized middle-class circles of power and privilege through a habitus of distinction which bore down heavily on females. Thus women were subordinated through a fusing of the compulsions of distinction, domestic morality and control: they experienced the dual effects of bourgeois ideals of feminity and exclusion from the art market – what has come to be called the ideology of the two spheres (Hall, 1992; Wolff, 1990).

The Victorian art world had two public portals; one permitted men access as professionals and the other women as amateurs. Women entered the public sphere as amateurs whose status flowed inevitably from their male kin. It is not that other identities did not circulate – there were women who lived off art and this had been so in the past. But where institutions ordered the identity of the male as professional they tended to disorder that of the female as professional. In this respect, of course, the rules of fine art exhibition colluded with the rules of property and Society in admitting women as dependants who could not properly earn a living from their art. These exhibitionary strategies were the actions of a gendered structuration of the upper class, which from the 1830s elaborated and finessed the rules of gentility as a means of regulating women and outsiders. Exhibitions, especially those of the RA and the water-colour societies, formed parts of the social round of the London Season.

The kaleidoscope world of water-colour reflects the exhibitionary dynamics of the field of art as a world in which creators competed for power and privilege. The art of water-colour had heterogeneous eighteenth-century origins in the practices of tinted drawing, surveying, topography, documentary illustration, antiquarianism, print-colouring and the profession of the drawing master with his female pupils. As water-colourists only, painters were lesser artists than those who specialized in oils and their art was limited by the patriarchal categories of the Academy. Regarded as little more than a kind of drawing by academicians and some connoisseurs, water-colour lacked a properly public status; artists who practised water-colour only were denied membership of the RA.

Though displayed by the RA, water-colours were poorly lit at the Exhibition and as an afterthought to the showing of oil paintings, which were given superior value within the academic hierarchy. Until the first water-colour society exhibitions of the early nineteenth century, water-colours lacked sympathetic public display. By the middle decades of the nineteenth century, water-colourists had coalesced as an exhibitionary force with which to be reckoned; they challenged the prerogatives of the RA and looked for professional association with the cultural state. This upward trajectory was linked to three changes which may be labelled as technique, subject and exhibition.

In the late eighteenth century some artists began to use water-colours to

achieve atmospheric and visionary effects that could not be realized in oils. Although some artists, and especially J. M. W. Turner, exploited both mediums, a distinct artistic subculture was formed. This consisted of a network of artists, patrons, theoreticians and entrepreneurs who promoted water-colour as an art rather than as mere technique. Apart from artists such as Turner, Cozens, Girtin, Pyne and the Varley brothers, key players included Thomas Monro (physician and patron) who sponsored an informal academy, and manufacturers (such as Reeves, Whately and others) who provided the products that were the art's trademark (pigments and paper). These developments were explained and promoted to a wider audience through the pages of a nascent art press and most notably so in the *Somerset House Gazette*.

Eighteenth-century modernization embraced economic, political and cultural changes which registered new attitudes towards land, permitted new ways of representing its value and undermined the hierarchies of the Academy. Among these was visual appreciation of land as landscape through the medium of romantic cultural practices such as tourism, writing and depiction. Where tourism had been a primarily aristocratic engagement with the sights of Europe, it was redirected to meet the vernacular needs of the bourgeoisie. Tourism and travel embraced practices of depiction bound up with the market for water-colours and with their amateur execution by the middle classes who recorded the places and sights they encountered. Celebrated artists such as J. M. W. Turner, Thomas Girtin, John Varley and William Pyne serviced the demand for views of nature. Uvedale Price and William Gilpin were among the connoisseurs who provided the theoretical basis for appreciating landscape as 'picturesque'.

The story of water-colours, 'the truly English art' (Redgrave and Redgrave, 1890), is one of how their medium came to connote a bourgeois national identity. It is, relatedly, one of how, in the wake of the RA, water-colourists followed a professionalizing exhibitionary strategy that gave their vision substance as cultural capital and allowed them a rapport with the developing cultural state. As interpreters of topography and landscape, water-colourists provided an iconography for the nation-state and gave substance to the imagined communities of England, Wales and Scotland. These developments emancipated landscape from academic tutelage and permitted its exploitation as a relatively autonomous art.

The changes that took water-colours from tinted drawings to full-blown paintings was driven partly by the struggle to stand exhibitionary comparison with oil painting. Here framing was a medium through which the authority of the artist as water-colourist was projected. Gold-mounted and gold-framed paintings conveyed the authority of the exhibition painting and competed with oils for the viewer's attention (Roget, 1891/1972: 109). Bayard captures the frame's function in regulating the interplay between the authority of the Season's fashionable and festive

exhibition and the authority of the artist as a creator: '[t]he exhibitions were meant to impress visitors first with the entire effect, and then upon close view to let them enjoy individual works' (Bayard, 1981: 32). Thus, if water-colourists interpreted the English landscape for the emerging middle classes, it was by means of their exhibitionary tactics which valorized their vision as an art that might challenge the RA's monopoly.

In the early years of the nineteenth century water-colourists instituted societies on a rising market. The politics of exhibitions were shaped by shifting balances of power between established professionals, amateurs and outsiders and by competition for talent between societies. The Society of Painters in Watercolours (often called the Old Water Colour Society) held its first exhibition in 1805; unlike the RA it was a joint-stock operation in which members shared in the profits. The Society's success encouraged the institution of a second more heterogeneous body in 1807, the New Society of Painters in Miniatures and Watercolours (later the Associated Painters in Watercolours) which permitted non-members to exhibit. The new Society's less exclusive policy was conceived as a challenge to the Old Water Colour Society's monopoly. However, this seems to have empowered amateurs *vis-à-vis* the professional members with the latter battling to keep control and eventually pushing through reforms that confined exhibition to members (Holme, 1906).

Competition between the two overtaxed the market and both ran into trouble. The Associated Painters foundered in 1812 and its assets were seized by the landlord of its exhibition rooms. When financial difficulties also threw the Old Water Colour Society into disarray in 1812 a reforming faction pulled away to institute a society which exhibited both oils and water-colours under the banner of the Oil and Watercolour Society. However, the admission of oils was soon diagnosed as the cause of further financial difficulties and the Society was renamed the Society of Painters in Watercolours (Royal Society from 1881). In 1807 the Associated Painters had responded to the exclusiveness of the Society of Painters. Again in 1831 another society, the New Society of Painters in Watercolours (later the Royal Institute of Painters in Watercolours) was established to meet the needs of outsiders and first exhibited in 1832.

These societies were divided partly by technique and developed different market specialisms: the more conservative Royal Society most concerned with landscapes, the Royal Institute with historical and literary subjects. The chequered histories of dissolution, repackaging and reconstitution that mark the water-colour societies are indications of the vagaries of the market and sometimes of water-colourists' failure to get the formulae right in competition with oil painters and their occasional need to forge alliances. None the less, by the middle of the nineteenth century water-colour had coalesced as a professional grouping of exhibitors and was, as we shall see, challenging the legislative power of the RA as oil painter.

Water-colour exhibitions were among the spaces at which the creative identities of women were anxiously glanced by male cultural authority. It is evident that some women did live off their art and that they serviced the artistic enterprises of men (as wives and mothers). Records of Royal Academy exhibitions show that, though in the minority, a growing number of women were getting their art into the public sphere. Some women were becoming artistic celebrities in their own right. Elizabeth Butler is well known, but there were others. In 1899 out of 1,192 RA exhibitors, 20 per cent were female.

One place at which this happened was the Dudley Gallery, founded in 1865 and 'from the first, a favourite resort of the ladies' (*Art Journal*, 1871). The Dudley was promoted by neither dealers nor professional societies but was managed by a committee of professionals and amateurs. Roget (1891/1972) informs us that it grew out of an experiment, managed by twenty-six artists and underwritten by 102 guarantors, at the Egyptian Hall in Piccadilly. Instituted as the General Exhibition, the Dudley was a key departure in three respects: (1) unlike the water-colour societies, exhibition was not confined to members, (2) unlike the RA, water-colours were well represented, and (3) it was receptive to women exhibitors. It quickly established a reputation as a place for their art and a feeder exhibition for other metropolitan exhibitions, and especially the water-colour shows. In 1882 the Institute of Watercolour Artists absorbed the Dudley management and launched a failed attempt to fuse with the Old Water Colour Society.

In the 1850s female artists pressed their claims for access to art institutions. And in 1857 women instituted their own exhibiting society – the Society of Female Artists – which gave hundreds of female exhibitors an annual opportunity to outflank the established societies. This development was inevitably associated with a sharp critical engagement in the press as male editors and critics confronted an apparently unnatural combination of women, art and commerce. Through the latter decades of the century art press reports became a subgenre in their own right. If the *Art Journal* is often among the more generous assessors, its authoritative voice sounds out from a discourse in which it is men who will most easily project themselves as creators: 'The flower and fruit painters ... are in themselves a host, and they reach almost without exception to such a fairly good average that individual criticism is scarcely called for' (*Art Journal*, 1870: 89).

At the heart of these politics were shifting balances of power within the field of art which drew different producers into competition and permitted exhibitionary alliances among patrons, water-colourists, oil painters and miniaturists. Artistic authority was never guaranteed; the water-colourist-as-artist appeared through the enabling and disabling associations of nineteenth-century stratification and sexual inequality. No doubt the drawing master status of many water-colourists provided opportunities for elite patronage. However, it also enmeshed them in the

world of the amateur and the amateur female from which the RA had distanced itself.

At first the Old Water Colour Society was almost exclusively male in membership and disallowed subjects in which females specialized. Women were admitted after 1820 in small numbers (Roget, 1891/1972: 552).[6] Between 1805 and 1820 there was of a total of 207 exhibitors at the Society of Painters in Watercolours/Painters in Oil and Watercolours. Twenty-three were females, two of whom, Byrne and Gouldsmith, were members. Yet they were ghettoized as amateur producers who could not be expected to live off their art, be burdened with official duties or be financially liable. Roget's history of the Old Water Colour Society indicates that women were not full members until 1889 (Roget, 1891/1972). In a patriarchal world where women made art and art serviced Good Society it was necessary to know what kind of women they were and what kind of art was being made. In particular there was the compulsion to categorize women in relation to their economic status as dependants.

Nineteenth-century water-colourists produced their identities through the medium of gendered relations of cultural power. By the middle decades of the century the Society of Painters in Watercolours was moving into a closer and authoritative association with the cultural state. Water-colour was represented at South Kensington and shown at the Paris Universal Exhibition of 1855. In the late 1850s there was a possibility that water-colorourists would benefit (partly through re-accommodation) from a reconfiguration of cultural institutions under the aegis of government. While the water-colourists failed to obtain any material advantage there can be little doubt that the actions of memorializing and propogandizing helped to raise the official profile of water-colourists as British artists.

The upward trajectory of water-colourists may well have been linked to constitutional changes that determined the position of women as associate members of the Society of Painters in Watercolour in 1860. Roget's history of the society indicates that this was the moment when the Society was 'setting its house in order' and twice refers to constitutional change as confirming women in a category to which 'they had always virtually belonged' (Roget, 1891/1972: 106; cf. p. 6). From 1850 females were listed separately in the catalogue and from 1860 reclassified as associate exhibitors (*ibid.*). Roget implies a previous indeterminacy in the status of female members. Thus in the decades when water-colourists were strengthening their links with the cultural state women seem to have had their subordinate status within water-colour societies confirmed.

For male artists, the spoils of bourgeois state formation were multiple; they included access to patrons via the mechanisms of Society, the opportunity to depict narratives of nation and morality in their art and the prize of consecration as a national school of art. These were the prizes that academicians, who were primarily oil painters, sought to monopolize

through the privileges of royal association, fashionable social intercourse and the command of the growing middle-class art market.

Official discourse of art

The growth of an art profession and the related expansion of the market placed strains on a centralized, congested and successful RA Summer Exhibition, this being controlled by a privileged elite of academician officers. Given that the RA had been born out of tensions between tradition and modernity, the friction associated with the Exhibition is not surprising. From the 1830s these tensions were exacerbated by industrialization, which opened up fissures within the field of power and created new balances of power which tended to fragment the elite. These changes led to a parliamentarization of cultural power (Elias and Dunning, 1986: 19–62) and the institution of official enquiry which empowered those marginalized by the RA (for example, engravers and water-colourists) to speak as 'cultural critics' of the Old Order.

From the 1830s the RA was wholly or partly the subject of official inquiries and of public interventions by reforming radicals. These include the *Select Committee on Arts and Manufactures* (1835–36); the *Report from the Select Committee on National Monuments and Works of Art* (1841); *Select Committee on the National Gallery* (1850); *Select Committee on the National Gallery* (1853); *The National Gallery Site Commission* (1857); the *Royal Commission Report on the Present Condition of the RA* (1863), and Edward Edwards' *The Administrative Economy of the Fine Arts in England* (1840). Edwards proposed reforms that would have amputated the exhibitionary function from academic teaching, professionalizing the RA as a central school with the support of public funds coupled to official inspection, and developing expertise in areas such as copyright. Among the dissidents who drew upon the Edwardsian paradigm, one forgotten figure is Thomas Skaife, a Liverpool miniaturist who appears to have exhibited at the Summer Exhibition between 1846 and 1852 (Plate 9). Skaife, who lampooned the Academy's sensitivities to public inquiry in his anti-RA pamphlet (Skaife, 1854),[7] found common cause with parliamentary radicals. Angry at the RA's rejection of his miniatures, in 1848 he challenged the RA's occupancy of the National Gallery (henceforth NG) in Trafalgar Square, queried the RA's charge for access to its Summer Exhibition in a public building, and drew heavily on the evidence given in Parliament.

The 1863 Royal Commission

Among the key divisions of the Victorian social order was the contested division between civic value and private need, and it was this that made

Plate 9 *A Chiel's Among You Takin' Notes.* Frontispiece illustration from *Exposé of the Royal Academy of Arts* by Thomas Skaife, 1854.

the Trafalgar Square location of the RA its Achilles' heel. The NG Select Committee of 1853 heard evidence that the trusteeship of Sir Charles Eastlake, who was also the President of the RA, gave him a conflict of interests. There were legitimate reasons for the RA sharing premises with the NG. However, in the 1850s and early 1860s, the placing of the RA at the NG was a privilege that required detailed explanation. The NG needed additional space. Might one or both institutions be transferred to South Kensington, or to Burlington House in Piccadilly? There was official recognition of an obligation to house the RA somewhere, but why was this the case? Such uncertainty attracted the attention of a second

wave of criticism by cultural commentators and parliamentary radicals, and resulted in the Royal Commission of 1863.

As early as 1850, the government, determined that the RA must be found new premises, suggested a move to Piccadilly. Short-lived and fragile administrations left the matter unresolved through this decade. The Derby administration accepted an obligation that, should the RA be required to move, new premises would be found at public expense. In 1859 it was proposed that a sum of £20,000 would be raised for the RA, this to contribute to building costs on its removal from the NG (Hutchison, 1968: 122).[8] Such was the context in which the 1863 Royal Commission sat down to deal with the RA. The Commission's remit was to:

> inquire into the present position of the RA in relation to the Fine Arts, and into the circumstances and conditions under which it occupies a portion of the NG, and to suggest some measures as may be required to render it more useful in promoting art and in improving and developing public taste.[9]

Seven Commissioners took evidence from over forty witnesses during five months of 1863 and reported in July with a volume running to 557 pages. The RA had repulsed the attacks of radical bourgeois critics of the 1830s and 1840s (Morgan, 1969: 410–20). This was the point of departure for the Report which cited plaudits by Robert Peel and Lord John Russell as evidence of the RA's public standing.[10] The overwhelmingly aristocratic and gentlemanly composition of the Commission should not be read as aristocratic survival but as contested modernization that brought a professional identity into focus and identified new models of occupational control and training. The Commissioners took evidence from Delebare Roberton Blaine (barrister and copyright expert) and J. Storrar MD (a member of the Medical Council) as to practices in other professions and were informed of the failure of the Medical Act of 1858 to secure lay recruitment to the Medical Council. From Richard Redgrave RA (Inspector-general of art schools at South Kensington) came an account of his institution's mode of training, and the Commission probed the possibility of an integrated training programme, with South Kensington feeding the Royal Academy schools.

The investigation penetrated deep into the RA: into its constitution and the legal status of the Instrument of Foundation; into its association with monarchy; into its composition (both categories and numbers of members); into the question of lay membership; into its government and finances; into relations with other exhibiting societies; into copyright and professional ethics; into the Summer Exhibition; into its teaching, and into its charities. It drew on a body of documentary evidence including statistics for revenue, expenditure and exhibition, a petition about the Exhibition from nearly eighty discontented outsider artists, official correspondence pertaining to the NG situation and other items. The subject of the building was paramount, for this pertained to politics and

political patronage. What was the RA doing in a public building? Did the exhibition space permit a proper assessment of national art? To whom did the Summer Exhibition belong: to the academicians or to the wider constituency of exhibitors, most of whom would never become members?

The prevailing opinion of the RAs, when pressed by the Commissioners, was that the RA was a private body exercising a public function. The rhetorics of public and private were important because they formed one of the conceptual spaces in which the value of the institution was measured. As Sir Charles Eastlake, the President of the RA, explained to the Commissioners, the RA was a public or national institution only in the sense that its objects were national. Commissioner Seymour clarified Eastlake's meaning: 'you only meant ... that it was instituted for the public good' (*Minutes*, Question (hereafter q.) 802). The academicians' evidence must have confirmed the Commissioners' sense of the need to clarify the RA's relationship with government. David Roberts stressed the difficulty of reconciling public status with 'taking shillings at the door'. The institution was, he claimed, more private than public (*Minutes*, qq. 1194–96). Edwin Landseer opined that indifferent rooms were all that the RA received in return for public service: well then let the government have a go at doing things better (*Minutes*, qq. 1318–20). For Daniel Maclise, the RA was 'a private institution doing ... a great public work' (*Minutes*, q. 1411). Richard Westmacott was frank: 'when we wish not to be interfered with we are private, when we want anything of the public we are public' (*Minutes*, q. 1909).

Among non-academicians, H. W. Phillips (portraitist, son of an RA and Honorary Secretary to the Artists' General Benevolent Institution) thought the Academy should be made into a properly public institution. Sir Coutts Lindsay detected conflicts of interest resulting from its constitution, while Lord Taunton saw dangers in bringing the RA under government. J. C. Robinson, an officer at South Kensington, thought the existing arrangement worked well, for it had created 'a professional aristocracy' (*Minutes* q. 4511). These matters were taken up by the Commissioners who probed the legal status of the Instrument of Foundation, which was the governing declaration made by George III in 1768. Monarchy was the key to the RA's ambiguity; the institutions had no direct relationship with government. The RA could disappear behind the aura of the throne at will; any attempt to make it a public body had to be sanctioned by monarchy. The Instrument of Foundation was, it transpired, a trust that was unobjectionable and enforceable in law. However, the Commissioners proposed the need for a Charter: this would give the RA a 'clear and definite public character instead of the anomalous and ambiguous position' that allowed it to determine the moments at which it was public or private.[11]

The Commissioners obtained information about the exhibition from Eastlake, who reported that most exhibitors were not RAs and that the majority of works submitted were rejected. The facts of submission,

acceptance and rejection at the exhibition raised issues concerning its management and selection practices, as well as the RA's capacity to act as a truly 'national-public' institution (*Minutes*, qq. 192–4).

The Commissioners judged that the RA was conducted honestly, but concluded that the demands of English art had outstripped its ability to satisfy them under its present constitution. Arrangements for display at the Summer Exhibition were generally sound, but the RA lacked the physical capacity to delineate the true range of contemporary English art. The arrangements and membership categories of the 1760s were inadequate for the 1860s and academicians retained exhibiting privileges that needed reform. On the subject of teaching, the Commissioners recommended the institution of a School Committee to deal with matters pertaining to the management, content and delivery of formal lectures. In addition, it was suggested that a salaried general director (not necessarily an academician) should act as superintendent, thus to overlook the production and reproduction of pedagogic regimes within the RA schools.

The Commissioners noted the hostility of artists to lay members but recommended they be adopted drawing on the model of the General Medical Council (Commissioner Lord Elcho had been associated with the Medical Act of 1858). Academicians were unhappy about a proposal for a new membership category of artist-craftsman. This was a response to evidence provided by A. J. Beresford Hope, the High Tory MP, writer on ecclesiastical and architectural matters, and collector of early Italian and Flemish painting (*Minutes,* qq. 4244–7). The Commissioners proposed that distinguished workmen in metal, stone or wood might receive honours from the RA. The RA response was the measured one that, if any benefit accrued, it could establish closer links with South Kensington on this matter.[12]

The Commission sought to determine how the profession of the artist should be constituted in a world where the received categories of public and private were chacterized by anomy. How might professional boundaries be determined when public and private were so interwoven at the institutional level? Training, lay control and public service were germane to professional autonomy and to professional boundaries, but the crucial matter was the state's relationship to the creative powers of the artist. For a few years, in the 1850s and early 1860s the RA was uncertainly subtended by two paradigms of professionalism; it might secure its independence at Piccadilly's Burlington House or, along with the National Gallery, it might be sucked into South Kensington. How it avoided the latter fate and how it retained its integrity testify to the subtlety of the profession–state relationship as it was worked out for and by RAs in the 1850s and 1860s.

Memory and record

In such situations, recording and regulating official memory is a process of generating, constituting and ordering information for the purpose of the

final report. It was customary for witnesses to be allowed to edit their
evidence; this may account for differences between contemporary
recollections of the 1835 to 1836 and 1853 Select Committees (Bell,
1959: 347–58).[13] At a sitting of the Select Committee of 1853, Lord Elcho
pressured a witness to soften his attack on Eastlake's performance as NG
Keeper (Skaife, 1854: 83–4). Elcho's case was that Eastlake was being
unnecessarily humiliated in a scandal about improper cleaning of pictures
and that it would be gentlemanly to spare him. It was this event, no doubt,
which encouraged Skaife to demonstrate the discrepancy between the
minutes of evidence and the Report, and to argue that there was a
conspiracy to keep scandalous events at the NG out of public view (Skaife,
1854: 44–7).

In 1863 an admission by Landseer revealed that the RAs had recently
discovered that they had no law against the admission of female students
to the schools. The discovery had emerged from the *cause célèbre* of a
woman, Laura Herford, who submitted a qualifying drawing with her
first name given as an initial. The drawing, explained Landseer with no
hint of irony, had therefore been favourably 'judged entirely on its own
merits' (*Minutes*, qq. 1006–7). That this was not pursued by the
Commissioners is unsurprising, although witnesses, for example, Blaine
and Robinson, proposed a limited female access to membership of the RA.
That it was not the only instance of academic ignorance about its own
laws raises the issue of amnesia and the implicit rules of institutional
action. A case arises from the 1863 Commission's attempt to clarify the
rules of election of associates to the RA, whose regulations required that
candidates resign from other metropolitan societies before offering
themselves for election. The RA consolidated its power partly by means
of strategies that marginalized artists other than the majority of successful
oil painters, sculptors and architects. A rule insisting that candidates for
membership of the RA withdraw from other societies was a means
controlling their access to the business of patronage. By the mid-
nineteenth century it was less clear that academicians had an exclusive
claim to represent the English School, as water-colourists and their allies
stated.[14]

The Commissioners explored the rule which compelled successful
artists to resign their membership of the major water-colour societies
before seeking election to the RA. The issue was important, for it could be
evidence that the RA did not represent the multiplicity of styles, genres
and media that comprised 'national art'. Eastlake informed the
Commission that water-colourists might be elected as associates of the
RA. Pressed on the matter, Eastlake's first reaction was to report that the
rule concerning resignation was not applied; in an oversight they had
forgotten to revise the law. Why then, Eastlake was asked, did last year's
exhibition catalogue publish the rule? Later, Eastlake converted an act of
discrimination into one of benevolence, claiming that the rule was
retained to please other societies (*Minutes*, q. 889).

David Roberts reported that, in practice, water-colourists were ineligible for election unless they turned to oils (*Minutes*, q. 1149). The water-colourists reported different and contradictory beliefs if not knowledge. Henry Warren, President of the New Society of Water-colourists, neither knew that the RA was open to water-colourists nor found it credible that the rule was a favour to other societies. The President of the Old Watercolour Society, Frederick Tayler, unaware that water-colourists were not constitutionally excluded from the RA, took the rule as a sign of its repressive nature. He went on to add that this indicated the RA's failure to recognize individual talent in its blind commitment to policing the divisions and hierarchies of art production: 'instead of recognizing the talent of the individual they [the academicians] confine honours to his particular mode of painting' (*Minutes*, q. 3735).

Tayler's observations, along with the confusions about the status of water-colourists, are indicators of the altered priorities that attended the autonomization of the field of art from the field of power. The early nineteenth-century RA had managed this process to its own advantage by developing practices that linked it with a range of aristocratic codes, systems and rituals. Tayler's evidence is important, for its assertion of autonomy is made in the name of an 'inferior' medium rather than the absolute authority of a particular institution. Professional freedom, then, is associated with the creativity of a vast multiplicity of artists; it is not generated by the regulations and systems of academic culture. This division between oil painters and water-colourists demonstrates that the divisions and conflicts within the Victorian art world were articulated through differentiated and unequal access to the field of power, which in turn determined forms of patronage and the process of professionalization.

Conclusion

Paradoxically, the RA's engagement with the forces of modernity favoured a closer identification with a monarchy that was also in flux. However, its trajectory through the field of the state gave rise to discursive tensions. In the middle decades of the nineteenth century the divisions of art, divisions between academicians, associate academicians, aspirant outsiders, other societies and institutions were articulated as four discourses of accountability. These divisionary articulations, projecting a vision of what the RA should be or should become, presented different images of its contradictory location within the force-field of the British state. These discourses were a fading radical bourgeois vision, a centralizing vision, a Chartist vision, and a royal vision.

The radical bourgeois vision had been associated with earlier figures like Joseph Hume and William Ewart, who fought a parliamentary campaign for free popular admission to the RA Exhibition and submission of the RA to parliamentary inspection. The radicals were

sympathetic to artist-dissidents and other malcontents who challenged the management of the Summer Exhibition. Their strategy was to connect professional discontent with a natural rights discourse, and thus to draw a distinction between the 'Toryism' of the RA and the liberalization processes associated with the modern industrial state. However, as we have seen, the Commissioners marginalized this discourse.

Among the centralizers, A. J. Beresford-Hope is a notable figure. Before the Commission he proposed the introduction of an artistic department of state under a cabinet minister who would be held in check by a central but independent body. The proposed body, he argued, would be an enlarged and strengthened RA to be located at the centre of an official arts administration, and thus clearly placed within the public sphere.

The Chartist vision, considered by the Royal Commission and recommended in its report, sought to reform the RA through the introduction of a Charter to act as a substitute for the Instrument of Foundation. The intention was to define the specific rights and duties of the RA, drawing its private business into the public realm. This was the key reformist element of the report, which recommended, among other things, widening the membership of the RA, broadening participation, reforming teaching and increasing the space: '[t]here is no subject ... on which the representations made to us have been more unanimous, or ... more justly founded, than the complaints of want of adequate space.'[15] The RAs did not demur; what separated them from others, however, was the answer to the question: Whose space is it?

The royal vision was much favoured by the academicians, which is not surprising as they guarded their direct relationship to the Queen (Hutchison, 1968: 120, 132). They conceded some proposals but resisted most, retaining the aura of association with the monarchy and securing the RA as a place beyond the rationalization associated with the state, which was seen as a centralizing agency.[16] The academicians went to the Commission with the resignation of those who felt that they had been over-audited and that auditors could have nothing new to learn. There was some anxiety that they might be put on 'a foreign footing'. Early in 1863 the Queen observed that she was not prepared to appoint the Royal Commission until the slate had the approval of Eastlake. She reported that, if the inquiry led to constitutional change, Eastlake and the principal members of the RA would leave (Eastlake, 1895, vol. 2: 167).

Some witnesses protested that official inquiry had become part of the normal politics of the RA. Landseer observed: '[e]very generation of 20 years there is an inquiry of this sort.' Maclise objected to a 'wretched suspicion in regard to the Academy' and to a constant repetition of questions by new generations of inquisitors. Maclise went on: 'during the whole of my career there has been a series of inquisitions as to its proceedings, which appear rather extraordinary to me, and the same thing happens over and over again. Even the questions that were answered 15 or 20 years ago crop up again' (*Minutes*, q. 1342).

Landseer and Maclise may or may not have been encouraged by Lord Elcho's suggestion that settling public disquiet might lead to a cessation of inquiries (*Minutes*, q. 1414). However, official inquiry was the price the RA had to pay for its autonomy and for its professionalizing trajectory through the field of state power. Inquiry (and thus knowledge) was at one with the broader impulse of a modernizing state whose panoptic gaze was turned on parts of itself. This was the price of professional autonomy. What is special about the RA is that its link to the state was refracted through the monarchy; its only answerable link to the state was beyond the reach of Parliament. The RA avoided integration into the bureaucratic bourgeois state by disappearing into the aura of monarchy. Despite its traditional faces, English upper-class power accommodated processes of modernization in which different categories of art were renegotiated throughout the nineteenth century.

The RA adroitly positioned itself as a private agency embodying civic characteristics and exercising public duties. The institution was more engaged with modernity than is allowed for by traditional stereotypes of academies. Institutions, such as the British Institution (1806), the Burlington Society (1857) and the Grosvenor Gallery (1877) were, of course, aristocratic interventions as the old order sought to recover itself on the terrains of the state and the art market; but in no sense do these amount to a rule of taste. The aristocracy was not free to rule in a world where the RA had consolidated its claim to be a national academy, and in which radical bourgeois elements sought to subordinate it and the NG to parliamentary power. Tradition did not sabotage modernity; modernity meant that at every turn tradition needed to think again.

Notes

1 See Whitley (1928: 226–8) on Kirby and this episode.
2 The association between the monarchy and the Academy was sometimes the site of suspicion and distrust. There was the latent possibility that disputes within the RA might be resolved by one party drawing the monarch into the fray – but at what cost? Such was the concern of Joseph Farington RA in 1804 when the deteriorating relationship between Benjamin West (President) and George III threatened to draw the King directly into the Academy's affairs. See Farington's Diary (Garlick and MacIntyre, 1978–), vol. 6: 2403. See also Whitley (1928: vol. 1, chapters 3 and 4). What is central here is the contradiction between the arbitrary nature of patronage and the institutional autonomy secured through the democratic election of academic officers. A quarter of a century later George IV is reported as considering the idea of changing the constitution of the RA with a view to installing a nobleman as president. Home Secretary Peel adroitly flattered the King out of the idea. As Peel pointed out, there were artistic appointments that fell within the King's gift – but the RA, although royal, was self-elected (see Whitley, 1930: 186–7).
3 Martin A. Shee, *A Letter to Lord John Russell (her Majesty's Principal Secretary of State for the Home Department on the Alleged Claim of the Public*

to be Admitted Gratis to the Exhibition of the Royal Academy (London, 1837),
p. 13. Shee was RA President from 1830 to 1850. An indication of convergence
between monarchy and RA is royal attendance at the institution's dinner:
'[b]efore May 3, 1851, the Crown had not been represented at the Royal
Academy dinner. It has seldom been unrepresented since' (T. H. S. Escott,
Social Transformations of the Victorian Age, London: Seeley, 1897), p. 350.

4 See also *Royal Academy, Position in Relation to Fine Arts, Royal Commission*,
Report, Minutes of Evidence, Earl Stanhope (1863) [3205], xxxv, iii, Minutes.
Appendix no. 17.

5 Whitley 1928, vol. 1: 250, Whitley, 1930: 186–7. From 1874 the Treasurer was
elected.

6 Thackeray's description of the Old Water Colour Society show as a place of
bishops, quakeresses, country squires and their families and pretty girls is well
known. In 1860 Emily and Ellen Hall (daughters of a retired officer of the
Dragoons) came up to London to see the Water Colour Society and especially
the work of Emily's tutor. Years later Emily visited the Institute of
Watercolours as an established exhibitor and confessed to the doorman that
membership was the summit of her ambition. The odds were stacked against
her (Mills, 1967).

7 A T. Skaife with a Liverpool location is listed as RA exhibitor in the years 1846
to 1852: A. Graves, *A Dictionary of Artists Who Have Exhibited Works in the
Principal London Exhibitions from 1760–1893*, 3rd edn (Bath, Kingsmead
Reprints), 1901/1970: 256. Joseph Sharples of the Walker Gallery Liverpool
kindly informs me that an F. Skaife is listed as exhibitor at the Liverpool
Academy for 1847 and that an A. Skaife showed at the same institution in
1860.

8 See also 1863, Royal Commission, *Minutes*, qq. 760–92.

9 The Parliamentary Papers include the RA's response to the Commissioners'
Report, 'Observations of the Members of the Royal Academy of Arts'. On the
Royal Commission see Robertson (1978: 351–3).

10 Royal Commission, *Report*, pp. iii–iv.

11 *Ibid.: Report*, vii.

12 Royal Commission, 'Observations of the members of the Royal Academy',
p. 7.

13 In 1863 Holman Hunt was permitted to revise his evidence with a footnote:
Royal Commission, q. 3042.

14 An indication of this is the display of English water-colours at the Paris
Exposition Universelle of 1855: Roget, 1891/1972: 89–90.

15 Royal Commission, *Report*, p. xiv.

16 'Observations of the members of the Royal Academy'. On the Charter the RAs
responded unambiguously: 'we are not prepared to ... surrender our present
Deed of Establishment.'

5

Art and reproduction: some aspects of the relations between painters and engravers in London, 1760 to 1850

This chapter concerns the situation of reproductive engravers during the late eighteenth and nineteenth centuries. In France and England engravers occupied an ambiguous position within the hierarchy of the fine arts. Early eighteenth-century writings on aesthetics provided some accommodation for engravers (Kristeller, 1951–52), but by the end of the century their situation was increasingly precarious. Engravers, although eligible for membership of the French Academy, could find their privileges questioned: 'If engravers have to be admitted to the Institute, then locksmiths will have to be admitted as well' (quoted in Adhémar, 1964: 231). In London, engravers were at first excluded by the Academy and then admitted as junior members.

In the nineteenth century the status of 'artist' was only reluctantly conferred on those who made their living from engraving.[1] The orthodoxies of fine art did not permit the engraver who personally worked the plate or block a publicly acknowledged creative role. At the same time there was a type of engraver, the reproductive engraver, who was able to assert a secondary but nevertheless publicly recognized claim to be creative. An issue which surfaced from time to time in the politics of art was the problem of the artistic status of reproductive engravers. Were they artists, or merely copyists? The Royal Academy of Arts recruited a handful of engravers, excluded them from the institution's government, denied engraving a place in the curriculum of its schools and was preeminently an academy run by and for painters.[2]

Before the development of half-tone photography in the 1880s engravers played a key role in supplying reproductions of paintings, helping to promote the reputations and fortunes of painters within a developing fine art market. Reproduction must not be conflated with photographic reproduction. Photography did not usher in the age of fine art reproduction. Photography appeared in a nineteenth-century art world already familiar with the idea of pictorial reproduction – reproduction through the agency of the handicraft printmaker (Plate 10). The effects of

Plate 10 An engraver's workshop depicted in an eighteenth-century trade card, 1726. Courtesy of Guildhall Library Collection of Trade Cards.

photography were experienced through its impact on the practice and perception of painting and on established means of graphic reproduction. Thus it was that photography came to be condemned as a 'foe to graphic art'!

The art of engraving was largely perceived as a reproductive art, particularly as a means for the reproduction of painted originals. Engraving was a 'language' in which painted originals were spoken after or about, a language which acknowledged (invenit, pinxit) that pictorial authority resided elsewhere and that the engraved image had a qualified status as a work of art. From the point of view of the living artist this was a matter of importance for his or her reputation and income. In 1822 the print publisher Hurst and Robinson agreed to pay Thomas Lawrence £3,000 a year for the exclusive right to engrave his paintings (Pye, 1845: 243–4). Later in the century Edwin Landseer was getting well over £2,000 and even £3,000 for individual copyrights, and was paid over £60,000 for copyrights by Henry Graves. The eighteenth- and nineteenth-century art trade thus developed partly as a trade in copyrights. Important here is the development of intellectual property with the copyright legislation of 1735 lobbied for by Hogarth. Copyright remained a focus for debate and pressure-group activity into the nineteenth century, particularly in the context of new methods of reproduction.

In the mid-nineteenth century there were thousands of people whose work brought them into intimate association with 'artists and men of science' (see *Report of the Census*, 1851: xcii). Among them were those engravers and copper-plate printers as well as (increasingly) lithographers and photographic workers who were occupied in scientific illustration and art reproduction. Engraving techniques had, of course, a wider

application: textile, ceramic, glass and banknote production, as well as ornamental and a variety of finishing trades, all made use of engravers. At the same time jobbing engravers served the routine needs of business, retail and fashionable society – contributing to the production of account books, trade cards, stock books, packaging illustrations, visiting cards, a variety of cheap illustrations and other ephemera. In 1851, 5,507 males were returned as engravers by the Census of Great Britain. For London the figure was 1,952. Among these was an elite of 'history' and 'landscape' engravers, people who had established independent reputations for their work in art reproduction and were in a different league from those belonging to the less artistic end of the trade.[3] None the less, they belonged to the world of trade and manual work, a world against which English fine artists had been insulating themselves since the early eighteenth century.

This chapter explores the roots of the ambiguous identity of engravers and assesses the changing situation of engravers within the relations of production of art. The experience of art, insofar as it was gained through encounters with reproductions of paintings, was inextricably bound up with two issues. One concerns the tension between the authorship of the painter and the 'translation' of the reproductive engraver. Here, there was an indeterminacy in the relationship between artist and engraver, which sometimes erupted into disagreement and conflict and which could also yield images whose authorial status was ambiguous. The second concerns the situation of engravers as a progressively submerged occupational group.

Two narratives are explored. One is the power struggle which took place between painters and engravers over the artistic status of engraving and its proper place within the Academy. Here at the level of professional politics we can see the foundation and consolidation of the Academy as evidence of the growing hegemony of the fine artist within an expanding art market. As we shall see, the concept of the artist received a clear affirmation when the Academy refused to change its policy on engraving in 1812. The second theme concerns the situation of the engraver within the context of the workshop and of technical change. Here it is a matter of the increasing isolation of the labour of reproductive engraving from the intellectual means of production. Throughout the eighteenth and nineteenth centuries the relationship between painters and engravers was nuanced by innovations in the techniques of reproduction and the organization of labour – innovations which were aimed at perfecting engraving's capacity to report the values of other media.[4] These developments were implicated in the transformation of the engraver's social identity and reputation as an 'artist'.

On the face of it, the struggle between painters and engravers was an attempt by the latter to improve their situation within the pantheon of the arts. However, the conflict had deeper resonances insofar as it led those who were dominant to define what they were about. Thus the

academicians' tactics in containing the demands of engravers led them to a consideration of what it meant to be a Royal Academy and what 1768 signified. Correspondingly, engravers elaborated their account of the history of the Academy and of the eighteenth-century events that had passed out of their control. Above all, what was at stake was the question of authorship in relation to the mass-production of art. While reproductive printmaking extended an artist's reputation, it did so through the translation, by another, of the work of art into a second medium – painting or drawing into printer's ink. Two things are important here: (1) the dominance of a fine arts ideology rooted in a way of seeing (Berger, 1972) that was endorsed by painting, particularly oil painting, and (2) the extent to which connoisseurship in painting was mediated through engraving.[5] What was at issue was the artistic status of pictures which might be dismissed as printed copies or which might yield a distinct connoisseurship insofar as they displayed the creative effects of more than one 'hand'. The story of the academic conflict between painters and engravers must therefore be set within the context of the struggle to determine the aesthetic possibilities created by nineteenth-century printmaking.

What is striking about the period under consideration is that few people – and Blake was one exception – took seriously the possibility that engraving, like painting, might be harnessed to original work. T. J. Clark, drawing on Marx and Engels' observations about Raphael and the structuring of talent, has called for an analysis of creativity which leads to 'a close description, of the class identity of the worker in question, and the ways in which this identity made certain ideological materials available and disguised others, made certain materials workable and others completely intractable, so that they stick out like sore thumbs, unassimilated' (Clark, 1974: 562). The case of nineteenth-century engraving begs such an analysis. There were, to be sure, artists who invested in printmaking the same kind of creative energy that others reserved for painting, but until the last part of the nineteenth century they did so against the odds.

The language of engraving

The printing both of literary texts and of paintings was linked to changes in the relationship between text and the concept of creativity. These changes were linked to cultural choices which cannot be taken as necessary effects of printing technology (Ginzburg, 1980: 16). In the case of printing we have (1) the fixing of the individuated author's sphere and the genesis of intellectual property; and (2) the sloughing off, from the text, of those attributes (such as voice, gesture and calligraphy) which are not conveyed by the press. Thus the question of the book as a physical object was marginalized in relation to matters that concern the literary text.

From the Renaissance on, the circulation of printed biographical records was one of the things that secured the enduring reputations of the Great Masters. Much the same point can be made about reproductive printmaking: that the 'exactly repeatable pictorial statement' (Ivins, 1953) was of decisive importance in Europe for the dissemination of knowledge about artists' pictorial achievements. However, while the origins of the artist go back to the fourteenth century, the first printed pictures did not make their appearance in Europe until the fifteenth century. By the middle of the century the woodcut and the engraving had become established as elements of pictorial culture.

Early sixteenth-century engravers evolved printmaking techniques that were capable of representing the world as it was evoked by the conventions of painting. In the seventeenth century the European engraving houses of Rubens, Callot and Bosse passed into a manufacturing phase, with workshops capable of organizing and supervising the labour of engraving. We know from the engraver George Vertue (1684–1756) and from Evelyn that painters did not care to become directly involved in engraving.[6] Where they did so, 'they usually made it clear that they were doing it for their personal amusement' (Gray, 1937: 24). In an imaginary conversation of 1736 the painter states that 'though a Painter, I have formerly pleasured my self at Times with the Practice of those two Arts [engraving and etching]'. The painter's partner in conversation, an engraver, has already conceded that the public image of his art is yoked to painting: 'we Engravers are pretty much Painters Copyists' (Atkinson, 1736: 1–2).

Engravers may have been copyists but, by modern standards, they took a surprising degree of licence in their copying. In fact they were more likely to say that they were translators than to concede that they were copyists. In this context connoisseurship might be sensible of an authorship other than that of the painting's artist – that of the painting's reproductive engraver. Meisal (1983) tells us that Dickens drew attention to this sense of pictorial displacement and that he was voicing a widely experienced, though unremarked, feeling. However, engravers talked about it. Along with Dickens, they took the view that the enjoyment of reproductions might flow from their skills in improving on a deficient original.

The author of *Sculptura Historico-Technica* (1770)[7] explains that the engraver may have to correct the rendering of hands and feet 'when he engraves from the Works of Painters or Designers, who were not perfect in this Branch' (p. 16). Even 'good Painters' may frequently leave certain matters 'to the Discretion of the Engraver' (p. 17). Strutt's biographical dictionary of engravers (1785) reflects on the accusation that engravers 'deserve not the name of artists' and are nothing more than copyists: 'What the poet has to do with respect to the idiom of the language, the engraver has also to perform in his translation, for so it may be called, of the original picture upon the copper' (Strutt, 1785: 5). This argument was a plank in the engravers' case against the Royal Academy and was sustained well into the photographic age – at least until the turn of the

century.[8] Questioned before the Royal Commission (1863) which was enquiring into the affairs of the Academy, the engraver George Doo opined that 'photography is incapable of correcting the faults of a picture, bad drawing, want of keeping, etc. but copies all the vicious with the good' (Royal Academy, 1863, 3205, xxvii, q. 2358).

In the art press, where discussion might be allied to reproductions, the critic might acknowledge not only the art of the painter but also that of the engraver. In considering an engraving after Turner's *Venice – The Dogona* published in the *Art Journal* of 1849, the critic pronounces:

> whatever contrary opinions prevail concerning Mr. Turner's pictures, there can be none as to the fact of their furnishing the engraver with magnificent material for his burin. When his colours are transferred to black and white, and his spots and dashes take form in the hands of a clever engraver, what an assemblage of beauty they present; one is astonished at the mass of matter contained in a single subject, a large portion of which is lost on the canvas, unless sought for by closest observation ... *it requires an engraver of more than ordinary talent to do justice to the production of Mr. Turner* inasmuch as he must often depend upon his own resources – his knowledge of the painting's intention, his skill in drawing, his perception of the mere ideal, independent of the capacity to follow such an artist through the varied, and often complicated treatment of his subject.
>
> (*Art Journal*, 1849: 260; my emphasis)

Painters often took a less sanguine view of engraved reproductions. While printmaking extended the artist's powers of communication it brought problems of aesthetic control and dependency. Sometimes scribbled in the margins of nineteenth-century art history are anecdotes concerning artists' anxieties over the fates of their designs and their disagreements with engravers. Turner had stormy relations with engravers, particularly over the production of his *Liber Studiorum*, and Landseer had to face complaints that his alteration of pictures at the proofing stage caused extra work. Rossetti found poetic parody an appropriate vehicle for expressing his feelings about the effects of wood-engraving on his art:

> O woodman spare that block
> O gash not anyhow!
> It took ten days by clock, I'd fain protect it now.
> *Chorus* – Wild laughter from the Dalziel Workshop.

George Du Maurier found a drawing was so badly engraved that he scarcely recognized it; John Leech once said to a friend who was admiring his work prior to engraving: 'Ah, wait till you see what it looks like in *Punch* next week.' Painters might come to favour the effects and interpretation offered by a particular engraver (e.g., Turner's encounter with the trembling John Pye: 'Are you the young man who engraved my picture? Well, I like it very much; it is one of the best that I have had done!' (Redgrave, 1891: 287–8). In some cases painters established a special relationship with an engraver, one of creative collaboration, in

which the artist supervised, directed and responded to the pictorial effects produced by the craftsman (e.g. John Constable and David Lucas).

Engraving, then, was the site of an aesthetic tension between artists and craftsmen. The effects of reproduction threatened to break through, challenge and even obscure the pictorial intentions of the artist, a possibility that was always latent in the antinomy of pinxit and sculpsit. Going on from Ivins, it seems likely that it was through photographic reproduction that the connection between the artist's intentions and the qualities of the medium in which they were expressed could first be widely experienced and demonstrated. However, while a knowledge of painting was mediated by the art of the handicraft reproductive engraver, the creative intention of the artist was exposed to the vagaries of another authorship and another language.

These aesthetic problems bore the inscription not only of technical innovation (by 1859 there were said to be 156 different reproductive techniques) but also of the struggle for cultural capital. The aesthetics of nineteenth-century reproduction (which were not culturally neutral) were structured in relation to new methods – lithography, wood-engraving, electro-typing, photography, etc. Technical change was linked to aspects of cultural stratification. New techniques were developed and appropriated according to a terracing of taste which was partly determined by the weight of middle-class demand for access to the fine arts; the middle-class 'battle to raise standards, to emulate the class above and differentiate themselves from the class below' (Ryder and Silver, 1970: 68).

The extension of the fine art market (partly through reproductions) was associated with new kinds of cultural capital and cultural anxiety. A paradigm case, one that speaks for the hegemonic character of an aristocratic and upper-middle-class aesthetic, is that of HEC of Bradford. Writing anonymously to the *Art Journal* in 1866 he (?) enlightens on the problems of impoverished taste: 'I am a clerk, and one of that class, who ... too often acquire tastes above their limited means. I visit Art-galleries, and examine ... the exhibitions in print sellers' windows, only, however, to sigh that some scintillation of genius cannot be transferred to my walls' (p. 351). It was in the context of this kind of class situation that popular guides to good taste flourished, encouraging their readers to locate themselves in an aesthetic hierarchy and to choose pictures that were both acceptable and within their means – perhaps not original works of art (which were the prerogative of the wealthy) but photographs and good wood-engravings rather than chromolithography (Eastlake, 1872). Moreover, the aesthetic possibilities of different processes were perceived through the medium of their class associations (Harris, 1969: 49–50).

Engravers and the Royal Academy of Arts

The Academy was established in 1768 following a petition to George III from twenty-two artists. Engravers, who could not be full members,

formed a junior corps of six associate engravers. As such they were excluded from participation in the Academy's government. This was underlined in 1813 when two engravers tried, unsuccessfully, to get sight of the Academy's minute books and were reminded 'that the government of the Academy exclusively belongs to the Academicians' (RA, *Council Minutes*, 2 February 1813, vol. 5: 18). Moreover, *qua* engraver, a person could not become a full RA.[9]

Engravers experienced the foundation of the Academy as a humiliation. The sources of their humiliation were in the development of a fine art politics from which they were progressively excluded and in the endorsement of a concept of creativity that eluded them altogether. The politics of the Academy's development and the situation of engravers were determined in relation to three aspects of cultural production: a residual craft tradition,[10] patronage, and the extension of bourgeois cultural and commercial interests within the domain of art. Eighteenth-century art institutions were, by comparison with the nineteenth century, aesthetically heterogeneous, and the divide between the arts and crafts was still in the process of being institutionally secured. The ambiguity of the engraver's identity speaks for a situation that was experienced as one of flux.

The key to the Academy's power is the way in which patronage, rooted in an agrarian capitalism, was imbricated with a developing bourgeois art market. Through the 1750s and 1760s the politics of art translated the tensions and accommodations between those artists relatively close to the Court and aristocratic patronage and those, not least engravers, who were more dependent on the market. Important here is the ideological weight of the bourgeoisie as a public with an antagonistic relationship to the ascriptive privileges of aristocratic culture. In the case of the fine arts, printmaking was central to the emergence of an art world which was an arena of public cultural exchange, debate and scholarship, one yielding the intellectual authority of its own professional practitioners – fine artists. None the less, the impact of patronage and attempts by wealthy connoisseurship and the monarchy to extend their influence over developing metropolitan art institutions persisted as features of art politics in the eighteenth and early nineteenth centuries. This sometimes threatened to fissure the professional art world in that patronage might find common cause with a particular faction. After all, it was precisely this configuration of patronage and market that had enabled the RA to establish itself as an exclusive and dominant artistic body.

In this context one strategy that was open to the engravers in their campaign to improve their lot was to seek the intervention of the monarch. The engraver John Landseer, in conversation with the powerful academician, Farington, indicated that an approach to the King might be dangerous: 'causing Academical matters to originate with the King' (Farington's diary, 6 May 1811; see Greig, 1922–28, vol. 6: 268). This would certainly have struck a chord with the diarist and may have been a veiled threat. Several years earlier a bitter struggle within the Academy

had, in Farington's estimation, threatened 'to throw all possible power over the Academy into the King's hands, viz: to supersede Elections & make the appointments of the Officers etc the King's nomination' (Farington's diary, quoted in Garlick and MacIntyre, 1979, vol. 6: 2403). Certainly engravers did attempt to advance their case through appeal to the monarch, and the tactics of the academicians may have had the effect of encouraging this. Thus in 1809 the Academy had ducked the whole question of engraving's artistic merits by responding to petitions with the argument that President and Council could not make fundamental changes in an institution originally authorized by the King. However, when, in 1812, the engravers played the royal card, the Academy responded, not in terms of the prerogatives of monarchy but in terms of the demands of art. In a sense the Academy was always as *royal* as it needed to be, always as royal as it was safe to be.

The hierarchical and oligarchical character of the Academy with its tendency towards closed orders of artistic practices bore the hallmark of an estate system of stratification, like that found in other occupational groupings such as medicine. These features were linked to the hegemonic principles of landed privilege and the gentleman. It was this association with aristocratic cultural power, along with the whiff of Old Corruption, that provided the terms of a radical bourgeois attack on the Academy in the 1830s.

Crucial here is the transformation of cultural politics within the context of parliamentary reform, a pressure for reform that was brought to bear on the Academy (which bourgeois radicals perceived both as a bastion of aristocratic and artistic privilege and as an obstacle to the pursuit of industry's artistic needs). A Select Committee was set up in 1835 to enquire into such matters and opened up questions of Academicians' accountability, their privileges, matters of art education, the affairs of the National Gallery and the claims of the engravers. Its report described the situation of engravers as 'extraordinary' (Royal Academy, 1836: 568, xi; Select Committee on Arts and Manufacturers, *Report*, pp. viii–ix). Parliamentary interest in the situation of engravers was renewed in 1844 with the Report of the Select Committee on the Art Unions: 'the interests of engraving ought to be considered; the alliance ought to be on a fair basis. She is not to be sacrificed to the interests of her elder sisters' (Royal Academy, 1845: vii; Select Committee on Art Unions, *Report*, p. xxxv).

What is important is the way in which the state endorsed the artistic claims of engravers (partly in relation to the moralizing influence of a mass-produced art) and accommodated a perception of engravers as victims of aristocratic privilege and Academic despotism. In this context engravers such as John Pye (as well as other artistic dissidents) came to play their part in a developing cultural politics. How did engravers experience their situation? What was their response? What were the terms within which the Academy defended its position?

The situation of the reproductive engravers within the Academy is to be

seen within the context of an eighteenth-century decline in their political power within the art world. The foundation of the RA had increased their institutional weakness and ensured their isolation from the key decision-making processes. Hogarth had suspected as much and resisted the idea of a Royal Academy. Moreover, the Academy threw engravers into disarray, generating ill-feeling between those prepared to accept what it offered in the way of membership and those who held out for something better. James Heath's decision to join the Academy in 1791 caused surprise and vexation among those who had 'spurned' membership on the grounds 'that it was injurious to the profession and degrading to the individual' (Raimbach, 1843: 19). The engraver Woollett is reported to have taxed one associate engraver with the query: 'Do they put you on a little stool when you go to their meetings?' (Royal Academy, 1836: 568, xi; Select Committee on Arts and Manufactures, Part 2, q. 1326). Gillray's satirical print *Shakespeare Sacrificed* (1789) captures the situation more graphically. It satirizes Boydell, the print publisher, and includes a depiction of a painter elbowing an engraver out of the way and into the edge of the picture.

Called to give evidence before the Select Committee on Arts and Manufactures, Pye was asked: 'Is it not an object of considerable ambition among engravers to be associates of the Royal Academy?' Pye, who ten years earlier had joined eight other engravers in a pledge not to become candidates for membership under the existing constitution, answered firmly that this was not so (Royal Academy, 1836: 568, xi). Abraham Raimbach wrote to Pye with congratulations for the 'manly, uncompromising spirit' of his evidence, and offered the advice that there was little point in pursuing the matter further with the Academy (Pye, n.d.: 28, Victoria and Albert Museum). He feared that any attempt to press the engravers' case 'might prove only a fruitless and additional act of self-humiliation' (*ibid.*).

Engravers challenged the academic laws that defined them as something less than artists. Their claim was (Landseer, 1807; Pye, 1845) that engraving was an intellectual activity, a form of translation.[11] As such, engravers demanded not equality, but a due and honourable recognition of what to their way of thinking was a creative vocation. The Academy resisted them on three grounds. First, questions concerning the Academy's constitution must ultimately be determined by the monarch. Second, the financial dependence of the Academy on its Summer Exhibition meant that there was a particular 'necessity for bringing forward original artists, who alone are capable of supplying sufficient novelty and interest to excite public attention'. Third, there were reasons of 'a more abstract and immutable nature':

> That all the Fine Arts have claims to admiration & encouragement, & honorable distinction, it would be superfluous to urge ... but, that these claims are not all equal has never been denied, & the relative preeminence

of the Arts has ever been estimated accordingly as they more or less abound
in those intellectual qualities of Invention and Composition, which
Painting, Sculpture and Architecture so eminently possess, but of which
Engraving is wholly devoid; its greatest praise consisting in translating with
as little loss as possible the beauties of these original Arts of Design.

(RA, *Council Minutes*, 30 December 1812, vol. 4: 396)

To admit engravers on equal terms would not be commensurate with 'the
dignity of the Royal Academy' and the nature of art.

The aesthetic integrity of the annual Exhibition was always a matter of
concern to the academicians and they were careful to exclude certain types
of object (e.g. needlework) which seem to have been freely admitted by
other, more aesthetically heterogeneous exhibiting societies. In 1813 to
1814 they are confirming the concept of original art: 'No Copy, with the
exception of paintings in Enamel & the Prints of Associate Engravers shall
be admitted' (RA, *Council Minutes*, vol. 5, pp. 94, 151). Up until 1854, the
only prints that could be exhibited at the Academy were those of the
associate engravers, and the conditions under which they were hung were
reckoned to be highly unfavourable (Pye, 1845: 245).

Engravers were denied originality. Crucial here is the vocabulary of
originality and the seventeenth- and eighteenth-century semantic shifts
which interiorized creation, establishing the artist as a creator possessed of
creativity. As Shils (1981) argues, originality was once 'a reminder of the
ineluctable dominion of the past over the present' – original sin, the burden
of a scribal culture that must seek out the authentic in the confusion of past
sources. 'Original' now comes to mean one who makes a cultural
difference, one whose art is accepted for display at the Exhibition as
'supplying sufficient novelty and interest to excite public attention'. In such
an exhibition there is a pressure to establish the inferiority of copies which
are separated from the origins of creativity but which, none the less, register
the aura of the original pictures which they reflect.

The campaign of the first half of the century must have seemed to be
getting somewhere when, in 1853, a new class of academician engraver
was created, into which Samuel Cousins was elected in 1855. The status of
the engraver was still not on a par with that of the painter.[12] It was not
until 1928 that the distinction between the two types of membership was
finally eliminated. By then the cultural power of the Academy was
weakening. Moreover, the role of the independent reproductive engraver
had been eliminated by photogravure machine-printing, and a new
concept of authorship (pioneered in the nineteenth century by Francis
Seymour Haden and his painter-etcher friends) had established itself in
printmaking under the authority of the original print.

Engravers: craftsmen or factorymen?

The Academy secured the promise of a professional identity for painters
and sanctioned the aesthetic subordination of engravers. The situation of

engravers was not, however, merely the effect of academic labelling. If the Academy emphasized the concept of an original artist and projected painters (along with sculptors and architects) as professionals, it is clear that engravers were heading in an altogether different direction. What the politics of the Academy effected was the endorsement of a process of class structuration within cultural production. There were three aspects to this. First, there were the professional painters whose artistic reputations were extended through printmaking. Second, there was the technical and entrepreneurial leadership, partly recruited from among engravers (e.g. the Boydells and the Heaths). Here we find engravers turning themselves into art directors, employing and directing others on the increasingly routine labour of engraving. Third, there was the proliferation of a class of depressed wage-earners, skilled and semi-skilled workers who were confined by the detailed labour of what was in effect art-manufacturing. As one guide to print collecting put it in 1844: 'The print is, in truth, not a work of individual art, but a manufacture' (Maberly, 1844: 163).

The story of engraving is the nineteenth-century one of a skilled trade 'threatened on every side by technological innovation and by the inrush of unskilled or juvenile labour' (Thompson, 1968: 269). Copper-plate engraving in the late eighteenth and early nineteenth centuries made increasing use of semi-skilled labour. The use of the tone processes (stipple, dot and mezzotint techniques) was associated with the fragmentation of production into separate detailed tasks and the genesis of a house style to which the creative energies of assistants were harnessed. Assistants specialized in engraving parts of the plate or were confined to specific stages of its production such as laying a mezzotint ground or punching holes for dotted prints.[13] Apprentices and journeymen could be forced into a dependence on their masters so that 'after labouring in their masters' studios for years, they were wholly incapable of carrying a plate through its various stages to completion; although skilled in the translation of "backgrounds", unapproachable in their "skies" or unrivalled in their "draperies"' (*Men of the Time*, 3rd edn, 1856: 644).

There were exceptional engravers who made reputations for themselves by avoiding the use of assistants. However, the economics of such reputations must have been increasingly difficult to sustain in the face of new methods of production. When produced by an independent engraver, plates could take many years to complete. William Sharp, the radical engraver, spoke of three years as the norm for line-engraving (Levis, 1912: 96), but some took much longer. Writing to Stewert Blacker (secretary to the Irish Art Union) in 1845, Richard Golding explains his slow progress on a plate that was to take a decade to complete: 'you know I am no factory-man and my window has the noonday sun on it; and though we can manage to etch with it, to grave is near to impossible for any continuance ... the plate will make but little way with me during the winter' (*Art Journal*, 1867, vol. 6: 8).

The independent engraver who was employed in illustrative or

reproductive work was threatened: 'such of them as aimed at executing the whole of a work with their own hands, soon discovered that they were unable to maintain their own families' (Pye, 1845: 372–3). For William Sharp (writing in 1810), there was an artistic price to be paid for these developments in that the labour of engraving now seemed to be separated from art. Assistants were employed who 'without any knowledge of drawing, or any Natural taste perform the greatest part of the labour' (Levis, 1912: 97). For Sharp's generation it was axiomatic that engravers must have some academic knowledge. Some reproductive engravers passed through the Academy schools,[14] although there seems to have been a decline in such admissions after 1800. Engravers exhibited their work at the Academy as well as at other exhibiting societies (Graves, 1901/1970). And eighteenth-century treatises extolled the virtues of a training in perspective and other artistic skills, skills that were required by the kind of artistic intervention referred to in *Sculptura Historica-Technica*.[15] But nineteenth-century workshop practice drove a wedge between intellect and the labour of engraving. Some masters clearly regarded any specialized academic training as an unnecessary interference in the workshop duties of their apprentices or else found it impossible to implement what was otherwise a 'good idea' (see Dalziel and Dalziel, 1901: 343; Raimbach, 1843: 17, 19).

By the mid-nineteenth century engravers were generally acknowledged to be a depressed group. We hear (1873) of the 'prison' labour of engraving; of Dicken's Pickpeck 'dot, dot dotting; first oppressed by the heat of the sun; then baked almost beyond endurance by the heat from his oil lamp'; of wood-engravers throwing away their patience and ingenuity on the reproduction of drawings – the 'reproduction of meaningless scrawl' (Morris, 1936, vol. 1: 333). In the late 1840s the *Art Journal* explains that it is 'employing twenty-eight line engravers, and ... twenty of the twenty-eight have no other work in "hand"' (*Art Journal*, 1847: 315). Elsewhere, a later report speaks of extinction: 'the art of steel engraving is dying out amongst us' (*Notes and Queries*, 1871, vol. 7: 510, col. 2). Thirty years on, Booth, speaking of the various branches of engraving, maintained that 'no other occupation had suffered more ... from the competition of new inventions and the change from ancient to modern methods' (Booth, 1903, vol. 4: 112).[16]

The key to this is the distinctive form of the relationship of engraving to the interests of a burgeoning art capital. *Pace* the Marx of the first volume of *Capital*, nineteenth-century engraving developed as a system of manufacturing based on handicraft skill. The integration of photographic methods into a means of mechanical production was not realized until the 1890s. It was the invention of dustgrain photogravure by Klic in 1875 and his collaboration with Samuel Fawcett, a calico engraver, which secured the development of rotary engraving in the 1890s with mechanical reproduction capable of 700 impressions an hour (Lilien, 1957: 16–19). The first steps towards photographic reproduction had, of course, been

taken much earlier. Niepce had researched the possibility of incorporating light-sensitive chemicals into handicraft reproduction in the 1820s; wood-engraving was using photographic methods of transfer by the 1840s; and in the second half of the century photogravure was turning engravers into finishing workers.

It is in this context that handicraft reproductive printmaking experienced the erosion of its independent craftsmanship.[17] The aesthetics of reproductive craftsmanship seemed threatened by sweating, and by photographic methods whose aesthetic values did not automatically declare themselves. The engravers' sense of decline was determined not only in relation to the art-politics of the Academy but also to their encounters with the middlemen of the print trade and the process of capital accumulation. Here it is important to stress the distinctive role of handicraft within the labour process. In the reproductive print trade, as elsewhere, skilled craftsmanship retained a relative autonomy as the foundation of manufacture, and constituted an obstacle to the process of capital accumulation. The relationship between art-craftsmanship and capital was a chronic source of misunderstanding, dishonesty and tension. The interests of independent engravers collided with those of capital, generating in various modes a sense of collective self-help which was partly fuelled by outrage at the Academy.[18]

At first silenced by the Royal Institution, the engraver John Landseer broke out into print with his *Lectures on the Art of Engraving* (1807), attacking the print entrepreneur Boydell: 'a man with talents too slender to support a reputation as an engraver' (p. 297). From a different aesthetic standpoint, Blake, in his 'Public Address' (1810) vented his anger against the individuals and practices associated with commercial engraving: 'Englishmen, rouze yourselves from the fatal Slumber into which Booksellers & Trading Dealers have thrown you, Under the artfully propagated pretence that a Translation or a Copy of any kind can be as honourable to a Nation as An Original' (Keynes, 1966: 595). John Pye is known to have refused co-operation with his employer on a plate when he discovered that he was to be one of several assistants. It appears that he managed to whip up the support of other assistants against Heath, their master. Raimbach records in his *Memoirs* how engravers resisted 'their (supposed) tyrannical employers ... with results highly favourable to the combinators' (Raimbach, 1843: 37).

In conclusion, it is necessary to point to the structuring of cultural identity, not one-sidedly through the terms of capital accumulation but also in terms of the language of engraving. Engravers fought back, but they did so on a terrain that was increasingly defined by a photographic way of seeing (Jussim, 1988). By the 1880s there were engravers who could deliver an Impressionist brush stroke. For the critic Hamerton, American wood-engraving was superior for its 'tone and texture' (Hamerton, 1882: 324). At the end of the nineteenth century American engravers were still associated with a discourse of reproduction which had not completely

submerged the authorship of reproductive craftsmen. Process reproduction could not interpret '[h]ow much of the beauty of these admirable cuts [wood engravings of Italian Old Masters] depends upon the temperament, the originality, the artistic skill, the "personal equation" ... of the man behind the graver' (*The Century*, 1890, vol. 18: 312).

Conclusion

Nineteenth-century reproductive printmaking is of interest for at least three reasons. First, the conflict between painters and engravers can be seen as one aspect of the process whereby the notion of creativity as an effect of a unitary intelligence gained cultural supremacy. What was at stake was the dissemination of the idea of the artist as expressing the free-play of a coherent creative will, one to which pictorial means and materials were subordinated. Such a notion of the artist-as-creator is central to the discourse of contemporary art history (Pollock, 1980), but for much of the nineteenth century the means of fine art reproduction was the site of an aesthetic tension which threatened the complete pictorial authority of artists. During their heyday craftsmen-engravers were agents in extending the reputations of fine artists. However, the hand of the engraver was an obstacle to the unqualified extension of a charismatic ideology: 'the ideology of creation which makes the author the first and last source of the value of his work' (Bourdieu, 1993: 76).

Second, the exploitation of the market for fine art prints was associated with the separation of engravers from the intellectual means of production. The process of capital accumulation within cultural production endorsed and accentuated the difference between the artist and the craftsman that had been ushered in by the Renaissance. The consumption of fine art prints increasingly presupposed a division between mental and manual labour that was internal to pictorial production. Here was the artistic parallel of the industrial revolution. The preferences and tastes of the new social groups, including the middle and working classes, were interpreted and shaped through a culture industry that unleashed new artistic powers. Here was a world with its own capitalists, its own people of genius and its own workers, a world that knew technological unemployment and labour unrest. At the same time few areas expressed modernity more poignantly and sharply.

Finally, engravers registered their responses to modernization and to the fragmentation that attended the culture industry. One response was the epitaph recorded by the wood-engravers George and Edward Dalziel in 1901 as they faced up to modernity:

> When we think ... of the vast mass of wonderful illustration given to the public, week by week, of every conceivable class of subject, direct from the camera ... we feel our occupation is gone.

Others, as we have seen, squared up to modernization with an alternative vision of history.

Notes

1 In Mark Rutherford's (W. H. White) *Clara Hopgood*, Frederick Dennis is a wood-engraver who 'preferred to call himself, an artist'. Dennis is drawn from the real-life wood-engraver W. J. Linton (Smith, 1973). Late-nineteenth-century biographers, memorialists, etc. stereotype engravers in relation to those of painters. The former are 'stay-at-homes', have 'less of "incident"' in their lives, and can be associated with the ridiculous. See the description of John Landseer in E. M. Ward (1924): 'a queer old fogey, who evidently had never mixed in good society ... I used to watch him ... carrying his dinner (tied up in a brilliant red pocket-handkerchief)' (p. 7). A meeting at the Royal Academy was reduced to laughter by the suggestion that a monument be erected in Westminster Abbey to the memory of the engraver Woollett (Hazlitt, 1830: 66). In fact a memorial was erected and inscribed 'Incisor Excellentissimus'. His tombstone is said to have been embellished with a less elevated message:

> Here Woollett rests, expecting to be saved;
> He graved well, but is not well engraved.
> (Bryan's *Dictionary of Painters and Engravers*, 1915, vol. 5: 394)

2 Between 1768 and 1904 there were 233 Royal Academicians: 170 painters, 31 sculptors, 26 architects, 5 engravers and 1 painter-etcher (Hodgson and Eaton, 1905).

3 Some reproductive engravers passed from adjacent branches to fine art work (the young Charles Warren (1767–1823) worked as an engraver for calico printers and gunsmiths), but this seems to have been unusual. Technical developments in fine art work drew on other branches of engraving. Warren adapted techniques used in Birmingham for the manufacture of ornamental snuffers for use in steel-plate engraving (Society of Arts, *Transactions*, 1823, vol. 41: 89); and the development of photogravure machine-printing at the end of the century involved Samuel Fawcett, an engraver employed by a calico-printer (Lilien, 1957: 16–17).

4 There are many books which provide a guide to printmaking techniques, including engraving. See e.g. Dawson, 1981. See also Harris, 1968, 1969, 1970.

5 Malraux asks: What prior to 1900 had connoisseurs seen? 'They had visited two or three galleries, and seen reproductions of a handful of the masterpieces of European art; most of their readers had seen even less' (Malraux, 1954: 15–16).

6 Evelyn lamented the reluctance of painters to take up engraving (Evelyn, 1905: 162). In the eighteenth century the engraver Vertue noted that as soon as engravers got started in painting or sculpture they ignored their first calling: 'at present this Mr. Toucher seems to be an instant of it when he alwayes declared himself since he came to England to be painter delineator. Architect & etc cetera, etc. But never said he was educated to Engraving that poor laborious stupid practice. thot. fitt for none but groveling spirits who could bear study hard labour & slavery' (The Walpole Society, XXII (1933–4): 119). This is the context of the observation that the eighteenth-century illustrator Gravelot was a 'designer but could not engrave. He etched a great deal in what is called the manner of Painters etchings, but he did not know how to handle the graver' (quoted from Farington's Diary in Godfrey, 1978: 37).

7 *Sculptura Historico-Technica* (*SHT*) is central to any appreciation of the lineage of English books about engraving (see Levis, 1912: 17–40). Four editions were published, the last in 1770. The *Universal Magazine* (October 1748) published a piece promoting the art of engraving where whole passages are 'lifted' from *SHT*.

8 See Godfrey (1978) on Stubbs (p. 57), and also (p. 74) for the metaphor of 'executive musician'. 'The mezzotint engraver translates the picture as it were into a new language' (Cyril Davenport, *Mezzotints*, 1904: 39). See also F. Vacher, *Engravers and Engraving* (Birkenhead Literary and Scientific Society, Session xxxi, 1887–88): 'In engraving, and engraving alone, is there presented a solution to this difficult problem – how to make the creations of the great masters accessible to the multitude' (pp. 6–7). For a discussion of reproduction and the persistence of the idea that reproductive engraving was 'creative interpretation' see Fawcett, 1982: 9–16.

9 The Academy's view that engravers were isolated from the virtues of original art corresponds to the obstacles encountered by those who tried to develop their art in ways that denied the distinction between artist and engraver. There is James Ward (1769–1859), a successful engraver who wanted to remake his reputation as a painter (Fussell, 1974: 79–80). There is evidence that artists with a whiff of the engraver's shop about them encountered academic discrimination. John Linnell may have been a victim (Story, 1892, vol. 2: 167). And the diarist and academician Joseph Farington records (1811) that William Daniell was thought unfit for election as an RA because he spent so much time engraving in aqua-tinta (Farington's diary, 10 February 1811; Greig, 1922–8, vol. 6: 238).

10 Nineteenth-century chroniclers of the Academy perceived aspects of its early craft membership as anomalous, or as requiring special explanation. See Edward Edwards (1808) and William Sandby (1862) on the engraver Bartolozzi and Catton the coach-painter. See also David Robertson (1978) on the ambiguous, though rising, status of academicians at mid-century: 'the Academicians had not quite arrived. Roughly a third of them were the sons of artisans or tradesmen; another third were the sons of artists or architects, likewise moving upward ... from the strata of men who took cash payment from their customers' (p. 113). Guizot was impressed in 1840 at an Academy dinner by the contrast with the City: 'The Company bore no closer resemblance to the dinner at the Mansion House than did the manners or the locality. They represented the aristocracy of England rather than the citizens of London; the aristocracy of all parties, and the philosophers, scholars and artists, receiving and received by them in the Palace of the Arts, with reciprocating dignity' (Guizot, 1862: 119).

11 Landseer, 1807: 177–8. Landseer argued that (1) the Academy should have four engravers of the rank of Royal Academician and (2) there should be a professorship of engraving (pp. 317–18). John Pye (1845: 208) quotes the following address to the Academy:

Pope, and Cowper, and Dryden, and Schlegel, have appropriated to themselves some of the laurels of their originals, and have never lost caste by their noble diligence. Intellectuality can never be denied to the translator, though inspiration certainly may. The extreme expression and intolerant opinion as to 'the physical and moral disability' of the

translators of the productions of the inspired members of the Royal Academy is, it may be presumed, applied in this sense only to engravers.

12 Report of the Royal Commission appointed to enquire into the Royal Academy (Royal Academy, 1863: 3205, xxvii: 'Even at present they [engravers] do not appear to be regarded as full Academicians... We can see no just ground for their still forming any separate class...' (p. xii).

13 The diary of the engraver Charles Turner records the employment of assistants. On 3 January 1800 Turner paid a Mr Frayling 12 shillings for three days' work and two years later the same man was paid £1 'for laying a head size ground'. A Mr Gathard was paid a guinea for three days' work in February 1800 (see Whitman, 1907). See William Blake's 'Public Address' (1810: 594): 'Wooletts best works were Etch'd by Jack Brown. Woolett Etch'd very bad himself. Strange's Prints were, when l knew him, all done by Aliamet & his french journeymen whose names l forget.' See Farington's dairy for 18 July 1816 and 10 January 1818. Farington reports (1) that many engravers have employed the services of an etcher called Tegg, and (2) John Landseer's deception in employing an assistant when 'the Drawings were given to Him to engrave expressly upon condition that the plates were to be the work of His own hand only' (Greig, 1922–28, vol. 8: 83, 162).

14 The following figures for the years 1770 to 1829 are compiled from Hutchison (1962) which reprints Royal Academy records of student admissions. In the five years 1770 to 1774, engravers made up 4.6 per cent of admissions to the Royal Academy schools. For succeeding quinquennia the figures are: 1775–79: 15 per cent; 1780–84: 23 per cent; 1785–89: 19 per cent; 1790–94: 17 per cent; 1795–99: 20 per cent; 1800–04: 4 per cent (no admissions 1804); 1805–09: 11 per cent; 1810–14: 6 per cent; 1815–19: 5 per cent; 1820–24: 5 per cent; 1825–29: 5 per cent.

15 See R. Campbell, *The London Tradesman* (1747: 113–14); the *Universal Magazine* (1748: 179); *Sculptura Historico-Technica* (1770: 15–17).

16 For further information on the situation of lithographers and wood-engravers in the nineteenth century see the Webb Trade Union Collection, Printing and Paper Trades (Coll. E Sect. A XXIX) at the Library of the London School of Economics and Political Science. There is a report of a wood-engravers' meeting (1891) to discuss means of protecting their wages, their health and the quality of wood-engraving (vol. XXIX, part 4, p. 354). The material concerning lithographers has much to tell us about art institutions other than those normally thought of as belonging to the domain of fine art. See e.g. the report of the London Lithographic Artists club and art class (vol. XXIX, part 4, p. 180).

17 Two aspects of the structure of fine art capitalism are worthy of comment here. First, the organization of the engraving trade displayed London's characteristic subdivision of skilled work 'within the shell of small-scale production' and in association with a dispersed means of production (Jones, 1976: 30–2). In the case of wood-engraving in the 1880s W.J. Linton reckoned that a craftsman could be equipped for 25/-. In 1841 the cost of steel plates started at 2/6d, gravers at 3d, and mezzotint rocking-tools cost between 5/- and 40/-. (For these and other prices see Fielding, 1841: 110.) Second, there was the development of a relatively large-scale art capitalism in the form of print-publishing enterprises.

18 See Levis (1912: 95–9) for evidence concerning the collective activities of

engravers in the early 1800s, also Pye (1845: 311–400), and Fox (1976). Academic discrimination as well as market situation encouraged engravers to think of themselves as engravers and to consider organizing to defend their interests. Two schemes, the first initiated in 1788 and the second in 1802, seem to have foundered. William Sharp argued in 1810 that the world of engraving was too fragmented to sustain the common purpose of a society: it was impossible to reconcile the differences of style, technique, skill and interest that had been generated by the print trade. See Levis (1912) and Farington's diary, 4 July 1810 (Greig, 1922–28, vol. 6: 64), on Sharp's misgivings.

6

Art classification and rituals of power: the resurgence of etching

A number of scholars have developed Malraux's (1954) original argument that the grand narratives of Western art were less revelations of truth by the museum than effects of its discursive weight on the constitution of objects (Crimp, 1993; Duncan and Wallach, 1980; Negrin, 1993). In *Making and Effacing Art* (1991), Philip Fisher argues that there is a complicity between art museums and modernization which is obscured by the prevailing romantic ideology of creation. The ideology is the received idea that art is the last refuge of a once ubiquitous artisan mode which, under attack from industrial capitalism, has retreated into the museum. It appears that the museum and the factory are worlds apart. Fisher, however, shows that the museum has an affinity with industrial capitalism; both are universalizing impulses which transcend the local and the particular. The factory turns out artefacts according to the principles of mass-production while the museum orders the objects of diverse local places and times in terms of the universal principles of knowledge.

In one of Fisher's most memorable passages we accompany the legendary dead warrior's fine sword of battle as it is taken in combat and as it passes into the ceremonial world of priestly ritual. Later, following defeat in battle it is looted and becomes the treasure of the victors. Finally, the sword is transferred to a museum and 'resocialized' in a world of ethnographic artefacts. Once valued as the crafted asset of a warrior, later venerated as a cult object, the sword is reborn as an exhibit that indicates the style of the organic culture of a people from which it came.

The sword story is an appreciation of how museums recontextualize artefacts and parade them as grand narratives of art and artefact. The museum, so Fisher argues, effaces the traces of artefacts' original contexts in favour of the universal message of art, just as the universalizing impulse of modern communication may transcend local cultures. Whether it is the factory floor or the floor of a museum, artefacts are ordered as series according to a developmental principle: the improved automobile model and the latest instance of an artist's style are located according to a shared disposition that these are elements within a series.

Fisher's museums are dream worlds or anti-worlds to the factory. While the latter source the flows that take mass-produced artefacts from

new usefulness to obsolescence, the former receive artefacts which are worthy of preservation and must be made to endure. Museums are time-machines in the sense that they preserve things against the degradations of time. In a world that has routinized obsolescence, the museum conscecrates the handicrafted making of things: tribal artefacts and abstract paintings are among the objects that it will readily admit subject to their resocialization as handmade things.

In consecrating the act of making, the museum institutionalizes objects which are at odds with craftsmanship's idea of the masterpiece as a finished object that conceals its making. The museum, suggests Fisher, sanctions a new kind of masterpiece, for it receives works (such as those of modern artists) which, in being original, display the signs of their making. In medieval times the masterpiece was a complete, finished artisanal product whose making was shrouded in the mystery of the guild and regulated according to custom. By the eighteenth century, when the modern system of the arts matured, the masterpiece was an original which outlived its maker. The aura of the trade or craft mystery was gradually displaced by the aura of originality. Where making was once a trade secret it came in the twentieth century to be publicly displayed in the marks left on canvas and stone by brushes and chisels. Fisher asks: '[T]o what extent is an art system that is driven by the requirement of originality inevitably driven to produce works with less and less artisanal quality?' (Fisher, 1991: 178). The artefacts of modern art which enter the museum reveal their making and assert the authority of the artist in a way that is radically discontinuous with the traditions of craftsmanship. Rather than displaying finish, the modern work of art shows spontaneity in the signs of its making.

Fisher argues that making was once secret to the guild so that the 'final surface' of objects gave the viewer no inkling as to process. However, by the late nineteenth century this ideology of the 'licked surface' (Rosen and Zirner, 1984) was in crisis, increasingly unable to contain the claims of the 'unfinished' to stand as works of art (Boime, 1971). Modernization decanted the trade secrets into the public sphere and the invention of the museum was part of that process of making art public. However, in this very moment of making art public the canonical work, the masterpiece, changed its spots.

Fisher complements other, sociological studies of the art–craft distinction. Bourdieu and Darbel (1991) show us that in sanctioning the art–crafts division the museum is sanctioning inequality, for what is at stake is the social distribution of the codes required to read the surfaces of museum artefacts as art. The museum's resocialization of objects presupposes the visitor's investment in the cultural capital required for reading them as works of art. Becker (1982), as we have seen, argues that the difference between art and craft is socially constructed and shows how, in art worlds, the artisan may be sucked into the orbit of the artist-as-creator. Following on from Becker, my argument is that in saying that

originality has driven out craft, Fisher captures one aspect of the art–craft relations because craft has also serviced originality through the secrets of the museum.

The spatial arguments of the modern museum are central to the production of art's meanings in contemporary societies (Duncan and Wallach, 1980; Fisher, 1991). In this century the presentation of art has been subject to innovations in conservation, framing, spacing and arrangement that brought the identity of the artist-as-creator into focus: '[t]he organic art of space was to make for the museum a total work of art' (Holst, 1976: 288). The management of space transmuted looking into 'a trance uniting spectator and masterpiece' (Bazin, 1968: 265) but did so in terms that stratified art, insulating masterpieces from other pictures (*ibid.*; Holst, 1976: 285–6). The museum materialized art history as the measure of the difference that an artist has made to art. The meaning of an image, insofar as it had been captured by the museum, took on the historical colouring of its place in the descent of periods and styles.

When Fisher asks if it is inevitable that the originality of the artist drives out the artisan, he might also have asked: To what extent does originality presuppose the services of the artisan? For example, the crafts of museum display and restoration or of fine art reproduction. Fisher's argument can be given a more radical twist by suggesting that the artist–artisan relationship is more polyvalent than he implies. There is a labour in achieving spontaneity; the modern artist may work no less hard at the signs of spontaneity than the academic artist worked at finish. However, that labour is not necessarily the labour of the artist.

The print as manufacture and art

I turn to printmaking as a topic that illuminates the issues which Fisher considers. There are several reasons for doing this. First, the development of print-collecting has much in common with museums as a mode of comprehensive rationalization that attempts to order the heterogeneity of the world. As Negrin (1993) observes, the project of the museum has its parallels in the stamp album and the encyclopedia. Museums, such as the British Museum, the Victoria and Albert and the Metropolitan, do of course have print departments. However, print-collecting represents an extension of the museum's impulse to ordering and preservation, as is clearly evident from the eighteenth century (Richardson, 1773; Strutt, 1785).

Preservation and ordering within series are as much a part of the print-collector's world as that of the museum curator. Comprehensive print-collecting by artists and connoisseurs was well established by the eighteenth century; it was one modality through which aristocratic distinction in art was converted into cultural capital. We hear of the discriminating eighteenth-century French amateur who 'has a collection [of prints] in his study':

he goes through them with a secret pleasure unknown to men without discernment, sometimes admiring the boldness and power with which the great masters have handled the burin, sometimes enjoying the discovery of the original work beneath a subsequent correction.

(Adhemar, 1964: 230).

In England authorities such as *Sculptura Historico-Technica* (1770), Richardson (1773), Strutt (1785), Caulfield (1814), Cumberland (1827), Fielding (1841) and Maberly (1844) set out the principles of collecting and connoisseurship, advised on cataloguing and classification, dwelt on issues of authenticity and originality and advised those amateurs who found themselves confused by changing technologies.

Second, the nineteenth-century print was, as we have seen, at the intersection of manufacturing and art (see Chapter 5). Print-publishers belonged to a commercial configuration which included engraving firms, independent engravers, metal plate printers and dealers and the big engraving firms such as the Heath family. In the 1840s Colnaghi's, Agnew's and other big players established a cartel, the Print Sellers' Association. Its aim was to regulate standards in the print trade and to eliminate fraud by securing transparency in the distinctions between different states of published prints and to regularize the trade in proofs. In 1884 the Association stamped 73,937 proofs with a nominal value of about a quarter of a million pounds (*The Year's Art*, 1885).

Third, we find the impulse towards an esoteric printmaking and the kind of appreciation of prints that was cultivated by amateurs and professional artists. Where the Print Sellers' Association was the leading edge of an exoteric trade in art reproductions, some artists and amateurs catered for the more restricted interests in printmaking – circulating prints among themselves, experimenting with the medium, and forming select societies that promoted new ideas about prints. In the second half of the century etching was the most notable medium for experimentation in printmaking. Etching was a source of new ideas about authorship which breached conventional distinctions between painting and prints as reproductions and which encouraged a select public awareness of the process of making prints.

Etching is both technique and art. As reproductive technique it is one of a large family of methods that have proliferated over several hundred years. Collectors have long groped their way towards terminologies that permitted rationalization of their collections according to sound principles of art history and technology. Their difficulty, as Harris shows, has been one of mapping a world of printed artefacts which contradicted and escaped the classifications of scholars and collectors; this heterogeneous and protean world spawned techniques which hybridized to meet the demands of professional artists and amateurs, the artistic needs of commerce and the commercial needs of capitalism. Prints might be classified but were never completely captured by the imposition of a fixed

classification (e.g. the relief/intaglio/planographic formula failed to arrest the flux that is the development of printmaking techniques).

Struggles over classification are of interest, as they relate to the social production of the difference between art and artefact and to the valorization of that distinction as cultural capital. The print trade was, as it remains today, quintessentially of modernity; rapid technical change generated problems of authenticity concerning authorship and quality. The manufacture of the print was a complex business where artists and craftspeople might lose control of the image to others, where new distinctions might be established for commercial advantage, where fraud was rife and the definition of originality contested.

The rediscovery of etching

The story is well enough known as a French, British and American art movement: the revival or resurgence of etching from the 1860s, its promotion as an art rather than a craft, the enthusiasm for collecting etchings, the proliferation of amateur practitioners and finally the collapse of the etching market as a kind of cosmic echo of the Wall Street collapse (Lang and Lang, 1990). In Britain, for much of the nineteenth century etching was considered to be either a reproductive technique or a sideline to painting. Academicians produced etchings as an aside, but this art was shown unsympathetically at the Academy which admitted printmakers to membership on the assumption that they were really reproductive craftsmen.

Partly under the influence of French ideas, some artists began to exploit etching as an autographic art. By the mid-nineteenth century five modes of exploiting etching are discernible. First, there was a popular commercial tradition associated with satirical prints, fashion plates and illustration. Second, there were reproductive engravers who might use it, often hybridized with other techniques, in their craft as handmaidens to painters. Third, there were artists who practised etching but who were primarily painters for whom etching was a sideline: Thomas Creswick (1811–69), Richard Redgrave (1804–88) and J. C. Hook (1819–1907) were painters and RAs who also practised etching. Fourth, there were professional artists who specialized in etching or were moved to pursue it as an autonomous art such as Samuel Palmer (1805–81) or James Abbott McNeill Whistler (1834–1903). Fifth, there were amateurs and connoisseurs who practised etching; the surgeon Sir Francis Seymour Haden (1818–1910) is the most notable of these people.

Two early societies, the Etching Club, established in 1838 and the Junior Etching Club of 1857 registered diverse commercial and artistic interests in etching. Membership included RAs along with Samuel Palmer, Haden, and briefly Whistler. The Clubs promoted the art and made forays into publishing with illustrations to literary works and broke with conventional understandings of the artist's role in printmaking. Palmer's

vision extended his creative reach into the process of etching. Where others found it natural to pass to others the mordant task of biting the plate, Palmer took it that his creative intentions were realized in the process of plate-making itself. Haden too extended his authorship from the late 1850s, insisting that an etcher must properly execute the printing or at least supervise the process.

In the summer of 1880 the Society of Painter-Etchers was established by Haden with the aims of (1) promoting and exhibiting etching as opposed to reproductive prints; (2) getting the Royal Academy to admit etchers as opposed to reproductive engravers; (3) persuading established RAs to create their own etchings, and (4) outflanking the trade cartel, the Print Sellers' Association. In an address given in 1890 to what was now the Royal Society of Painter-Etchers (RSPE), Haden explained the position and suggested a strategy:

> The almost helpless position of a society like this, whose modest mission is to explain that an etching is an original work, full of fine qualities – after nobody – may be imagined, I see no way out of this difficulty but for the society to publish its own works, or to arrange with some special publisher or publishers to deal with them.
>
> (Haden, 1890: 760)

The new Society began its life at the house of Francis Seymour Haden. At the first meeting which Haden presided over, Alphonse Legros (1837–1910), Hubert von Herkomer (1849–1910), Robert Macbeth (1848–1910), Heywood Hardy (1842–1933) and James Tissot (1836–1902) were present. The Society established itself on the art scene and secured royal endorsement (both the Queen and Albert were widely known to have been amateur etchers). Among those who gave assistance and later became members were Frank Short (1857–1945) and William Strang (1859–1921).

Under the dictatorship of Haden and with his appointments of influential members, the Society formed strategic institutional alliances and developed as the voice of etching. These alliances were central to the promotion of etching in the face of academic hostility. The Society became an influential interlock of officials serving in other institutions. William Drake (1817–90) was Chairman of the Burlington Fine Arts Club, Sir Charles Robinson (1824–1913), also of the Burlington, was a key figure at the South Kensington Museum, and Legros taught at the Slade School of Art. The appointments of Frank Short and Frederick Goulding (printer to the Society) at South Kensington were signficant. In addition, Sir Charles Holroyd (1861–1917) was brought on board in the late 1890s as Keeper at the new Tate Gallery. After 1883 all engravers elected to the Royal Academy had 'without exception' been members of the RSPE (Newbolt, 1930: 11).

A first exhibition was held at the Hanover Gallery in 1881 when 126 artists submitted over 500 prints with 491 hung. *The Times* of 1880

noted the growing 'number of publishers and sellers of etchings in London and Paris, and the general vogue and popularity of the art' (*The Times*, 3 April 1880). Among the dealers moving into etching was Dunthorne, the first to specialize in publishing original etchings. In 1881 *The Times* observed of etchings published by the dealer Colnaghi's, that: 'If it is true that supply always indicates demand, the taste of art in one of its highest forms is making steady progress. Every day seems to bring forth new etchings.'

These developments were coupled with new critical ventures of which the flow of books and periodicals from P.G. Hamerton's hand and eye are the most notable. Two exclusive periodicals – *The Portfolio* and *The Etcher*, along with the first edition of Philip Hamerton's *Etching and Etchers* of 1868 – also proselytized the art. Hamerton, the English voice of original etching, set out its radical claims as a free-standing art that stood comparison with painting. In the separation of print from paint there are two aspects. One is an evocation of modernity which captures the experience of change, of modern stimuli and uncertainty. It is the speed of execution, in one sitting, that can be the hallmark of etching as proposed by Haden and which puts it at odds with the archetypal academy painting. In this respect etching was a sign of modernity; it released printmaking from reproductive service to the hierarchy of art.

The other aspect is the expansion of the authority of the artist-as-creator. Here and elsewhere we find the argument endlessly stated: that the etched line emerges from the artist's mind and has a different ontology from the finished engraved line associated with reproductive work. Samuel Palmer compared etching with authorship: the 'best *comptu* exponent of the artist-author's thoughts.' The etched line, so speedily accomplished, takes creativity back into the eye and hand of the artist as a wider audience learns to see art where before it might merely have seen an unfinished work. In 1880 the *Art Journal* described the virtues of etching: 'the spell of etching lies in its volition and vitality, in its immediate response to the artist's will, in the intimate reciprocity between outward form and the inward conception.'

A year later an original etching 'possesses qualities which cannot be found in work at second hand – expression, originality, personality, and mental properties, which common sense at once shows are not translatable by the engraver, however talented' (*Art Journal*, 1881).

It is characteristic of the modernist masterpiece that its works directly register 'the spontaneous movements of the [artist's] hand' (Fisher, 1991: 185) and it seems clear that the revival of etching is a chapter in the gestation of that idea of the masterpiece. Nineteenth-century etching is of interest partly because its claims were perched on the boundaries between art and manufacture. Haden and company promoted a categorical distinction between the spontaneous line of the etching and the crafted engraved reproduction. Following Fisher, we can see that the resurgence of etching entailed the confiscation of artisanal secrets as publication and

critical assessment converted them into the cultural capital of bourgeois amateurs and collectors.

However, closer inspection suggests that the distinction between originals and reproductions was less secure than the propoganda claimed. While the Society of Painter-Etchers gave the etcher as an original artist a particular coherence, there were identities and artefacts which could not be so readily consigned to one side of the original–reproduction divide. My argument is that the social reproduction of originality presupposed skilled people of craft.

Frederick Goulding

The revival of etching was a dramatic turn on the road to originality. However, the search for originality brought with it a craftsmanship. The etchers, as we have seen, extended the creative project of the artist into the process of printmaking by executing tasks, such as that of etching the plate, which were more usually passed over to craftspeople. However, despite Haden's strictures, specialist printing remained a craft skill upon which artist-etchers such as Whistler depended. Lurking in the shadows of the artist-as-creator is another authorship: that of the printer (Lang and Lang, 1990).

The life of Frederick Goulding (1842–1909) illuminates some of the issues raised above. Goulding was a third generation copper-plate printer who was apprenticed to a firm of lithographers, Vincent Brooks, Day and Son in 1857. The business developed its interest in copper-plate printing as lithography declined in importance, and the young Goulding was soon to be found printing the work of established reproductive engravers and artists including J.M.W. Turner, Edwin Landseer and Rosa Bonheur. In 1859 Goulding encountered Whistler who, unusually for artists, insisted on proving his own prints.

Goulding had been assigned to act as devil or assistant to Whistler. Later, as a demonstrator at the Great Exhibition of 1862, he met other figures in the world of reproductive art and etching including Haden, brother-in-law to Whistler, and also James Lahee who had printed mezzotints for a number of well-known engravers. Goulding seems to have been drawn gradually into the world of fine art etching.

The passage of the image from plate to paper is fraught with difficulties, and printing is a highly skilled task unlikely to be mastered by engravers, etchers or painters: a knowledge of presses, inks, inking, wiping and so forth closely determines aspects of the image. What Goulding offered was an uncommon facility in exercising his craft and effacing himself, and convincing the artist that his pictorial intentions had been realized. Goulding was a creator who created in the moment between inking and printing the plate, the moment of 'intelligent *retroussage*' when the printer, wiping excess ink from the plate with a muslin rag, draws a shade of ink out of the etched lines across the plate

Plate 11 Reproduction in photogravure of the oil painting *Portrait of Goulding at Work* by A. Hartley. Reproduced in *Frederick Goulding: Master Printer of Copper Plates* by M. Hardie, published by Eneas Mackay, 1910. Courtesy of Keele University Library.

(Plate 11). For Haden he possessed 'the hand of a Duchess'. For A. H. Palmer (Samuel Palmer's son) the distinction was to be made between such as Goulding and the printer as machine: 'a crude machine without machinery's susceptibility of adjustment' (Hardie, 1910: 123).

Goulding was no mere technician. He interpreted the divisions of class which were at work in the studio; the artist-etcher was incapable of translating his own yearnings into 'cockney workshop jargon' (*ibid.*). Haden's correspondence also suggests Goulding's work as interpreter when he instructs how his plates are to be treated: 'The work of the printer ... is really measurable in proportion to his intuitive perception of the temperament and intention of the Etcher' (Haden to Goulding, quoted in Hardie, 1910: 65). And earlier, on receiving a proof: 'really quite perfect, and in harmony with all my views and requirements!' (Hardie, 1910: 64). Not that he always got it right, as Haden pointed out on occasion.

Goulding's was the life of craft in the service of the artist's intention. His mediations as printer were dedicated to the apparently unmediated presentation of the artist (Plate 12). Yet the indeterminacy that is the difficult passage of the image through the hands of the printer could permit him to appear as a creator and to be recognized as such within the coterie of etchers whom he serviced (Haden, Hardie and others). It was apposite that Hardie should publish a limited edition biography of 350 copies (Hardie, 1910). Drawn away from the more commercial reproductive printing and into the orbit of the etchers, Goulding

Plate 12 *The Trial Proof*, etching by R.W. Macbeth. Reproduced in *Frederick Goulding: Master Printer of Copper Plates* by M. Hardie, published by Eneas Mackay, 1910. Courtesy of Keele University Library.

developed a posture that was commensurate with an artist-craftsman status (Becker, 1982).

Goulding's later life provides a moment of resistance when the Print Sellers' Association (PSA) tried unsuccessfully to woo and then press him into membership of the trade association. In its bid to guarantee the value of engravings and to drive out fraud in the business of proofs and edition sizes, the PSA sought to register publishers and printers and to guarantee only those engravings that were published and printed by its members. Registered printers were required to display the Association's rules and to record, for each edition, details of proofing and so forth. The aim, as the PSA frankly observed, was 'absolute control' over standards (Hardie, 1910: 116). Goulding objected to commercial surveillance as infringing his independence and as throwing into doubt the integrity of his craft. His earnest refusal to join was a refusal to have the standards of independent craft submerged by big business. Goulding's point was that in a lifetime of craft he had raised the standards of printing; his point of view is one that sheds light on the collective action of creating and contesting value in art worlds.

Haden's volte-face and the meaning of mezzotint

There is a puzzle in the history of the Royal Society of Painter-Etchers (RSPE) which is associated with the character of Haden but it is not reducible to his character. Haden was by all accounts a dictator. He controlled appointments, altered minutes of meetings and was ever at the elbow of the long-sufferng secretary. In an extraordinary volte-face in the 1890s he began to plot a new direction for the Society. The first indication

of this seems to have been when, in 1890, a royal diploma was granted for the art of original or painter-engraving (Newbolt, 1930: 29). In 1897 there were proposals to add 'engraver' to the Society's title. In 1898, against strong opposition and in the face of resignations, a resolution was tabled and went through for alteration of the Society's title and the admission of reproductive engraving, along with original and reproductive mezzotints. In 1898 the Council passed a motion allowing inclusion of 'some proportion of reproductive work'. The puzzle is, of course, that one who so vehemently argued the deficiencies of engraving should now seek to accommodate it. One authority, Francis Newbolt (1930), gives Frank Short (Plate 13) a key role in this development. His background at South Kensington as student and later instructor, his involvement in mezzotint and his influence over Haden are significant:

> By merely studying Short's work, and learning many things from him, which he refused to learn from anyone else, Haden lost his life-long prejudice against engravers ... and tried to justify his conversion by a process of reasoning that was contradictory, misleading and confused.
>
> (Newbolt, 1930: 20)

I want to suggest that Haden's confusion and the influence of Frank Short may be aspects of a developing field of art whose contours cut across individuals and institutions. The RSPE was born out of the failure of the Royal Academy to respond to the artistic claims of etchers and was symptomatic of long-term changes in cultural power which decentred the Academy and fragmented the public domain of art. The RSPE aimed to

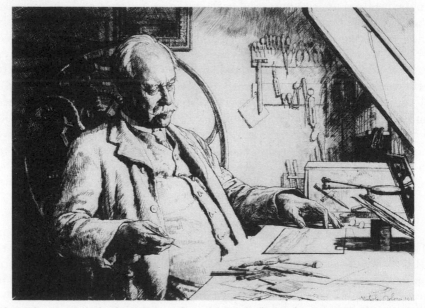

Plate 13 *Sir Frank Short RA*, etching by Malcolm Osborne, 1931. Courtesy of Victoria and Albert Picture Library.

wrest the definition of the art print from both the RA and the Print Sellers' Association and to consecrate etching and the etcher as opposed to the reproductive print and craftsman. Yet there were limits to this recontextualization of etching, for some of the players moved in both worlds.

Art dealers and critics played a key role in promoting etching: Colnaghi, Arthur Tooth and Sons, Dunthorne among others. Members of the RSPE included RAs, but recruits also came from newer power bases within the art establishment: South Kensington, where Frank Short taught, and the Slade School of Art. The influence of the RSPE was built partly through institutional alliances and associations and it seems likely that these were outgrowing its reach, although Haden seems to have had imperial ambitions. Newbolt observes that '[t]here was always in Haden's mind the danger of another society being formed on broader lines than ours' (Newbolt, 1930: 23). The Society did accommodate and depend on reproductive craftsmen. Frank Short, for example, had a reputation both for his etchings and his reproductive work in mezzotint. The Langs (1990) suggest it may have made strategic sense to hold on to members by acknowledging the heterogeneity of printmaking and especially so in the face of competition from two new societies which appeared in 1898. One of these was the Society of Mezzotint Engravers and the other the International Society of Sculptors, Painters and Engravers. The latter was under the presidency of Whistler with whom Haden had long ago fallen out. At the same time Haden was set on colonizing other print media, including the mezzotint, with the ideology of originality.

The mezzotint, in this period, had an ambiguous status. Its authorship cut across the sharpening divide of reproductions and originals. Mezzotint reproductions had a constituency among gentlemen collectors and antiquarians. The art critic and collector Frederick Wedmore (1844–1901) pronounced that it did not recommend itself to original work. Yet somehow it hovered between reproduction and originality with the claim that it had something that photographic reproduction lacked. There was also a certain *frisson* attached to the royal associations of its seventeenth-century development.

Within the classifications of print-collectors the mezzotint had an uncertain place. The medium had a 'legitimate sway over collectors' for, although generally applied to reproduction, 'each interpreter seems to have employed a different accent … the work of almost every engraver has its own individual qualities' (Salaman, 1912: 121). Whitman had compiled authoritative biographies and catalogues raisonnés of the early nineteenth-century reproductive mezzotinters Samuel Reynolds and Samuel Cousins. At the same time there were indications that the medium was cut out for something else. If mezzotinters had been a largely reproductive art it was patent that this was a decaying art and that any future would or should be original expression (Hind, 1963: 287).

Such puzzles expose problems of authenticity and relate to issues of

power as they are interwoven with the commercialization of images. Who controls the image? In exploring the dynamics of orginality we may see the politics of the RSPE as a process of classification. The early RA, the Print Sellers' Association and the RSPE were centred authorities which legislated strong boundaries in the domain of prints. The RSPE and Haden imported originality into prints; they gave priority to the distinction of original work and brought to public notice a submerged tradition of printmaking. Although Haden was, by modern standards, more relaxed on these issues, we can none the less detect the emergence of rituals and practices whose absence had not detained earlier collectors: the preservation of the plate margin, the innovation of signing and the numbering of prints from the 1880s. The effect of these rituals was to preserve the print as something that was made and to secure the singular authorship of the artist in the signs of its making and approval. The print became one site at which people think about the boundary between art and commerce.

Art classification

Etching's revival may be situated within a broader account of art classification and the changing shape of the art world. A number of writers have noticed how the formation of art institutions after the 1880s (both in Europe and the USA) was an enlistment of art publics, their differentiation through rituals of cultural power and new materializations of cultural capital. Thus one aspect of the etching revival is the cascade of books and periodicals promoting the art. P.G. Hamerton began a lineage of art publishing that took the amateur as well as the professional into the studio and encouraged amateurs to install their own studios. *Etching and Etchers* (1876) went through three editions, and among other notable publications are the translation from the French of Lalanne's *A Treatise on Etching* (1880), Frank Short's *On the Making of Etchings* (1880) and Haden's own publications. There was a stream of new books servicing the needs of collectors and amateur etchers with something of a spurt in the early 1900s. We are witnessing the creation and diffusion of cultural capital as the layout of the studio, the appropriate materials, the strength of mordants, biting times and Old Master practices become public property.

The promotion of etching was *pace* Bourdieu a symbolic revolution which changed the priorities of print connoisseurs. The priorities of the etchers were to make etching into an original work and to distinguish the etching from reproduction, for expansion of the market for etchings was part of a long-term fissuring of culture which had counterparts in other institutions. At its heart was an irony, that of the commercial exploitation of etching's difference from commerce. The *frisson* attached to etching, well enough recognized at the time, was that reproducibility was intimately bound up with questions of connoisseurship and the

stratification of taste: 'a little unpopularity is a sort of consecration. It [etching] is really too *personal*, and consequently too *aristocratic*, a genre to enchant people other than those who are naturally artists' (Baudelaire, 1965: 221–2). Or as Wedmore observed, the demands of the connoisseur and the public were no more sharply divided than they were in the case of etching (Lang and Lang, 1990). Within the world of printmaking a cleavage had appeared between an elite that focused on the intrinsically creative possibilities of etching in the hands of artists such as Whistler, Haden and others and a broader public that understood etchings as no more and no less than reproductions of paintings.

The aesthetic of the original print has achieved an importance in the fine art market only in recent times. The modern notion of the original print is intimately and ideologically associated with the social construction of authorship as it relates to the heterogeneous world of prints. The 'originality' of an original print is predicated on (1) the print's categorical difference from a reproduction, (2) its independent status as a work of art, and (3) the assignment of complete pictorial authority to the artist. The hyperbole of the contemporary art market freezes our thinking about image-making, naturalizing the distinction between reproductions and originals, and encourages us to seek a unitary creativity in the heterogeneity of diverse art worlds past and present. There are therefore discursive and ideological aspects to the original–reproduction dichotomy insofar as it fails to accommodate the range of printmaking practices, past or present.

Does the artist who decides to make prints after one of his or her own paintings make an original print? How much more original is this than the artist whose prints are manufactured after his or her designs by a team of artisans? Or the artist who signs photographic reproductions carried through without any supervision on his or her part? Francis Newbolt, etcher and chronicler of the RSPE, notes Haden's anachronistic mapping of the originality of etching on to Old Master practices. Whistler went to law, successfully, with Joseph Pennell and against Walter Sickert, to claim that his lithographs were originals and not reproductions as Sickert charged. What was at stake was the authorship of transfer printing. How could Whistler's prints be original when the artist, rather than working the lithographic stone, committed the design to 'transfer paper' in the first instance?

The etchers were wedded to the idea of an original moment of creation that was pushed back into the eye of the artist; an etching was born out of a complete authorship whose possibilities contrasted with the codes of artisanal reproduction. Yet, as we have seen, the etchers depended upon artisans such as copper-plate makers and printers. In that respect the ideology of creation that was proposed by etching's propagandists was a misrecognition which concealed the social relations of cultural production.

In her study of Rodin's *The Gates of Hell*, Krauss (1986) identifies the

discursive character of claims about originality which she shows to be at odds with the practices of the foundry at which the artists' sculptures were cast. The originality of the artist was grounded in the division of labour of the foundry and in the otherness of the copy. Krauss helps us to see that, with nineteenth-century prints, we are at a moment when the inter-connectedness between originals and copies was nearer the surface of things and that this interconnectedness is something that the institutional-ization of modern art repressed. Though nearer the surface of discourse about art, the copy was retreating in the face of the charge that it did not fully pass muster as a work of art. At mid-century an instance of this caught the interest of the 1863 Royal Commission of Inquiry into the RA in the form of C. R. Leslie's painting *My Uncle Toby and the Widow Wadman*. Several versions of this widely known painting had been executed for patrons and it seems likely that the Victorians were more sanguine towards copies than twentieth-century collectors (MacLeod, 1996). However, signs of anxiety were evident at the Royal Commission when a witness implied that the case was evidence of sharp practice and of the need for an ethical code.

As Foucault argues, far from being a perennial source of free invention, the author is a functional principle which arrests the flow of meaning by excluding things. The case of etching enables us to see this censorship at work in the stigmatizing of reproductive engraving and in the uncertainty over the mezzotint. I turn to the concept of classification (Bernstein, 1971) as a means of illuminating the matter of the discursive character of originality. Classification is the encoding of social relationships in the ritual practices of cultural institutions. In his studies of school curricula Basil Bernstein develops a distinct perspective on pedagogy as socially classified knowledge. Bernstein's argument is that curricula entail a pedagogizing of knowledge. By this he means to say that curricula are the outcome of selective processes which, in organizing a subject, abstract and combine elements from a domain of knowledge. Schooling as he expresses it turns carpentry into woodwork (Bernstein, 1996)! Equally, we can think of national galleries of art as places which museumify art by ordering together artefacts that may have kept entirely different company in the worlds from which they previously came. To put it this way is to emphasize the action of museums in ordering art worlds rather than executing the orders of social classes, art dealers and so on.

In this case we are concerned with the heterogeneous world of printmaking and a simple distinction between originals and reproduc-tions. The field of cultural production is reordered through the definitions, both explicit and implicit, of print-collecting. *Pace* Bernstein on the concept of classification, the original print is a discursive object secured through the cutting and splicing that keep some things apart and put others together. Following Fisher, we can see that rituals of classification, hegemonized by the museum, construct originality as a moment within a series: solander boxes, portfolios, framing, matting and

the connoisseurship of editions, states and proofs are the means through which order is brought to the ambiguities of material culture and by which the habitus of the museum is diffused through the social structure.

Originality is both deeds and words for the rites of print-collecting, supervising, proofing, numbering, signing, and defining originality is at once the dividing up of the world of images into the most authentic and the least authentic. There may be a literal refashioning of the image as it passes into the hands of the collector – cleaning, restoration, framing and so on. A telling illustration is the one-time practice of collectors who clipped margins in the case of intaglio prints. Before the eighteenth century it was standard practice for collectors to trim the margins of prints. Since then the prized print is one in which the margin, the space between the edge of the paper and the impress of the plate, carries a sign of its authentic making.

7

A Trojan horse at the Tate: the Chantrey episode

Introduction

The decline of academies was linked to the emergence of new modes of authorizing art at the end of the nineteenth century. This reordering of the art world had implications for art museums that have not been well explored. Academies were intimately associated with the lives of museums; academicians formed recruitment strata for museum official-doms while their works were routinely purchased for national museums such as the Luxembourg in Paris and the Tate Gallery in London. However, at the end of the century this association was increasingly perceived as one inimical to art.

The problem was not an archetypal conflict between artists and museums but one of change in cultural authority. Against the view that the museum and the modern artist were antithetical, that the museum shackled modern art, Negrin (1993) establishes their interdependence. Indeed, both art museums and academies developed as institutional expressions of the emancipation of art from the ritual and decorative spaces of traditional upper classes. However, by the late nineteenth century the power of one type of artist, the academician-artist, was widely felt to be at odds with the universalism of art. At this point the antithesis was between the academician-artist and the museum. The museum responded by evicting the academician's art.

Interwoven with the problems of markets and museums was the provocation that was modern painting. In Britain a disagreement between the Royal Academy of Arts (RA) and the Tate Gallery concerned the aesthetic status of modern art. The conflict turned on the divided management of the Chantrey Bequest which was a purchasing fund dedicated to British art. By means of the Bequest, the Tate acquired works of art whose selection was controlled by the RA through the trusteeship of its ruling Council. Under arrangements imposed by the Treasury, the Tate Gallery was obliged to accept and display Chantrey works selected by the RA.

Many of the Chantrey purchases were thought by the Tate officials to be unworthy of display in a national collection and symptomatic of a

failure to meet the claims of modern art for inclusion. During the course of the early twentieth century the Tate endeavoured to free itself from the thrall of the RA. This endeavour, along with the RA's struggle to defend its interest in the Bequest, constitutes the Chantrey episode in the development of the Tate as a gallery of modern art.

The issue was the failure to admit modern art (e.g. Impressionism and post-Impressionism) to the canon. Impressionist paintings were first exhibited in Britain in 1870. At two London exhibitions of modern French painting (1910 and 1912) the artist, critic and curator Roger Fry staged an English reception for modern artists while rubbishing Victorian academy art. This put paid to the inclusive aspirations of the mid-nineteenth-century museum movement, undermined the power of the RA and provoked the problem of the Bequest.

Three official Inquiries[1] dealt wholly or in part with the Bequest: the Crewe Report (1904), Curzon Report (1911–16) and Massey Report (1946). They are of interest because they expose the making of an aesthetic partnership between the British state and the professional class. At stake was the museum status of modern artists (some of whom had forged their own independent institutions) and for whom a creative life outside the academy seemed possible. These moderns were promoted by dealers and by critics; among the latter were the so-called New Critics (D. S. MacColl, R. A. Stevenson and George Moore). They introduced the middle-class to a way of looking, the pure gaze, which marginalized the subject painting as art and called for the recognition of a new ontology – the quality of the medium, the formal properties of style (Bourdieu, 1996; Flint, 1984). Their critical vocabulary was at odds with the narrative and literary aesthetic associated with the RA and which was so heavily represented by Chantrey acquisitions.

Enrolling the people in British art

British modernization spawned capitalist fractions with diverse combinations of economic, political and cultural assets, with different orientations to the struggle for distinction and with competing stakes in the process of nation-building. There were agrarian capitalists, those established families who distinguished themselves as collectors of Old Masters (Cannadine, 1995). Along with City financiers, commercial interests and the professions, the early nineteenth-century aristocracy formed a closed elite united by a dominant ideology of Anglicanism and patriotism (Rubinstein, 1993).

By the mid-nineteenth century it was a conventional wisdom that art was being extended beyond the confines of old patronage both to new wealthy patrons and to a comparatively modest and 'middling' purchasing power. Where aristocrats had been preoccupied with collecting dead foreign Old Masters, a new generation of collectors promoted the virtues of a native British, sometimes English, school of art. Its members were

living testimonies to the nation's creative capacity, and their commercial success was readily attributed to 'middle-class' taste-makers. New collectors (northern industrialists and commercial interests) invested in the works of living British artists. At Old Trafford the Manchester Art Treasures Exhibition of 1857 was significant for the way it promoted the British School of Art alongside aristocratic Old Masters. By the time it had closed its doors the number of visitors was counted at 1,335,915. For W. B. Jerrold, instructing his readers through the pages of the *Art Treasures Examiner*, it was necessary to interrupt the 'systematic sequence' of art history so that they might come 'face to face with Hogarth, Reynolds ... and others of almost equal fame' (*Art Treasures Examiner*, 1857: 33). Commentators such as Samuel Carter Hall, Gustave Waagen and Mrs Jameson acknowledged this novel middle-class presence and, in the case of Hall, reported its developments as part of a moral crusade for authentic British art and against the trade in fraudulent Old Masters (*Art Journal*, 1850: 265; 1852: 151–52).

The class divisions of capitalism pulled the institutions of art in three directions: towards the ascriptive powers of the aristocracy who sought to conserve taste, towards the middle classes who sought to corral art as cultural capital but who challenged the priority of the Old Masters, and towards the professionals (artists, connoisseurs, dealers, critics, etc.) who produced and interpreted art through the medium of institutions such as museums, exhibitions, the art press and the art unions. Speaking of the Art Treasures at Old Trafford, Jerrold muttered of 'whig ingratitude' by Devonshire and Sutherland who had sent nothing to the Exhibition and then quickly passed to the 'glowing canvases of Reynolds, Wilson, Etty and Maclise ... Even Rubens must feel a passing chill' (*Art Treasures Examiner*, 1857: 1). These transformations were therefore not so much a matter of middle-class access to the treasures of art as they were a renegotiaton of cultural identities. As Steegman observes, connoisseurship was separated from ownership of the Old Masters so that by the 1830s an art collection could legitimately be acquired from the hands of living British artists (Steegman, in Hermann, 1972: 235–9).

These developments were not effects of pre-existing bourgeois interests; class has to be seen as an economic and cultural process. As MacLeod (1996) shows, non-aristocratic collectors were a heterogeneous lot shot through by regional and occupational divisions. MacLeod's evidence, I suggest, invites a processional view of nineteenth-century class identities as organized and sanctioned partly through the medium of art institutions. Art institutions did not reflect class interests; rather they interpreted class relations and were media through which people came to a consciousness of themselves as aristocratic, middle-class and so on.

The National Gallery was formed in 1824 from the gift of an aristocratic amateur (George Beaumont), the purchase of a banker's collection (Julius Angerstein) and augmented by government grant-aided purchases. While the National's origins may be traced to the dominance

of a country house aristocracy that gave private collecting its first priority, it was born out of a growing sense that there was a national taste to be cultivated and a national heritage that was being threatened by the trade in art. Regulated by trustees and displayed according to decorative principles, the early National was an aristocratic patrimony that had entered the public sphere, an impersonalization of cultural power which turned aristocratic collectors into donor-trustees and cultural stewards. The collection began with the amateur taste of a coterie generation in European Old Masters (e.g., Carracci, Claude, Correggio). It was gradually rationalized (through acquisitions and display) as an historical representation of European art and the deepening history of its national schools.

The middle class, which had an antagonistic relationship with the privileges of aristocratic culture, increased its weight within the official fine arts. In the mid-nineteenth century, industrial capitalists and a growing population of clerical and professional workers shared a middle-class consciousness structured by the economic, political and cultural tensions with the old order (Scott, 1991). New organs of cultural power such as the art unions which distributed engravings and art prizes sprang up to promote an inclusive pictorial culture, while the influential *Art Journal* campaigned for honest British art on behalf of the middle and respectable working classes. Academic ideals of high art history painting were reoriented as a cult which served the national needs of an empowered bourgeoisie. The cult reflected on the Englishness of bourgeois power, retailed the Whiggish story of its progress and depicted the founding myths of its state (e.g. the checking of arbitrary monarchy and the extension of the franchise) (Strong, 1978: 32–3). Thus by the mid-nineteenth century, art was one of the modalities of culture through which the bourgeoisie became conscious of itself as a distinct class. Its specifically bourgeois self-image was expressed in new patterns of collecting and in its search for authentic, virtuous and national art free from the anxieties of fraud and forgery that bedevilled the trade in Old Masters.

In the 1850s and 1860s South Kensington emerged as a countervailing middle-class force of industrial trainers within the state. It grew out of Select Committee proposals of 1835 and was funded by profits from the 1851 Exhibition's celebration of industrial capitalism. Its officers and allies were outsiders to the fine arts establishment. South Kensington threatened to absorb elements of the fine arts; it established a distinctive architectural and decorative style, forged an educational partnership with industrial capitalism and promoted itself to working-class visitors. It was to South Kensington that one of the definitively middle-class collections was given (namely, the Sheepshanks collection) while it also serviced a middle-class taste for water-colours.

At museums and exhibitions working-class visitors were encouraged to attend to their demeanour, to restrain their behaviour in favour of others' pleasure and to know the meaning of private contemplation. The politics of art were marked by frank references to class, to personal habits and

behaviour, to anxieties concerning the safety of exhibits and the suitability of visitors: 'the promiscuous access of the mob ... the invasion of the populace ... the rush of a crowd' (Shee, 1837: 18–24); 'persons whose filthy dress tainted the atmosphere' (Waagen, 1853: 123); idle people whose children 'cracked nuts' (quoted in Fox, 1977: 75). At the Manchester Treasure Exhibition there was 'something to study at every footstep' (*Art Treasures Examiner*, 1857: 2). Creativity became a target of official inquiry and intervention that registered the interdependence of working-class leisure, the requirements of capital accumulation and of social control.

Tensions within the propertied capitalist class gave official art institutions a divided though inclusive character. Pronouncements of statesmen, intellectuals and the developing bourgeois press pointed to art as a medium that would enrol all classes in the mission of civilization: 'the enjoyment of art was accessible alike to the Royal Academician and to Kingsley's labourer wandering the National Gallery' (Minihan, 1977: 166; cf. pp. 94–5). Divisions between the old and new orders were associated with competitive struggles for cultural hegemony (through religion, art and education) over subordinate classes. The RA exploited the indeterminacies of the field of power; so, for example, it resisted radical bourgeois attempts to open up its affairs to public scrutiny and subordinate it to a reformed Parliament. During the 1860s, the RA outmanoeuvred the bureaucratic state, although one of the issues dogging cultural politics in the 1860s was whether or not the RA would go to South Kensington as a part of Prince Albert's grand vision of cultural reorganization (*Survey of London*, 1963, 1975).

The Tate Gallery and the Chantrey Bequest

Founded in 1897 as the National Gallery of British Art, that is with a British remit as opposed to the European Old Master concerns of the National Gallery at Trafalgar Square, the Tate was intimately associated with the Royal Academy of Arts (RA). Under arrangements determined by the Treasury, the Tate's purchasing fund was the Chantrey Bequest which had been donated by the fashionable sculptor Sir Francis Chantrey (1781–1841) but which was not activated until the late 1870s.[2]

Sir Francis Chantrey RA was an academician whose Smilesean success was built on the business of sculpture. His wealth flowed from the demands of fashionable Society for portrait, public and funereal sculpture and from his wife's dowry of £10,000. Marriage and career took him from poor craftsman to artist and was of a piece with the RA's consolidation of its professional status and influence. Chantrey made a bequest of £105,000 for the purchase of works of art; the object was to create 'a public collection of British fine art'. It seems likely that the gift was a response to the widely appreciated problem that the received academic tradition gave precedence to an artform for which there was little demand from private

patrons or officialdom, namely, history painting in the grand manner, and was most probably inspired by the failure of such works to sell at the RA Exhibition.

Professional autonomy *vis-à-vis* the state is the key to the Chantrey episode. The gift was an initiative aimed at enhancing the profession and encouraging the state to sponsor the building of a national gallery which would celebrate British artists. It became an arrangement which permitted the RA (as Chantrey trustee and as the representative of the profession) to demonstrate its artistic achievements and to determine the contents of the National Gallery of British Art.

Chantrey, the Bequest and the man were creatures of the academic system as it developed in Britain during the first half of the nineteenth century. There was a prohibition on charitable expenditure which was consistent with the RA's professionalizing rupture with friendly society mutuality – something which was still an issue in the 1840s (Pye, 1845). As already noted, Chantrey instructed that the fund be devoted to the encouragement of British fine art only, and the RA was to administer the Bequest. Purchases were to be of the highest merit; with the proviso that they were created in Britain, works might be by artists of any nation and prices paid were to be liberal. Chantrey's instructions (those assigning a central role to the RA) emanated from a world which took as natural the association between the academy and consecrated art.

Whatever Chantrey's intentions, as applied by the RA, the Bequest became a collection dominated by academicians who specialized in subject paintings. Visitors to the early Tate were confronted by Chantrey paintings which were arranged to occupy rooms on both sides of the sculpture gallery (Plate 14). In this manner assembled assessments of the collection's calibre entered public consciousness. By 1903 110 Chantrey works had been acquired. The collection was always more heterogeneous than the stereotypes of its critics, but it contained a large number of anecdotal, literary and popular historical subjects of a didactic kind that were heavily reproduced for schoolrooms and elementary history books. Most were subject paintings with historical, classical, religious and literary themes (*Cromwell at Dunbar*, 1886; *The Bath of Psyche*, 1890; *The Story of Ruth*, 1877; *Amy Robsart*, 1877). There were domestic scenes (*Mother's Darling*, 1885); also historical costume pieces (*My Lady's Garden*, 1899), landscapes, seascapes (an aggregate of thirty-four works fall into this category). Some were representations of an idealized national past. Others, for example, seascapes such as *Britannia's Realm* (1886) by Brett or *The Pool of London* (1887) by Parsons, denoted Britain's commercial and imperial identity. Of the 110, 105 had been purchased at the RA's annual Exhibition (*Chantrey and His Bequest*, 1904: 27–31). Of about £60,000 expended up to 1903, 'over £30,000 was paid to members of the Academy, between £17,000 and £18,000 to those who shortly after became members, between £12,000 and £13,000 to other exhibitors' (MacColl, 1904: 4–5).

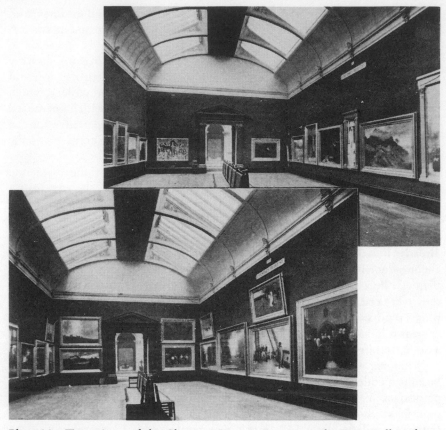

Plate 14 Two views of the Chantrey Bequest Rooms at the Tate Gallery from the *Art Journal*, 1899.

Henry Tate, whose philanthropy paid for the erection of the Tate, was in the tradition of nineteenth-century entrepreneur patrons such as Robert Vernon (1774–1849) and John Sheepshanks (1787–1863). They had forged a non-aristocratic patronage of anecdotal and moralizing art by academy artists thought of as a British school to be measured against European standards. In becoming the home of the Chantrey Bequest and in acquiring the collection of Henry Tate, the Gallery was the centre of a broadly middle-class art grounded in a popular aesthetic. Furthermore, the Bequest became an arrangement which permitted the RA (as Chantrey trustee) to determine the contents of the National Gallery of British Art. To the officers of the Tate it may have seemed that the Treasury had smuggled in a Trojan horse out of which emerged a steady trickle of academicians who occupied their walls.

Three developments turned the collection into a scandal. First, it was the subject of a campaigning journalism which stigmatized it as inferior art. Works like Joseph Clarke's *Mother's Darling*, Hubert Herkomer's *Found* and J. Young Hunter's *My Lady's Garden* were seen as examples

of Chantrey failure. Critics argued that it was incomplete. Among works thought to be missing were examples of the modern French school and British artists influenced by it. (At the Crewe and Curzon inquiries witnesses produced lists of unrepresented artists. Critics thought in terms of lost opportunities: of 'Whistler's mother' rather than *Mother's Darling* and of the failure to acquire the work of foreign artists who had worked in Britain; for example, before the Crewe Inquiry, MacColl argued that a Monet might have been acquired.)

By the 1930s there were rumours that the worst Chantrey examples were displayed by the Tate 'as a standing reproach' to the Academy. To the Tate, the standard of the collection was 'deplorable': 'Alpine valleys, puppies in baskets, ladies in eighteenth century dress standing on chairs, affrighted by mice, and the like' – all exhibited as the 'climax' of the Tate's collection (Rothenstein, 1966: 4). In 1949 the collection (now in excess of 400 works) was exhibited as a whole. The proposal for exhibition had come from the Tate and was understood (by the President of the RA) to be a challenge by the Tate to the RA. It attracted a large winter audience: over 99,000. Much of the middle-class press was hostile: 'the equivalent of the best seller in fiction' (*The Times*, 8 January 1949); a 'freak show, a bland, unashamed affirmation of a collective taste informed by little more than ostentatious materialism and its concomitant sentimentality' (*Guardian*, 8 January 1949); 'a skeleton which the Academy has long kept in the Tate Gallery's cupboard' (*News Chronicle*, 8 January 1949) (cf. *Daily Telegraph*, 7 January 1949).

Second, from the early 1900s RA–Tate relations entered a period of conflict punctuated by episodes of uncertain co-operation. The RA was concerned that its rights were threatened; the Tate was on guard against the possibility that the RA's influence at the gallery might grow. Treasury Minutes of 1897 and 1898 assured the RA that Chantrey's Will was inviolable, that the Tate had no powers of selection or elimination in the Bequest. There were times when the protagonists sat on their absolute rights; there were moments when they thought more pragmatically of 'altered conditions' (Blomfield, 1932: 280) or of 'theoretical rights' (Chantrey Files [hereafter CF]: Witt to Aitken, 23 January 1929). Curzon gave currency to the idea that the Tate need not display Chantrey works. In 1918 Chantrey conferences between the Tate and RA yielded an RA concession – that it would consult the Tate over purchases, and in 1922 two Tate representatives joined the committees responsible for selecting Chantrey works. In the late 1920s relations deteriorated; the RA rejected selections in 1926 and 1927 and the Tate boycotted meetings. President Dicksee of the RA insisted that the RA Council reserved the power of final decision in Chantrey choices (CF: Dicksee to D'Abernon, 26 November 1927, 7 December 1927). Aitken insisted on the Tate's duty to refuse works deemed unworthy (CF: Aitken to Lamb, 26 November 1928). In 1929 the parties were, with the RA under a new President (William Llewellyn), pulling back from complete estrangement.

The Tate, although without an alternative purchasing fund, did acquire works independently of the Bequest. Its Keepers presided over the Tate's colonization by modern and foreign art by means of gifts, and this development was officially sanctioned by a Treasury Minute of 1917. In the 1920s the Tate's postwar renaissance was announced with a transfer of British masters from Trafalgar Square and the admission of 'the most advanced types of painting' (Galerien, 1921: 187). In 1924 the essayist E. V. Lucas noted the presence of 'old Royal Academy favourites' and the works of foreign artists – Boudin, Degas, Gauguin and Rousseau. In 1934 the *Birmingham Post* observed the promotion of a 'peaceful revolution' and the elimination of 'a certain incongruous mixture of Victorianism with contemporary work' (Buckman, 1973: 38).

In 1906 the appointment of a Chantrey critic, D. S. MacColl, strengthened the anti-Academy lobby in official circles. MacColl claimed (before the Curzon Inquiry) that he had been encouraged by the Treasury to create a deadlock with the RA by refusing to accept Chantrey pictures. By the late 1930s the balance of power within the state had shifted, allowing the Tate's officers to exploit *de facto* control of a gallery space and to challenge (though not overturn) the RA's legal rights in the Bequest. At the end of the 1930s the Tate was asserting its position, refusing to hang Chantrey works (Rothenstein, 1966: 207–17). In 1939 the Director of the Tate admitted there was justification for a Major Cardew's charge that 'the work of all painters prominent in England from 1850–1900 [including many Chantrey works] is practically excluded' from exhibition (Tate Gallery Chantrey Files 3: Cardew to Lutyens, 8 June 1939; Rothenstein to Lamb, 14 June 1939).

By 1946 the Tate was in receipt of a purchasing grant. In 1951 the Tate was able to assure the RA's President that 'all causes of friction' had been eliminated despite having complained earlier in the year about the RA's lack of co-operation (cf. Rothenstein to Kelly, 12 June 1951). Chantrey choices continued to provoke disagreement. In 1954 the link between the Tate and National Galleries was severed by Act of Parliament and in 1956 it was agreed that the 'Tate trustees were to receive only those works that they were willing to accept' (Hutchison, 1968: 190). By the 1960s rising government funding had secured the Tate's autonomy *vis-à-vis* the RA.

Third, a sequence of public inquiries consolidated an official view that the collection was bad art. The Bequest was the sole topic of one (the Crewe Inquiry of 1904) and one of two topics addressed by another (the Curzon Inquiry of 1911). The reports sanctioned a radically individuated discourse of creativity which, in stigmatizing academy art, uncoupled cultural authority from Good Society. They recognized the difference between presently successful RA artists and unknown artists whose professional reputations would be converted to renown but who were currently unrecognized, i.e. excluded from exhibition. They called for reforms that would empower the Tate at the expense of the RA. The Curzon Report proposed expropriation of the Bequest from the RA while

both reports endorsed the critical campaign which had stigmatized the Chantrey collection as bad and popular art. The Massey Inquiry and a PEP report, both of 1946, took Chantrey inferiority for granted.

It was less a question of the RA's malpractice (Crewe cleared the RA of corruption) than the production and circulation of an official discourse which proposed the Academy's irrelevance to a universal art (and thus its unsuitability to dictate Chantrey choices). The inquiries gave official recognition to the following: (1) that the RA's interpretation of the terms of the Will was unduly narrow, (2) that the collection was unrepresentative of British art, and (3) that the purchases were largely of inferior works. Crewe made two main recommendations: it proposed a broader purchasing base and the establishment of a purchasing committee composed of the President of the RA, one Academician and one Associate member. Curzon was more hostile to the RA than Crewe. Curzon observed frankly that his object was to break down the Chantrey arrangement in the face of likely protest from the Chantrey trustees. That the Tate could consign Chantrey pictures to store in the 1930s was partly because this was sanctioned by an official discourse that knew Chantrey pictures to be ridiculous.

The early Tate was a contested space and shaped by a disintegrating coalition which had been imposed by the Treasury. It was caught in the crossfire between (1) commercially successful RAs who were widely thought of as the British School, who had been patronized by a new fraction of the capitalist upper class and who were oriented towards a broadly middle-class conception of art and nation, and (2) those artists who had emerged from the modernist revolution and who were oriented towards the field of restricted production (Bourdieu, 1993). The Tate was stretched across fields of power and culture; in Bourdieu's terms the Chantrey crisis reproduced tensions within the cultural field (between the domains of heteronomous, commercial production and restricted production). The Tate was pulled towards a popular national art which equated merit with RA exhibition success and towards an elitism which did not expect validation from a contemporary art public.

The Chantrey problem was a struggle over distinction. A powerful, though declining, professional body (the RA) had control over the purchasing fund for a national collection. The fund yielded a collection of stigmatized popular art which was housed at a national gallery which was, in turn, being drawn into the orbit of an esoteric modern art. The dispute was one in which the parties were unable to settle 'out of court' and in which the government (particularly one at war) drew back from radical measures. While the balance of power between the protagonists was often uncertain, the Tate was able to challenge and marginalize, though not expropriate, the Bequest from the RA.

Board membership of the Tate

The Tate was founded as a department of the National Gallery in Trafalgar Square and correspondingly did not have its own board, though it gained *de facto* independence from the senior gallery. The Treasury had conceded the need for a separate Tate Board in 1917. However, there was to be a single accounting officer for the two galleries with sub-accounting done at the Tate.[3] Between the Tate and the National there was an understanding that this arrangement would bring in trustees who were interested in modern art.[4] This was the state of affairs until 1953 when the National Gallery and Tate Gallery Bill was passed by the Commons. In 1917 the Treasury had endorsed proposals that the Tate should have its own Board of Trustees appointed by the Treasury (Tate Gallery Chantrey Files, hereafter CF; Treasury Minute, 24 March 1917). It was also determined that professional artists should be recruited as members. However, proposals for artist-members of the Board provoked anxiety at the Tate over the appointments of RAs.

The Treasury thought it appropriate to include the President of the RA (PRA), Aston Webb, as an *ex officio* member. At the Tate it seemed that the RA's influence would be enhanced. Keeper Charles Aitken threatened resignation. Concern was voiced that the RA, 'failing to get a favourable reception at the Treasury', had agreed 'nominally to a policy of friendly discussion'. On this account the aim of the RA was to 'limit concession to polite words and meanwhile secure as many Trusteeships as possible with a view to learning the policy of the Board if not dominating it.'[5] Significantly, however, the portion of the statement referring to RA policy is marked 'omitted' in the archive document.

Challenged by the National Gallery Board, the Treasury now accepted the need to avoid official representation for the RA, reporting that the PRA also accepted this. Aitken was not reassured, despite Treasury protestations that he had not been 'given away'. The Treasury, by now exasperated with Aitken, pleaded for co-operation rather than resignation:

> I have not been expressing any views of my own on the points that you [Aitken] mention. I have merely explained to you and others (with whom I have been in semi-official communication ...) the official effect of perfectly definite undertakings and decisions arrived at by the Heads of the Treasury from time to time.
> (CF: Davies to Aitken, 18 May 1920; Davies to Aitken, 23 June 1920)

The moment passed, though Aitken remained vigilant. In 1926, the RA having lost its copy of the relevant Treasury correspondence, Aitken reminded it of the terms of Webb's appointment while explaining that his Board would greet appointment of Sir Frank Dicksee (PRA) as an infringement of Treasury rules (CF: Aitken to RA, 19 November 1926). However, artist-trustees became an accepted feature of Tate government, and the Treasury endorsed the notion of an inclusive Board that would represent the wider interests of art, not simply the RA.

Board membership is an indicator of the contested process of separation of artists from control over the museum and of the struggle to determine museum authority in relation to the plethora of modern styles of art. In the 1950s, Director John Rothenstein had battles with artist-trustees and with other Board members which placed his authority and integrity as Director at stake (Rothenstein, 1966: 260–368). Tate boardroom struggles over the application of trust funds spilled out into the public sphere as matters of trust and cultural authority; some of Rothenstein's critics determined that Tate acquisitions were failing to follow the course of modern art.

These skirmishes were moments in the autonomization of the cultural field; they shed light on the museum as an arena of struggle between officials, artists, collectors and so forth. The autonomy of art was a contested process which cut across institutions and people. Lost correspondence, amended records, misunderstandings, hopes, a sense of betrayal, official decisions whose outcomes are not fully appreciated – these are tokens of the routine messiness of official lives which yield episodes of co-operation, institutional deadlock, unexpected outcomes and structured inequalities. These events do not reflect structural contradictions; they are evidence of people struggling to put their institution on the road, to think what they might or might not have in common with each other.

Chantrey's will and official discourse

Had not Chantrey intended his gift to fund the creation of a collection of works by British artists? On that interpretation the Tate was founded as a gallery which would realize his intentions. His intentions were something that the Chantrey inquiries sought to establish. Out of the Chantrey inquiries flowed discourse which sanctioned the autonomy of the field of art and the distinction between art and mere pictures of objects. The 1904 Inquiry expressed concern about the popularity of Chantrey paintings: 'The collection ... contains too many pictures of a purely popular character' (Crewe, 1904: 498). The Committee was echoing the sentiments of MacColl, who called for a purchasing policy that forestalled public opinion in recognizing genius and did not go to the most popular pictures of the year.

Critics of the RA proposed that purchasing art was a wager on the future, a wager which created a distance between the true collector and popular art:

> it is a matter of exact arithmetic to tell at what date Degas will be added to the canon. In about a year he will be too great to paint as he does; in another he will have taught us ... in three he will 'make an appeal to the ordinary person'. In five years 'L'Absinthe' or some other work of the master, will be in the National Gallery, if we can afford it.
>
> (MacColl, quoted in Thornton, 1938: 25–6)

The popular novel *Trilby* drew its readers into the world of difference between merit and sale: 'this picture [painted thirty-six years ago by the artist-hero] ... sold only last year ... for three thousand pounds. Thirty-six years! That goes a long way to redeem even three thousand pounds of their cumulative vulgarity' (du Maurier, 1896: 208).

Chantrey's instructions (those assigning a central role to the RA) emanated from a world which took as natural the association between central academies and consecrated art. The nineteenth-century RA was a visible source of cultural power so that Society and Academy shared centres. The turning of the Chantrey Bequest into a problem was an assault on that mode of authorizing creativity. The residues of academic power were sustained and challenged at the Crewe and Curzon inquiries as RAs and their enemies tried to pin down the Will's terms and defend their definitions of art. For RAs it was difficult to accept that the best pictures did not come to their Exhibition. For art officialdom and those art critics arraigned against the RA it was evident that important art might be discovered elsewhere if only the RAs cared to go out and look for it.

The Crewe and Curzon inquiries are windows of opportunity for viewing the relationship between the state and museum classification. They projected the wishes of a donor who had died in 1841 on to the early twentieth-century art world; they interpreted his instructions by reference to early nineteenth-century fine art practices. Some questions were resolved by reference to the orthodoxies of early nineteenth-century high art or history painting, the kind of art upon which the academic tradition was based. What did early nineteenth-century high art connote in the early 1900s? Chantrey was projected into the twentieth century by MacColl, as someone who would have professed support for artists such as Degas, Monet, Pissarro and Rodin:

> You must suppose the testator to be a continuing being. If he has to pronounce a judgement on the art of our day you must not have him cut off dead in his grave and put to him things which had not come about in his time.
>
> (Crewe, 1904: 593)

MacColl's whimsy sheds light on the museum; it reflects the need to justify practices by reference to an enduring inner principle, in this case the intentions of the testator. It indicates the agency of art classification in its freezing of modernity and in its abstraction of elements, past and present, from the field of art. Here inquisition purports to reveal the truth of Chantrey's intentions and to ground them in the priorities of the early twentieth century. Yet such inner principles (whether of art or donors' intentions) are fabrications; they are evidence of the process that is the making of the museum. MacColl tears Chantrey from his context and converts him into a disembodied capacity to recognize the genius of any time.

The Chantrey inquiries brought three discursive objects into focus: modern art, the artist-as-creator, and professional expertise. The Will instructed that preference be given to works of the highest merit. Accordingly the inquisitors probed the selection practices of the Chantrey trustees. Were exhibitions other than that of the RA surveyed? Were portraits candidates for selection? Did the trustees visit artists' studios? The 1904 Inquiry noted the absence of studio visits. Identification of these omissions signified change in the basis of cultural authority, for they implied that creativity did pass through a central exhibition. The Chantrey inquiries looked for the fortuitous discovery of art at an artist's studio. They gave coherence to a radically individuated creativity, uncoupled cultural authority from Society and recognized the world of modern art. Before the Curzon Inquiry Roger Fry called not just for the expropriation of the Fund but for its subordination to expertise. With Curzon's remit to consider the problem of the sale and export of national treasures there was also the question of gathering intelligence on the market. Who was to be an expert? Critics? Dealers? The Inquiry settled for quasi-official expertise: an 'elastic' arrangement with a small group to be consulted individually and secretly as 'beaters for the Trustees' (Curzon, 1914–16: 348).

These were acts of power and knowledge. Official inquiries normally elide power, for their *raison d'être* is to appear as revealed truth. However, there were moments at which the power to call witnesses, the power to speak, the power to edit, bobbed to the surface. Curzon was clearly partisan where Crewe handled things with 'scrupulous fairness and courtesy' (Blomfield, 1932: 268). Curzon was not a committee of government; it was appointed by the trustees of the National Gallery and passed itself off as official. The witness stand was packed against the Royal Academy. When the key witness for the RA, Edward Poynter PRA, asked leave to return with a crucial correction to his evidence, he was refused.

A national gallery of British art?

The Tate promised something which seemed, until 1897, to lack coherent museum representation – British art. Through the Bequest it was armed with a fund that allowed it to receive British art. What was British art and how did Chantrey define it? Problems emerged which suggested that the Tate was not a response to the priority of Chantrey's real intentions. Rather than being a medium through which the intrinsic Britishness of its collection was disclosed, the Tate was a contested site at which the significance of nation and the meaning of British art were determined.

The Chantrey inquiries revealed anomalies arising from attempts to map the history of British art onto historic periods which had lacked a concept of the British artist. When and where were British artists? Chantrey instructed that works purchased might be executed by artists of

any nation provided they were entirely executed within the shores of Great Britain. Such an instruction cannot have been at odds with the heterogeneous national composition of the early RA. However, the Will, as interpreted by RA purchases, proposed a more narrowly national definition of British art. A question raised at the Chantrey inquiries concerned the meaning in Chantrey's Will of 'British fine art'. Did it mean art produced in Britain and perhaps by foreign artists, or did it mean art produced by British nationals?

Before Curzon, Sir William Armstrong of the National Gallery of Ireland declared that 'art, to be interesting must be national' (Curzon, 1914–16: 64). However, confronted with the ambiguous story of nation-building, the inquiries' classification of British art ran into the sands of anachronicity. How many of the early academicians were foreign (Crewe, 1904: 521–2)? Was Van Dyck, as an artist who had painted in England, to be assigned to the National at Trafalgar Square 'as a foreigner or to the Tate as an Englishman' (Curzon, 1914–16: 406)? If the Chantrey Bequest was a national gallery of British art, why were no selections made from Scottish exhibitions (Crewe, 1904: 562–3)? What was British art? Was modern art really foreign art?

These were years in which citizenship was defined legislatively (in 1905 and 1914). As others have shown, the museum was one of a panoply of institutions which registered a British imperial identity in which class divisions were supposedly to be dissolved (Coombes, 1991). Some of the witnesses called before the Chantrey inquiries of 1904 and 1911 felt compelled to point up the contrast between British and foreign art – and to defend the former's integrity from the dangers of contemporary French influences.

In Europe the dominance of Paris established French painting, both positively and negatively, as a measure of developing local vernaculars. As an international centre of training and exposition, Paris provided alternatives to the RA with consequences which gave academic versus modern a national connotation. The Impressionist and post-Impressionist exhibitions of 1905, 1910 and 1912 provoked outraged accusations that modern art was degenerate (Bullen, 1988). Stephen Spender recalled his father's 'public indignation' at modern art, his raging against certain rooms at the Tate, those he called the 'lunatic asylum' and his demonizing of the moderns, Augustus John, Bernard Shaw, Lytton Strachey and Vincent Van Gogh (Spender, 1952). The coding of bourgeois taste as national academic style made the artistic controversies of this period potent and acrimonious; in its challenge to academic classification post-Impressionist discourse threatened the concept of a national school. Where the years 1892 to 1905 had marked a period of 'retrenchment' in which British roots for Impressionism were discovered (Gruetzner, 1979; McConkey, 1989), the post-Impressionist shows were expositions of works which were assimilated by supporters of the RA as symptoms of national degeneracy and mental illness.

The Tate, the state and the development of the cultural field

By the mid-nineteenth century the three key fractions of the upper class, land, finance and industry, were interdependent but not integrated. Divisions within the propertied class had created an expansive fine arts system which had empowered the middle class and (e.g. through the purchases of the Bequest) accommodated its art in a national collection. However, the upper class began to fuse in the face of agricultural depression, changing world markets, the political demands of the working class and the emergence of the representative state. The aristocracy lost its identity as a purely landowning class and was drawn into closer associations with finance, industry and particularly the professions (Massey and Catalano, 1978; Scott, 1991: 61). Decline of the landed aristocracy accelerated impersonalization of cultural power. It led to a rapid commodification of art (facilitated by the Settled Lands Act of 1882) which was serviced by a new expertise, dealers, specialist periodicals, etc. Confronted by the threats of mass democracy and the mass media, the state was drawn into the business of creating a national collection of British art; the building of a national collection was imbued with the politics of democracy. These processes (an acceleration in the decline of the landed aristocracy, fusion of the capitalist class, expansion of the state-sponsored professional class) shifted the balance of power within the cultural state (Savage *et al.*, 1992; Scott, 1991).

The structuration, or active constitution, of the upper class favoured new aesthetic partnerships between class fractions and the state. For example, it seems likely that the demise of the old aristocratic British Institution and the establishment of the Burlington Fine Arts Club are moments in the cultural integration of the capitalist class. The Burlington Fine Arts Club was a successor to the British Institution which expired in the late 1860s. The Club's aim was to provide a focal point for collectors who might compare artefacts and share their interests. In addition, there was the goal of exhibiting artefacts. In this its objectives were frankly exclusive and exhibitions were accompanied by highly scholarly and illustrated catalogues. Thus key figures of the old order of aristocratic collectors and amateurs (such as Lord Lansdowne) were drawn into association with South Kensington experts through the Burlington Fine Arts Club. The Club was formally established in 1866 although its roots go back to the mid-1850s *conversazioni* of the Fine Arts Club which met at the residences of its collector members during the Season (Benson, 1924).

Among the leading lights in this society was South Kensington man J.C. Robinson (1824–1913). Robinson, erstwhile head of the government school of design at Hanley and first superintendent of art collections at South Kensington (then at Marlborough House), moved in the circle of Staffordshire's country gentry.[6] Robinson is credited with founding the group and with obtaining official permission to meet at the museum. Both

its membership and its associations are indicators of a shifting balance of cultural power, for membership included art officialdom (Eastlake of the Royal Academy, Redgrave of South Kensington) as well as traditional collectors. The institution's access to South Kensington is an indicator of a cultural *rapprochement* between the old and new orders.

British art institutions were, therefore, not passive reflections of class interests; rather the Burlington, the RA, the Tate and the Chantrey Bequest were sites at which class identities were proposed and interpreted. The Chantrey conflict was one in which the protagonists made themselves up and were made up – there was no essential Tate, no essential RA. The key players – the RA, the Tate and the Treasury – formed a configuration of shifting institutional power caught up in cross-cutting ties of cultural interdependence which extended into the wider society. The actions of building national art collections, forging new institutions such as the National Trust and trying to solve the problem of the Chantrey Bequest were moments in the formation of a capitalist class which was losing its singular association with the land and confronting the cultural correlates of modernity.

Thus it was that the Curzon Inquiry brought two subjects into the same frame: the fate of aristocratic art and the making of an aristocracy of culture. Its remit was to 'inquire into the Retention of Important pictures, and other matters connected with the National Art Collections [i.e. the Chantrey Bequest]'. One of its actions was to set in motion discreet official trawls for donors to the national collections. Confidential correspondence of 1913 to 1918 between Norbert C. Witt, Lord Curzon and Aitken of the Tate contains lists of potential donors, thumbnail sketches, lists of works that might come to the nation and observations on their likely stances.[7] Here we can see the culturally mediated incursion of powerful economic outsiders: imperial plutocrats such as Edmund Davis, bankers such as William C. Alexander and art dealers such as Otto Gutekunst. The national collection of art was a location at which new class identities were forged as these candidates for inclusion in the Establishment offered up their credentials as art donors to the nation.[8]

Recent scholarship establishes the variety of aristocratic responses to agrarian decline and the reordering of Society. One was the sectarian response of withdrawing into a set or clique such as the overtly aristocratic Souls (Davidoff, 1986). Another was cultural collaboration with other sections of the upper class (Cannadine, 1990). Aristocrats became stewards of national treasures whose potential for export was converted into a collective anxiety. They were heavily recruited as trustees in the developing national museum system (Cannadine, 1990: 578–81). Attacks on the RA's Chantrey prerogatives were aspects of this remaking of cultural power as public service. As museum trustees, aristocrats established an identity that was consonant with the ideological requirements of a disinterested state: Lords Crewe and Curzon presiding

over Chantrey inquiries (the former a committee of the House of Lords), the ubiquitous Lord Crawford on the Board of the National Gallery, Lord D'Abernon chairing the Tate Board and Lord Plymouth chairing RA–Tate Chantrey conferences in 1918 to 1919. In the late 1930s the Tate Board was 'seigniorial in tone, dominated by aristocratic connoisseurs and men of affairs' (Rothenstein, 1966: 19).

A consequence of shifting balances of class cultural power was a conflict over art classification which centred on the Tate. One effect, combined with the Treasury's funding arrangements, was to make the Tate Gallery a site of competing classifications. On the one hand the class politics of British democracy deepened the state's commitment to delivering a national pictorial culture to subordinate classes. On the other hand the process of state formation spawned a stratum of professionals whose reproduction as a class depended on the struggle for distinction from economically superordinate and culturally subordinate groups. The outcome was an aesthetic partnership between the state, the professional class and a declining aristocracy. This manifested itself as an affinity between the Tate's officers and a reformed Treasury's officers who shared a habitus of distinction.

The professional class pressed the privilege of cultural capital against economic capital (securing its own reproduction through credentialism) and disqualifying others from speaking on grounds of lack of expertise. Its exploitation of economic capital's dependence on cultural capital went hand in hand with the state's domestication of economic capital (e.g. through taxation and inheritance laws) and with the promotion of cultural capital as a resource to be exploited by the state (e.g. as intelligence, qualifications). The professions had a stake in clarifying and legitimating inequalities of cultural capital as the natural order of things. Thus Fry, who spoke for expertise as a witness before the Chantrey inquiries and recommended expropriation of the Bequest from the RA, located Alma-Tadema's constituency among 'the half educated members of the lower middle-class' (Tillyard, 1988: 216).

Middle-class expansion intensified the struggle for distinction as the professions perceived their boundaries to be threatened by a lower-middle-class army of clerks and administrators (Banks, 1954: Chapter 7; Perkin, 1989). Political enfranchisement magnified the lower-middle-class sense of working-class incursion as the former increasingly sought difference on the terrain of secondary education. As Carey (1992) shows, after 1880 a number of English intellectuals imagined the new enfranchised as the masses and invented identities of dirty ineptitude and deplorable appetites – people who unreflectingly snapped the world with their Kodaks. At the same time the professional class differentiated itself from the economically superior plutocracy of industrialists and financiers who cultivated aristocratic displays of wealth. The visibility of the plutocrat's search for distinction was the target of cultural strategies that exposed the vulgarity of conspicuous display and the effort that was

necessarily a failure to achieve the ease of distinction. Through du Maurier's Society Cartoons of the 1870s and 1880s, to *Trilby*[9] (du Maurier, 1896), *Hadrian VII*[10] (Rolfe, 1978), *The New Republic* (Mallock, 1906) as well as memoirs of the late Victorian art world flows the *frisson* of discovering the outsider artist (e.g. the celebrated Lawson), the superiority of ascetic distinction and the vulgarity of commercial success.

Professional interests were accommodated by educational reform and by the attack on aristocratic patronage. The Northcote–Trevelyan reforms introducing open competition into the Civil Service were not directed to the elimination of the aristocracy, but its partial displacement towards cultural capital. Gladstone sold reform to the aristocracy on grounds that their distinction from the mass, their superior 'natural' gifts and their acquired advantages of 'birth and training' would stand them in good stead (Ingham, 1984: 139–42). This would be in a reformed Civil Service which, as he explained, retained recognition for aristocratic merit at the upper echelons. An aesthetic which naturalized the gulf between the elite and the masses had an affinity with the developing mandarin culture of the Civil Service and particularly with the Treasury. Reform promoted a cult of public service that drew on the culture of the humanities while it marked its distance from the material world of industrial capitalism. As a reworking of the distinction embodied in the aristocratic leisured gentleman it was a middle-class bridgehead to the upper class. Reform endorsed the separation of the routine clerk from the intellectual means of production.

The enlarged professions included those fine artists and museum officials who challenged the prerogatives of the RA. Art institutions were sites at which struggles to make the difference between mental and routine non-manual labour palpable took place. One officer at the National Gallery in the early 1900s believed that he had been passed over for promotion because he had 'needlessly and heedlessly' passed an examination that had tarred him with the brush of second division clerk (Holmes, 1936: 263–4). It is significant that the early officers of the Tate were not RAs – by kinship and occupation they had affiliations with professions such as banking, the Church and teaching.[11]

The reproduction of the professional class placed it at odds with Chantrey pictures. Their accessibility via the codes of school history, literature and Victorian morality gave Chantrey art irredeemable provincial and lower-middle-class associations. Its passage through the exhibition tarred it with the brushes of interest and conspicuous consumption. Expertise, the need for a national collection which was distinguished, the metropolitan sense of London as the locus of cultural power were among the tacit assumptions which drove the inquiries of 1904 and 1911. They gave coherence to a metropolitan perception of creativity which stigmatized Chantrey pictures. Stigmatization went hand in hand with a growing rapport between the Treasury and the Tate. The appointment of MacColl as Keeper at the Tate in 1906 was said to be a

strengthening of the anti-Academy lobby in official circles. Before the Curzon Inquiry MacColl claimed the Treasury had encouraged him to create a deadlock with the RA by refusing to accept Chantrey pictures.

A mode of acquisition that was heavily dependent on gifts and bequests corresponded to Treasury practices. Division of responsibility in the management of the national collection does not imply the absence of centralized control over metropolitan galleries and museums. The public players in the Chantrey affair were, of course, the RA and the Tate Gallery. Behind the scenes was the Treasury controlling expenditure; the situations of the RA and the Tate were interwoven with Treasury power. In refereeing the Chantrey affair the Treasury was sympathetic to the plight of the Tate; consolidation of Treasury power spawned an ethos that was consonant with the aristocratic Curzon style, with the notion of modern art promoted by the Bloomsbury group and other intellectuals. MacColl of the Tate espoused a philosophy of patronage that was consonant with Treasury aims: 'It is no business of the State directly to "encourage" art any more than it is its business to encourage eating and drinking' (MacColl, 1931: 375). His successor as Keeper at the Tate, Charles Aitken, noted the Tate Board's success in enlisting 'gifts and pictures worth more than a quarter of a million' (CF: Aitken to Cameron, 17 July 1920).

The politics of the Bequest may have been linked to an ideological convergence between the Treasury and the Tate and to the consolidation of Treasury power over the cultural state. Minihan suggests that there was an affinity between the shift away from generous mid-twentieth-century cultural subsidies and aesthetic attitudes which drove a wedge between art and the public (Minihan, 1977: 166). Treasury containment of public arts expenditure accompanied artistic ideas which celebrated the antagonism between artists and the public. Why bother funding art when, by definition, the true artist and the actual public were poles apart? It is also plausible that there was an affinity between the spirit of a reformed Treasury and the Tate.

Implementation of open competition was a protracted affair; patronage continued as a feature of the Civil Service into the twentieth century (Bourne, 1986; Cannadine, 1990). None the less, the process of professionalization is evident (Cannadine, 1990: 243); '[i]n every ministry, there is a clear point when the old nobility bowed out and the new professionals took over: ... 1911 in the Treasury' (Cannadine, 1990). Among the key Treasury figures dealing with the Tate and the RA were Francis Mowatt (1837–1919), Thomas Little Heath (1861–1940), J. Bradbury (1872–1950), George Lewis Barstow (1874–1966) and R. S. Meiklejohn (1876–1962). Mowatt belongs to an earlier generation but the others were products of an opening up to new men of talent who arrived via the reformed and elite public schools (Roseveare, 1969: 152–81): a generation whose dazzling intellectual achievements readily fused with aristocratic distinction. Opening up to them was a closure against the mechanical clerk. Reform secured the distinction of mental labour in

the service of the state through a translation of aristocratic culture into cultural capital.

The Tate and the RA dramatized the story of modernism together through the routine intercourse of their members' institutional lives. The RA remained a force within the cultural state as the voice of the midcult taste of the middle and lower-middle classes: 'What the British public wants is pictures of dogs and babies, of "Granny's chairs" and Mother's darlings, of moving tales by flood and field.' In the 1930s one academician opined that it was 'mainly concerned with the unsophisticated visitor who hopes to apprehend readily what he sees' (Lambert, 1938). In describing its mission the RA presented itself pragmatically 'as a steadying influence on the haste or extravagance of innovators' (Lamb, 1951: 115).

Conclusion

Assessments of the English reception of modernism and the fate of Victorian painting have usually had a different focus from the one provided here. In the past, as Tillyard (1988) shows, received wisdom dramatized the English reception of modern art by privileging the agency of pioneer critics and collectors at the expense of shifts in the visual habitus of the urbanized professional class. I have tried to show that these transformations were interwoven with the wider modernity that was the commodification of aristocratic art, the decline of the landed aristocracy and the formation of an aristocracy of culture. This chapter has been concerned with an association between that transition and a reordering of the relations of state cultural power.

Interpretation of the Bequest pulled the Tate in two directions: towards a popular national art which equated merit with RA exhibition success and towards an elitism which did not expect validation from a contemporary art public. The problem was conflict over art classification; the Tate confronted the difficulty of reconciling the invention of national tradition with the mapping of distinction. Conflict over classification was an aspect of state formation and in four key respects.

First, state formation was a process which pitched official institutions against each other; the problem of the Bequest opened up fissures within the state. The key players – the RA, the Tate and the Treasury – constituted a configuration of institutional power caught up in the cross-cutting ties of economic and cultural interdependence which extended into other parts of the state and into the wider society. The protagonists were different kinds of intellectuals – Curzon, that 'most superior person', an aristocrat struggling for office within the bureaucracy of Empire and Viceroy of India, MacColl, Rothenstein and others located as arts officials and, of course, the artists of the RA.

Second, Chantrey was part of a remaking of the relationship between knowledge and power which fractured the public sphere of late Victorian

culture. The Bequest was a site of official struggle over classification, a struggle to make the difference between art and mere pictures palpable. Its outcome was a separation of the RA from the means of determining a national collection. In endorsing this separation the state was responding to the autonomization of the cultural field. The collection was, as it were, laid over the shifting continents of the field of power and the cultural field. Tremors, if not an earthquake, were inevitable.

Third, the outcome of the struggle was the forging of an aesthetic partnership between the state, the professional class and a declining aristocracy. The class politics of British democracy deepened the state's commitment to delivering a national culture to subordinate classes; it spawned a stratum of professionals whose reproduction as a class depended on the struggle for distinction from economically superordinate and culturally subordinate groups. Lord Curzon would have endorsed the critic Hamerton's insistence in the 1870s that '[t]he multitude is not the supreme judge', and Stevens' impatience with the painter who cares to score by playing on the literary tastes and social instincts of the crowd (Hamerton, 1889: 270; Stevens, 1897: 4–5).

Finally, elements within the field of cultural production and within the field of the state converged on a conception of disinterested patronage. The ideological significance of the arts ran beyond expenditure: they highlighted the virtues of a minimalist state that privatized taste, left individuals to their own creative devices and encouraged donations. The Chantrey arrangements were of a piece with Treasury practices which favoured a gift-horse and looked-for savings. Most government museum expenditure was sanctioned by parliamentary votes and paid through the Treasury. The annual purchase grant to the National Gallery was cut from £10,000 to £5,000 at the close of the nineteenth century while the Tate had no grant from its inception until the 1940s. The Curzon Report reckoned that the annual average parliamentary grant to the National was £13,262 in the period 1865–89, £6,844 for 1892–1901 and £9,200 for 1902–11 (Curzon, 1914–16: 7). In the 1920s gifts to the British Museum and the Victoria and Albert Museum substantially outstripped the values of their purchase grants (PEP, 1946: 108–10).

Notes

1 The Chantrey Bequest was the sole subject of the Crewe Inquiry, one of two subjects covered by the Curzon Inquiry and one of several covered by the Massey Inquiry: Chantrey Trust: Report, Proceedings and Minutes of Evidence, Select Committee House of Lords, UK Parliamentary Papers (1904), 357, v, 493 (Crewe Inquiry). National Gallery, Committee of Trustees, UK Parliamentary Papers, 1914–16, Cd. 7878, 1914–16, Cd. 7879 (Curzon Inquiry). The Report of the Committee on the Functions of National Gallery and Tate Gallery and, in respect of paintings, of the Victoria and Albert Museum together with a memorandum thereon by the Standing Commission

on Museums and Galleries, UK Parliamentary Papers, Cmnd 6827, May 1946,
4 (Massey Inquiry).

 Vincent Massey and his wife were collectors of modern art. In 1946 the Tate
exhibited seventy-one works from the collection of Mr and Mrs Massey. The
show, *A Collection of Contemporary English Painting*, contained works by
Vanessa Bell, Ivon Hitchens, Paul Nash, Walter Sickert, Graham Sutherland
and others (Tate Gallery, 1946).

2 Chantrey's Will was published as an Appendix to the Royal Commission
 enquiring into the affairs of the RA: United Kingdom Parliamentary Papers,
 1863: 3205; also in *Chantrey and His Bequest*, 1904: 15–22 (extract); MacColl,
 1904.

3 John Bradbury (Treasury Chambers) to National Gallery, 24 March 1917
 (Curzon Papers: Mss Eur F 112/58).

4 Aitken to Director and trustees of the National Gallery, 4 September 1916. The
 letter refers to the possibility of diverting the Chantrey Fund after the war and
 notes how much can be accomplished through gifts and bequests.

5 Statement by the Director in regard to the four Chantrey conferences and the
 attitude of the Board towards the Treasury in respect of the Chantrey Bequest
 (Chantrey Files).

6 Keele University, Sneyd Papers, s[RS/Rev.WS]/41; s[RS/Rev.WS]/66; s[RS/
 Rev.WS]/75;76.

7 Curzon, 1914–16.

8 Edmund Davis of Chrome Co (with interests that bear on munitions) is willing to
 make over a Gainsborough, three Whistlers, an Alfred Stevens and a Corot. The
 offer requires a KBE. Otto Gutekunst, with no children, is a partner in Colnaghi
 and Obach and feels that he has been 'overlooked in favour of Agnews [a rival art
 dealer]'. Marked 'Strictly confidential' is the name of William C. Alexander, who
 has promised a Whistler and indicated that more is in the pipeline. Others are Sir
 William Lever, J. C. J. Drucker, T.J. Barrett (chairman of Pears Soap), Sir Joseph
 Beecham, Lord Howard de Walden, and Sir Edgar Speyer. An additional list
 names Lady Tate, apparently hurt that she had not been consulted on the Turner
 wing, and Joseph Duveen. See, following correspondence on these and other
 related matters: Curzon, 1914–16; Aitken to Curzon, 27 October 1913 (F112/56),
 Aitken to Curzon, 8 November 1913 (F112/58), Witt to Curzon, 12 December
 1918 (F112/58).

9 *Trilby* plots the mythic artistic career of Billy Bagot, who dies prematurely but
 is immortalized in his art. Driven by lost love Bagot pursues the low life in
 Whitechapel and at the Docks – at 'the eastest end of all'. However, he comes
 'to prefer ... the best and cleverest of his own class – those who live and
 prevail by the professional exercise of their own specially trained and highly
 educated wits' (du Maurier, 1896: 232).

10 *Hadrian VII* is a fantasy about an Englishman elected Pope. Hadrian is an
 ascetic who purges the Vatican of its treasures and covers its walls with brown-
 paper packing. As an act of charity and despite the fact that he does not wish
 his face to be committed to posterity, he commissions his portrait from a
 painter he detests: 'He loathed the cad's Herkomeresque cum-camera-esque
 technique' (Rolfe, 1978: 169). In 1904 two paintings by Hubert Herkomer hung
 in the Tate's Chantrey galleries.

11 The first Keeper, Sir Charles Holroyd (son of a merchant) was originally
 destined for a career as a mining engineer; MacColl (son of a clergyman)

studied at London University; Aitken studied history at Oxford and was a schoolmaster before becoming Director of the Whitechapel Art Gallery; Manson (son of a writer) began his career as a bank clerk, abandoning this to study art in Paris.

8

Towards an historical typology of art museums

Introduction

Recent research has advanced our understanding of the role of museums in defining art and fixing identities (e.g. Crimp, 1993; Duncan and Wallach, 1980; Sherman, 1987). However, apart from Zolberg (1981) there has been little systematic attempt to map the social relations which are sources of discursive conflict at the museum. How do conflicting visions of what a museum should be relate to the social order? How are conflicting visions of the social order represented in the discursive heterogeneity of the museum? To what extent is discursive conflict also social conflict? This chapter tries to answer these questions by focusing on art museums and by proposing an analytical framework based on Basil Bernstein's theory of cultural codes. It presses the case for a map that will establish the social co-ordinates of museums without treating them as appendages of social structures.

I have in mind a map which locates the art museum as a shaper of the social terrain, not one which places it within the fixed co-ordinates of an already drawn map. There are three reasons for saying this. First, the display of artefacts is a relationship. The subject of the meaning of a museum collection is the web of people and artefacts which constitutes its institutional life: it is those patrons, curators, visitors, etc. who have of course other lives as rulers, experts, employers, employees, spouses, schoolchildren, etc. Museum meanings cannot be assigned to a particular group; they arise continuously out of the social intercourse of groups and their interdependencies.

Second, museums are constitutive of groups. The museum, along with other cultural agencies such as schools, pays its way by articulating identities. Thus aristocratic, bourgeois, proletarian, gender, age and ethnic identities can be, in part, museum identities. The museum tacitly answers the questions: What does it mean to be middle class or working class? Who is a professional? When is a child? The museum is partially constitutive of the very social order which it might be thought to express in that it organizes and disorganizes identities. This argument has ontological implications in that art museums, along with other art

institutions such as academies and exhibitions, are not ideological servants of enduring interests. Rather they are sites at which identities are projected, though not always successfully or enduringly so.

Third, art museums do not receive art; in part they make it. To put it more precisely, art and the museum are dialogic counterparts to each other: they form a developing partnership. This partnership has been associated with the process of state formation.

These observations suggest the need for an analysis capable of specifying the museum's transactions with other institutions without dissolving it into the social structure. To give the problem a different formulation: How, from the late nineteenth century, did the museum become a necessary or obligatory 'point of passage' for the art of living artists (Callon, 1986)? It was not always so, for once the academy authorized artefacts to be art. With hindsight we can see the animus of some modern artists towards the museum as interwoven with a shifting balance of power from the academy to the museum. The rise of the museum of modern art (e.g. the Luxembourg, The Tate and MoMA) brought the artist-as-creator into focus just as artists-as-corporations (the Academy) were separated from the means of determining art history. The problem is to account for the museum's point of view as it emerges within a configuration of institutions and social actors, and to do so while avoiding the pitfalls of reductionism.

Only connect

One aspect of the contemporary division of academic labour is its unproductive compartmentalization of diverse inquiries which could together become mutually informing enterprises. A case in point is the almost complete failure of museologists to spot the work of British sociologist Basil Bernstein.[1] He is widely known for his pioneering work on social class, language and schooling as well as for his key contributions to the sociology of the curriculum. However, the wider significance of his work for cultural theory and research has been little appreciated, although the case has been made (Atkinson, 1985; Dimaggio, 1982, 1987).

Bernstein's relevance to museums arises from his work on school curricula as socially organized knowledge and from his analyses of curricula and pedagogies as encodings of power (Bernstein, 1971, 1975, 1986, 1990, 1996). Like Pierre Bourdieu, who has also contributed to the sociology of education and inequality, Bernstein is concerned with the role of schools in permitting and privileging identities and modes of social control. Like Bourdieu, Bernstein is concerned with the relationship between the ordering of the school and the ordering of society. Bernstein agrees with Bourdieu that schools conceal social power in the myth that the school is neutral (Bernstein, 1996). However, Bernstein argues that there is more to it than this, for schools also re-engage creatively and discursively with the world to 'contain and ameliorate vertical

(hierarchical) cleavages between social groups' (Bernstein, 1996: 9). This is important because, partly under the influence of Bourdieu, some research has treated the art museum as little more than a vehicle for a dominant ideology or dominant class (Duncan, 1995; Duncan and Wallach, 1980).

This is where Bernstein has carved out a distinctive theoretical space. He argues that the school is neither a conveyor belt for the power of dominant classes nor a sealed textual space for celebrating difference (Bernstein, 1996). Rather, the differences and solidarities which may appear to be 'out there' in the wider social structure are partially written in and by the school in the action of pedagogizing knowledge. The problem is to find a theoretical language which permits us to make the connection between schools and power or, in our case, museums and power, by specifying the grammar that corresponds to the 'writing' that recontextualizes or transforms artefacts. The point about museums is that, in acquiring artefacts from the field of art and in displaying them, they recontextualize and encrypt cultural power. This chapter deploys three of Bernstein's concepts – code, classification and framing – to theorize discursive conflict at art museums. It argues that Bernstein can enhance our understanding of the museum as an interweaving of meaning and power.

Bernstein insists that because classification is a *relationship* of power/ knowledge there is always potential conflict or resistance which may disrupt prevailing educational discourses. I suggest that his analysis points to sources of disruption which are suggestive of David Lockwood's classic distinction between system and social integration (Lockwood, 1964). I argue that modernization is to be conceptualized in terms of this distinction; that the source of a museum's contradictions is the network of institutions *and* actors in which it is located and through which power flows. The distinction allows us to conceptualize the museum's point of view, its ordering of identities, but without leaning on aesthetic or social teleologies. It alerts us to the possibility that social actors, for example, museum directors following a new mission, may enact possibilities arising from contradictions between their own and other institutions.

The second part of the chapter, building on Bernstein, draws on the history of patronage and markets to propose a sociohistorical typology of art museum discourses. The objectives are threefold: (1) to grasp the connections between the institutional fine grain of museums and external distributions of power without sacrificing agency to structure or structure to agency, (2) to establish the co-ordinates for mapping museums in social space, and (3) to allow for the mutability of museums. Finally, the chapter draws on the evidence of the Chantrey Bequest dispute which was the subject of Chapter 7.

The museum as classification and framing

Art museums are classifying agencies; for example, classification is implied both by acts of acquisition and gallery arrangements. Museum

artefacts have other lives, even in those cases where they have been produced with an eye to their display as museum pieces. To translate Bernstein to the museum: the selection and combination of acquisition and display is a recontextualization of artefacts from other places, an abstraction from other spaces: from temples, chapels, palaces, households, exhibitions, artists' studios.

Abstraction can be a kind of violence, a symbolic violence, where the spectator's self-image is undermined or visual faculties disordered. Eighteenth- and nineteenth-century accounts record a visual anomy associated with the liquidation, looting and transfer of objects from palaces and churches to museums. A sense of estrangement could follow the emancipation of art from its ritual contexts: the loss of organic totality that was Italy (Goethe); a sense that objects had been torn from their proper contexts (Delecluze); of dazzlement and bewilderment at the Louvre (Shee).[2] Thus the making and remaking of the museum may cut across identities, provoking the surprise, protest or submission that attend symbolic violence and conjuring up conflicting visions of what it means to be an artist. Where, asked President Munnings of the Royal Academy of Arts, is there room for a large academic canvas in the modern gallery (Munnings, 1949)? And Ranciere and Vauday show how the witness of worker-delegates to the 1867 Paris Universal Exhibition is evidence for a contested abstraction in which the employers erased skill in favour of a spectacle of mechanization (Ranciere and Vauday, 1988).

Thus museum classifications may be contested not just in terms of the intrinsic attributes of artefacts (where does this belong?) but in terms of the ordering principles themselves. Museums are agencies of cultural classification in this deeper sense; they preserve not only artefacts but ways of apprehending artefacts and ordering the heterogeneity of the artefactual world. Their officers select and combine art(efacts) to create displays which order meaning and define what counts as art.

Classification at the museum is an encoding of power; it is a process by which some people's worlds are incorporated into the public culture and others are excluded. The museum naturalizes the social order; it stabilizes meanings, it regulates and interprets the uncertainties that flow from the divisions of modernization. It creates boundaries between things and people: those that go together and those that are set apart. There will be a boundary between the museum's galleries and the universe beyond (between the canon and other pictures) and there will be internal differentiations (e.g. between the styles of nations, historical periods or different kinds of artefacts).

The arbitrariness of power relations is expressed in the frozen categories of the museum which dislocate the 'potential flow of discourse' (Bernstein, 1996: 20). The museum punctuates and deletes aspects of cultural production; it recontextualizes things. For example, while reputations have circulated through the market as mass-reproductions (engravings, photographs, etc.) the museum has either stigmatized

photography as the medium of art's autonomy or recognized it through the classifications of pre-photographic categories. In this instance it is the *potential* flow of discourse through different spaces of art that is important, for the uncertain status of photography at the art museum betrays the latter's dependence on the former (Crimp, 1993: 1–31).

Pace Bernstein, discourse is ordered not just through classification of the universe but also through interaction or *framing*. Just as the centre of gravity between teacher and pupil may vary to yield different instructional modes, so too may the visitor/curator relationship or the curator/artist relationship vary the rules for apprehending and displaying artefacts. For example, the museum may determine the visitor's route through its displays or allow the visitor to make the determination. Bernstein's perhaps pre-Foucaultian[3] insight into schooling was that such changes, rather than releasing the child from power, were a reordering of power over the child; child-centred education brought the pupil more under the school's surveillance. By the same token it seems likely that museums know more about their visitors than they did twenty years ago.

Classification and framing identify implicit rules through which power is coded as discourse; power is in the process of encoding. Bernstein defines a code as a regulative principle which is tacitly acquired and which underlies the production of cultural forms such as speech or school curricula (Bernstein, 1982: 306; 1996: 193–6). Surface cultural forms, such as museum collections, are encodings of power which create and legitimate boundaries. In the case of museums, codes regulate how things may be brought together for legitimate public display, what must go together and what must stay apart.

Strong and weak classification

At school there may be variations in the strengths of curricula boundaries, internally and externally. Differentiation within a curriculum can be strong or weak, so that subjects are more or less insulated from each other. The ceremonial order of the school may be predicated on strong visible boundaries between specialists and their subjects of the kind associated with English A levels and single-subject honours at university. So too the museum may make the nation and the artist palpable through its classification of national schools of art, through its revelation of art's linear historical development. Oil paintings may be insulated from works in other media; there may be a strong hierarchy of subjects of the kind celebrated under the nineteenth-century academic system. In the cellular architecture of the nineteenth-century art museums we have the strong classification of nation and period that positions the viewer within the co-ordinates of European time/space.

On the other hand, the contents of school curricula might stand in an open relationship to each other, so giving weak classification. The curriculum might be reordered as topics to which diverse subjects are

subordinated: 'the Victorians' introduces pupils to history and geography, 'ecology' requires that boundaries between chemistry and economics are breached. The point is that previously insulated subjects are cast in open relationships through their subordination to some new ordering principle – a concept of the child or a political programme. Bernstein identified an impulse towards weak classification in British child-centred primary schooling of the 1960s where pupil identities were predicated on learning as a process of discovery (Bernstein and Davies, 1969).

Since the 1980s, but in different ideological circumstance to those of the 1960s and 1970s, museums have been subjected to the kinds of changes that prompted Bernstein's sense of a shift from strong to weak classification. The past twenty years have seen a reorganization of the museum world that has had profound consequences for the identities of curators and visitors. The postmodern museum, people's museums, eco-museums have challenged the strong classifications established by the nineteenth-century museum. We have the weaker classification exemplified in the new museology's reflexive shift towards a concern with visitors and the multiple meanings of artefacts, and towards a breaching of departmental hierarchies within museums.

Strong and weak framing

Framing specifies the underlying principle which regulates the encounter between teacher and pupil. To translate the analysis to museums framing is the term through which we specify the relationship between curator/patron and visitor. Where there is strong framing there are limited options available to the visitor. At one extreme the visitor may be escorted through the museum by a servant/guide, etc. (as at the early British Museum). As Duncan and Wallach (1980) show, the architecture of the museum may presuppose a singular route through the story of art so that the perambulations of visitors are rewarded by the revelation that the present achievement of a nation's art was the goal of the past.

Where there is weak framing, the visitor may be invited to discover different routes which yield interpretations rather than a final revelation. Visitors may be informed of the curatorial principles underlying the organization of displays, or even invited to take on the role of curator. Visitors' evaluations have of course, since the early 1980s, become part of the stock-in-trade of museum professionals. The arms'-length relationship between curators, artists and visitors is giving way to more collaborative modes of association in the form of art installations and people's exhibitions.

In keeping with Bernstein, variations in the strengths of classification and framing can be specified to identify two museum codes: collection codes and integrated codes. Collection codes are characterized by strong classification and strong framing, integrated codes are characterized by weak classification and weak framing. With a collection code there will be a hierarchy, with visible boundaries marked by strong internal

specialization and strong framing which determines the options open to the visitor. Where we have an integrated code we have the blurring of boundaries between artefacts, the subordination of previously insulated artefacts to a unifying principle such as a period taste or a theory of art.

I turn to the question of how museum coding is related to other social spaces and their transformations. There are, for example, the spaces of the artist's studio or the dealer's exhibition, through which artefacts may pass as candidates for museum status. Under what conditions will the ordering principles of the museum become exposed to assessment and criticism? Under what circumstances might the rules of a given ordering be stretched so thin that consent is withdrawn and new orderings proposed? If, as Bernstein argues, classifications contain contradictions, what will be the limits of their containment? We need a closer specification of the way in which the world outside the museum may or may not be successfully encoded, for the museum has a double relationship to the world: that of institutions and that of actors. The contradictions of classification invite consideration of David Lockwood on integration.

System integration and social integration

Lockwood proposed this distinction as a way of moving theories of social change beyond the impasse of 1960s conflict and consensual models of society.[4] An adequate theory required specification of structural opportunities which might or might not be enacted by social actors. The potentiality for change was to be theorized from two perspectives: that of system integration and that of social integration. The concept of system integration focused on 'orderly or conflictual relationships between the *parts*, of a social system'; the concept of social integration focused on 'orderly or conflictual relationships between the *actors*' (Lockwood, 1964: 245, emphases in the original). The former is concerned with the compatibility between institutions; the latter with relations of conflict or co-operation. Lockwood's central point was that the potentiality for social change was just that: system contradictions did not automatically unpack into social reordering. Social integration focused attention on performative aspect, on the possibility that social actors might or might not contain the latent tensions of institutions, that people might or might not withhold consent from the institutional arrangements in which they were enmeshed.

In the 1980s and 1990s the distinction between system and social integration has been revitalized as a way of comprehending two different aspects of institutions and the social organization of identities. One is modernity's tendency towards flux and uncertainty as institutions run out of control and out of kilter, permitting the possibility of changes. The other is that the maelstrom of social change creates latent possibilities for the emergence of new kinds of social actors, with new identities and new interests in classifying things.

To provide an illustration: the progressive unworkability of the academy in the nineteenth century. We have seen that in their study of the French academy the Whites (1965) identified tensions between the centralized academy and the market. The academy was grounded in the residual patrimonial norms of an estate system of cultural stratification. The point of reference for judging a work of art was the traditional legislative norm of a masterpiece which transcended any particular artist. Yet the success of the academy as an institution which caught the aspirations of the mass of artists was grounded in the norms of a heterogeneous market for critical interpretation rather than academic legislation. Moreover, the radical individualism of the market proposed artistic identities that were refractory with respect to academic norms. The Whites show how artists, among them the Impressionists, struggled to make the academy work yet finished up making the modern art world.

This analysis can be fruitfully viewed through the lens of Walter Benjamin (1970). Benjamin, it will be recalled, explored the developmental tendencies associated with technical change in art and argued that the nineteenth century had ushered in a crisis of painting associated with its exposure to the masses (Benjamin, 1970: 236). Where, as late as the eighteenth century, painting had passed into the world according to the rituals of a 'graduated and hierarchized mediation' (Benjamin, 1970: 237), the nineteenth century confronted the crisis of multiple receptions that undermined auratic art. Benjamin's thesis that reproductions and exhibitions sabotaged the auratic norms of ritualized art is an account of a potential decoding that opens up new aesthetic possibilities at new places. Much ink has been wasted on testing Benjamin as someone who predicted the dissolution of auratic art. He is more appropriately treated as identifying the paradigmatic possibilities of modernization as they inhere in the system tensions of art worlds. Bourdieu (1984) might be interpreted as offering an account of how social actors, enmeshed in the struggle for distinction, enact paradigmatic tensions and put the aura back into art.

Museum classification and framing is the meeting point of agency and structure, of social integration and system integration. System contradictions will tend to disrupt codes, generating uncertainty and doubt about the application of rules (Figure 8.1). For example, is the viewing obtained in the artist's studio at odds with that obtained from exhibition or reproduction? Classification and framing are actions through which a given order is reproduced in the face of system contradictions. The concepts specify the mechanisms through which uncertainty is or is not resolved as order. However, under what circumstances do actors seek to mobilize and succeed in mobilizing a new ordering of artefacts and people at the museum? Under what circumstances does the normative order thin out to leave power-holders as naked possessers of cultural and economic capital?

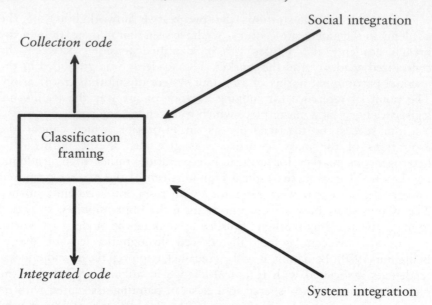

Figure 8.1 The museum's dual relationship to the world as institution (system integration) and people (social integration)

Codes of display

By way of answering the above questions, I propose a framework for analysing the display of art in modern societies (Figure 8.2). The concern is with the principles which organize the selection and combination of artefacts and not with the displays themselves. The framework is constructed from two dimensions: Bernstein's collection versus integrated codes, and the historical distinction between patrimonial modes and market modes for authorizing art. I now turn to the second of these dimensions.

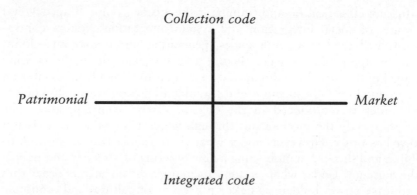

Figure 8.2 Co-ordinates of display

Patrimony, states, museums and markets

The word 'patronage' is sometimes used anachronistically to describe modern collecting. The activities of Medici Princes are not equivalent to contemporary endorsements or 'friends' of a museum. Rather, patronage has reformed itself and diversified through the medium of a developing *cultural field* (Bourdieu, 1993). The development of the cultural field entailed a shift in the balance of power from patrons to artists and mediators; 'the choices of the patron found their ratification in the collective assent of the public' (Crow, 1985: 86). Mobilization of public opinion, by intermediaries (dealers, critics, museum curators, etc.), decentred cultural authority, integrating patrons into the market and subjecting the spaces of art to the vagaries of interpretation.

In interpreting these changes I propose a theoretical continuum – patrimony–market – which is abstracted from the social history of art institutions and which permits the identification of discourses of display within a comparative framework governed by two central questions. Thus we can ask: Which has priority? Is the market refracted through patrimony or is patrimony refracted through the market?

If modernization, as the development of a relatively autonomous cultural field, separated some artefacts from the 'fabric of tradition' (Benjamin, 1970), then there was a spatial and material dimension to this intellectual change. Recent research shows how the making of an eighteenth-century public space for art was linked to a new mode of visual for cueing visitors (Beard and Henderson, 1995; Crow, 1985) that emancipated painting from the patrimonial authority of the palace and allowed, say, salon audiences visually to abstract art from palatial contexts.

Modernization disembedded art from tradition through its proliferation of spatially and chronologically dispersed viewpoints. The museum constructed a viewpoint and a spectator as did the chapel, the palace, the academy exhibition, the artist's studio and the art reproduction. A recurring issue in the politics of art is that of authenticity and the regulation of multiple sites; the chain of meaning through which artefacts may pass is made and remade as auratic hierarchy. In this way some viewings are hegemonically privileged as authentic while others are stigmatized as bereft of aura.

Following Lockwood, a distinction may be made between two aspects of the chain of viewing: between system integration and social integration. First, in terms of system integration we have the institutional configuration in which the museum is embedded. What a famous painting means depends on its historical passage through a chain of sites (artists' studios, patrons' palaces, academy exhibitions, critical texts, dealers' shops, museum spaces, art schools, reproductions). The concept of system integration locates the museum within a chain of institutions and allows us to identify the uncertainty that attends the social construction of the

arts. If indeterminacy and risk attend the passage of artefacts from space to space one aspect of the chain of meaning is the coalescing of 'necessary points of passage' (Callon, 1986; Clegg, 1989) through which authentic works of art must pass. For most of the nineteenth century art academy exhibitions were necessary points through which authoritative new art flowed on its way from studio to museum.

We can map the configuration of institutional spaces through which artefactual meaning is produced while identifying the discursive tensions between different modes of viewing as aura is undermined by the exhibitibility of artefacts. The meaning of a painting and the life of its artist may be successively determined at different locations which may be strongly or weakly classified in relation to each other. These locations are not spatial containers so much as media through which the creative process is constituted. Institutions and technologies which extend the reputation of the artist may disrupt existing classifications of art and artists, undermining patterns of classification between institutions. Moreover, there can be a reflexivity to the flow of meaning as artists make their art in terms of its destination at, say, a domestic setting, academy exhibition or museum.

Second, there are interdependencies between groups who may encounter each other (directly and indirectly) through the medium of exhibitions and displays. Here we have the dimension of social interdependency and conflict over classification. Museums have internal relationships to modernization in the sense that as agencies of classification they are relationships of cultural interdependence between groups. These take the form, not of a singular relationship between two groups, but of a configuration of groups (e.g., artists and other cultural producers, business class, professions, the lower-middle class, working class).

A feature of such interdependencies is the struggle of groups to stabilize classification, to fix meanings and to privilege particular sites. Stabilization can be fragile; the flux of systemic conflict will tend to disrupt classification and offer the potential for realignments which transform classification to admit new subjectivities, new artefacts and new spaces. For example, in Hogarthian London, in Paris and other modernizing cities of the late nineteenth century, in California and London of the 1960s, rapid marketization of art placed existing classifications at stake by challenging auratic art.

It is the link between group situations and classification that is significant for my analysis. Thus, dual front classes (Elias, 1983: 262–64), those groups compressed between upper and lower classes, may find themselves compelled to sharpen and fine tune the differentiating rituals of museums. This is the situation of the dominated fraction of the dominant class (Bourdieu 1984), of those intellectuals and professionals whose ascetism in art is a refusal of the materialism of both plutocrats and the poor. Or, in Dimaggio's analysis (1982) of Eastern Seaboard art institutions we have those Boston Brahmins whose cultural aspirations

emerged from compulsions of their interdependence with European elites and the migrant masses of late-nineteenth-century America. Thus social groups may be indirectly related to each other through flows of cultural power that are at once flows of artefacts through time and space.

Modes of display

Building on the concepts of classification and framing, and drawing on the historical sociology of patronage and markets, I propose a sociological map of museum discourses. Combining the two dimensions, patrimony-market and collection-integrated codes as cross-cutting continua allows a specification of discourses of display. For example, (1) the princely collection, (2) the modern museum, (3) the intrepretive museum, (4) the collector/patron museum. The typology specifies the tacit rules through which discourses are ordered, how different displays organize and disorganize identities, privilege and disprivilege different creators. I am not describing institutions at this point, but discourses. Museums co-exist in time and space as intrepreters of the distribution of social power – they may be stretched along the continua of patrimony/market and collection/integrated codes. The museum's ordering of art(efacts) is an encoding of power in which museum officers make their institutions through their exchanges with others. Any given museum may find itself pulled and stretched between different viewpoints as it forms multiple discursive alliances with diverse and even competing institutions.

The next stage in the argument is summarized in four diagrams. Figure 8.3 locates discourses of display as these constitute different kinds of spectators: subjects, visitors, citizens and consumers. Figure 8.4 is concerned with the question: Which authority is privileged: for example, sovereign or state? Figure 8.5 sets out the key elements of the four discourses identified in Figure 8.3. Figure 8.6 provides historical examples.

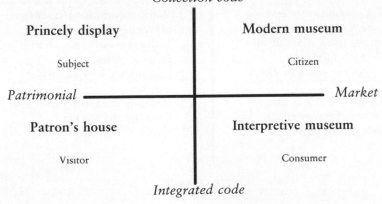

Figure 8.3 The constitution of spectators

Collection code

Illuminates personal power
(sovereign)

Illuminates impersonal power
(state)

Patrimonial ———————————————— Market

Illuminates taste of patron

Illuminates market

Integrated code

Figure 8.4 Which authority is privileged?

Collection code

☐ Strong classification/framing
places subject in the time of the
lineage

☐ Encodes difference insiders/
outsiders
☐ Visibility for hands that
illuminate the sovereign

☐ Erases outsiders and those who
have fallen from favour

☐ Strong classification/framing
places citizen in the deepening
times/space of nation/
civilization
☐ Encodes distinctions of nation/
status/control (modernity)
☐ Visibility for hands which
illuminate impersonal power of
state
☐ Erases hands that compromise
grand narrative of museum art
history

Patrimonial ———————————————— Market

☐ Weak classification/framing
places visitor in the
heterogeneous times of the
collector's taste
☐ Encodes outsiders/insiders

☐ Visibility for hands that
illustrate the argument
☐ Erases the established

☐ Weak classification/framing
places consumer in the
heterogeneous times of co-
existing styles
☐ Encodes collapse of insider/
outsider
☐ Visibility for those hands that
illustrate the market
☐ Erases the social

Integrated code

Figure 8.5 The elements of discourse

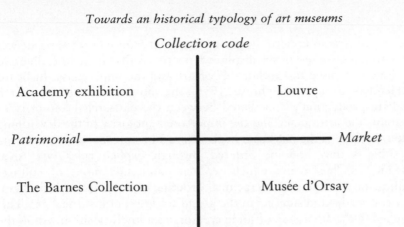

Academy exhibition ... Louvre

Patrimonial ———— *Market*

The Barnes Collection ... Musée d'Orsay

Figure 8.6 Historical illustrations

It should be evident that the aim is to capture the multi-discursive character of museums. For example, while the centre of gravity of nineteenth-century museums might have been in the top right-hand box of Figure 8.3, it was likely to have a patrimonial tail in the form of aristocratic trustees and academic hegemony.

Patrimonial/collection code: the princely collection

At its most patrimonial, a princely collection is a storehouse of treasure: precious metals, jewels, dynastic symbols, household valuables, sacred objects and images which are held together under a regime of strong classification as signs of a sovereign power that regulates difference. Here, for example, we have the medieval Treasury whose accumulations will only later appear as heterogeneous. Display time is the time of lineage, of reign and of ancestors and not that of art history. Framing is strong in that visitors gain access as subjects or as the subject emissaries of other princes. Visitors may be escorted; most people are excluded, for there is nothing they should see and no ideology to convey beyond the limited circles of the dominant class (Kaufman, 1994).

Where patrimonialism is strong, the artist belongs to the household or is perhaps a courtier whose career flows from the visible power that is the cult of monarchy. Where patronage displays artefacts it does so as 'a spectacle of [marvellous] treasures' (Grana, 1971: 100); the eye of the visitor is dazzled by the patron's cultural power. In a word it is the *aura* of artefacts that is transmitted through display as, for example, in the seventeenth-century *wunderkammer* where the distance between subject and prince is encoded as wonder.

With the development of cultural markets display takes on the relatively impersonal authority of a Good Society that is mapped on to fashionable public spaces. Thus the exhibitions of the early Royal

Academy of Arts in London staged at Somerset House (a royal residence) with paintings sumptuously displayed on the walls, floor-to-ceiling, so that the effect fused the authorities of art and the upper class. In Beard and Henderson's apposite phrase (1995), the show was a 'visual potlatch of palette production'; it mediated between the patriarchal authority of monarchy and aristocracy and the impersonal authority of the developing market. Insofar as the market is hegemonized by patrons, different media and subjects may now be ordered through explicit rules (via royal academies) as hierarchies which replicate an estate mode of cultural stratification and encode a hierachical ordering of, say, mechanical/liberal arts, or of media and subjects in the grand tradition of historical art. This is implied in the admission of some creators to a lowly position within the estate of the arts (engravers, water-colourists).

Market/collection code: the modern museum

Principal examples are the Louvre, London's National Gallery and twentieth-century museums of modern art (MoMA, the Tate Gallery) and other national museums born out of the rationalization of the state and the grand narratives of enlightenment. The Universal Survey Museum (Duncan and Wallach, 1980) gives us the classification of sharply defined national schools of art along with the strong framing of a predetermined path of understanding for the visitor. Here there is greater internal differentiation (organized around strongly classified national schools of painting and periods). There may be clear classification between the past and the present. If the princely collection gives us the visitor-subject we now have the citizen. Again there is a hierarchy, a visible ordering of cultural power – but it acquires an impersonal mode. It is the state and the citizen, not the sovereign, that are illuminated by the classical museum display which brings public taste and behaviour under the panoptical gaze of expertise. Framing will be strong; paintings or other artefacts may be arranged chronologically in ways that provide a predetermined route through art history. Visitors are likely to be positioned as citizens, unambiguously located within the certainties of nation-state formation, fixed within co-ordinates of a deepening time and widening space. The development of the museum is associated with the rise of the expert in the person of the professional curator (Zolberg, 1981) and the eviction of the artist as corporation. The emergence of museums of modern art was a radicalization of tendencies towards strong classification of competing national schools and thin linear Western stylistic histories.

Residual patrimonial power may be present in the control of museums by trustees and in the survival of premodern modes of classification. A recurring feature is the strategic reorganization of patronage on the terrain of public exhibition (e.g. the establishment in London of the British Institution in 1806). As late as the 1850s the case was being argued for an historical organization as against the decorative aristocratic modes

at the National Gallery in London. The Royal Academy's move from the National Gallery building in the late 1860s required that the British government met a royal obligation to provide the institution with a building (see Chapter 4).

Patrimonial-integrated code: the patron's house

Here display relaxes strong classification in favour of integration whose ordering principle may be the cultural authority of the patron, the patron's eccentricity or period. The display may subordinate previously insulated items (say, arts and crafts, paintings and furniture) to the proposed authorship of a (period) collector. There is the modern tradition of wealthy avant-garde collectors, often eccentric, sometimes outsiders, who subvert the established classifications as, for example, in the weak classification of the Barnes Collection in Philadelphia dating from the 1920s. To quote Matisse on Barnes: 'There the old master paintings are put beside the modern ones, a Douanier Rousseau next to a Primitive, and this bringing together helps students understand a lot of things that the academics don't teach' (Wattenmaker, 1993: 17). Works may be juxtaposed in ways that blur established boundaries and subvert the traditional hierarchies. We may have the blurring of boundaries between artefacts, the subordination of previously insulated artefacts to a unifying principle such as a period taste or a theory of art. The Barnes Foundation Collection combined in one display artefacts previously separated by the protocols of the modern museum. The boundary between primitive and European was blurred, as was that between European past and present in a display that juxtaposed African art, Old Masters and moderns. Display was informed by the educational philosophy of John Dewey and masterminded by a maverick collector who challenged the cultural establishment, crossing racial and aesthetic boundaries (Wattenmaker, 1993; Zolberg, 1995). Albert Barnes is of interest for his ultimately Canutian fight to regulate reception of his collection by establishing an educational programme, regulating access and controlling reproduction of his collection.

Market-integrated code: the interpretive museum

Again, display relaxes classification and framing. Here we have the collapse of hierarchy and the exhaustion of progress in a museum concept that permits the co-existence of styles (weakening classification) and a plurality of viewpoints (weak framing). The balance of power shifts within the museum as accountants and marketeers challenge the professional curatorial hierarchies (Zolberg, 1981). Where the modern museum judges and places the creations of artists, the interpretive museum has a reflexive relationship to artists as it acknowledges its complicity with modern art (Fisher, 1991). Curators may collaborate with

visitors and artists while artists may consciously produce art with a mind to the museum as the place of destination (Serota, 1997). The visitor is engaged as consumer in a lifestyle mode and hegemonized by an extension of the museum-without-walls (the virtual visitor whose access is via the technologies of CD-ROM and the internet home page).

British museum trajectories

By 1900 there were three powerful London museums with claims to be national galleries of art: the National Gallery at Trafalgar Square, the Victoria and Albert Museum (which had recently been renamed) at South Kensington and the Tate Gallery at Millbank. On the surface they constituted an official and natural division of labour in the interpretation of material culture: Trafalgar Square charged with preserving the Old Masters as a national patrimony, South Kensington with industrial training and Millbank with promoting British artists. Taken together, these museums belonged to an exhibitionary complex (Bennett, 1995) of official spaces which included not only museums but also exhibiting societies and industrial expositions.

This configuration was part of a more extended network of state agencies which included the Crown, Parliament, and government departments such as the Board of Trade and the Treasury. Museum officers navigated ways through the force-field of the state, building their institutions through the medium of departmental interdependencies which extended through the state and into wider society. Correspondingly, other parts of the state produced themselves through the medium of their transactions with art institutions including museums. We have seen that the development of the Royal Academy of Arts as a semi-official artistic body with material claims on government was linked to the complexities of the transformation of the monarchy and the parliamentarization of power.

The exhibitionary complex was shaped by observable flows of power in the form of decision-making, conflicts over the allocation of resources, appropriate means for achieving ends, etc. Behind the closed doors of officialdom and professional associations were intentions and decisions which were less public and only posthumously available as recorded gossip or archival evidence. More intangible were the flows of power associated with implicit grounds of action: institutional complicities, tacit disagreement, discursive alliance, discursive conflict and displaced goals. The segmented character of the British system, the absence of a central department of art, should not be mistaken for the absence of a decision-making centre or centralizing process. Rather, a fragmented system of art museums complemented the growth of Treasury power over the cultural state. To account for the development of the great national museums is to explore complicities and alliances within the field of state power as these institutions moved through the space of the state and interpreted British modernization as parsimonious cultural progress.

Each museum was a coalition (e.g. of academicians, patrons, connoisseurs, officials and others) whose mission continuously emerged at the intersection of competing discourses. Each was a contested space: the locus of tensions concerning acquisition and display. Each fought to enhance its position within the shifting distribution of power that characterized the state. Museums forged cultural alliances and established themselves in distinct metropolitan spaces. Each moved through the space of the exhibitionary complex melding discourses through the work of acquisition, preservation and display – following distinctive institutional trajectories within the co-ordinates of dominant discourses. Whereas the National flowed from the nationing of an aristocratic Old Master tradition, South Kensington emerged in the 1850s as a competing 'middle-class' museum rooted in the countervailing power of industrial revolution. The latter was conceived as a didactic project that would complement the training of artisans and improve design; it also accommodated the fine art aspirations of wealthy outsiders such as the textile merchant John Sheepshanks (1787–1863).

The National Gallery, South Kensington and the Tate were born at the confluence of three discourses of modernization: community, discipline and difference. The museums were part of a wider process of recoding that sanctioned national traditions, endorsed national taste and heritage and converted patrimonial art into bourgeois cultural capital. Acquisition, preservation and display was a recontextualization of aristocratic, industrial, imperial and marketized artefacts that established identities of nation, labour and social status through strong classification. In recruiting artefacts museums brought these identities to a focus. For example, established as a gallery of Old Masters and hung according to patrimonial principles the National was, by the mid-nineteenth century, making a more historical interpretation of its collections. A didactic deepening of the time/space of European schools materialized the lessons of art's progressive story; museum art was British national genius made palpable.

The deepening of historical time that accompanied national narratives of art created uncertainty. Museums were charged with obligations that were not necessarily consonant with each other. As national institutions at the confluence of discourses they might find themselves required but unable to juggle identities. How could South Kensington meet the requirements of the industrial trainers when middle-class women saw it as a fine art school? How could the Tate's collection of popular British art satisfy the bourgeois struggle for distinction when its collection was overwhelmingly composed of popular national paintings? In this way art museums were subject to cross-cutting pressures. They might pursue strategies that were at odds with their mission; they might find themselves pulled in directions that were unanticipated.

Museum points of view

The early Tate or National Gallery of British Art (Figure 8.7) was pulled in different discursive directions. Out of the RA by Henry Tate, the sugar magnate, with the Treasury as parsimonious midwife to a difficult birth in 1897, its remit was to display the national school (as opposed to the European Old Masters at Trafalgar Square). Primarily a collection of paintings by successful and popular British academicians, it proposed that Britain had artists who bore comparison with the Europeans. It was also part of a programme to diffuse the arts to the working class, which in the 1880s had spawned the Whitechapel and South London galleries. The spectre of mass democracy at the end of the century provoked a middle-class sense of the need to dispense the culture of citizenship to the masses, and it seems likely that the Tate was conceived with such a didactic purpose. Finally, the early Tate formed a discursive alliance with modernism that was to lead it into major battles with the RA.

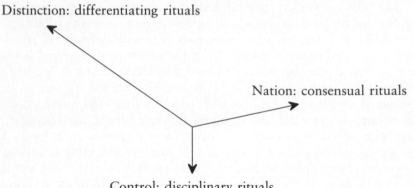

Figure 8.7 Tate discourses

In this way the early Tate came to be at the intersection of three discourses, with one discourse gaining priority: discourses of nation, control and distinction. How was this discursive shift possible? Why did the Treasury, having set up the arrangement, seem to sympathize with the Tate? In Chapter 7 I provided an account of how the Tate's officers steered a course through the force-field of the state, how they formed a tacit alliance with the Treasury and evicted the RA. How was that possible? What resources was the Tate drawing upon? The Tate's officers wanted control of the Chantrey Bequest. They succeeded in confiscating cultural capital from the RA by sacralizing modern art and stigmatizing the academy. How was that managed?

System integration

The nineteenth-century RA contained the tensions between residual patrimony and the developing cultural field. Its fashionable annual Exhibition was a national site at which Society rooted in agrarian capitalism represented itself as a gathering of distinction. The RA enhanced its power by enlisting new techniques (exhibiting and reproducing art) in the service of a contested and increasingly impersonal cultural power. By the mid-nineteenth century its members enjoyed considerable influence over the cultural state as officers of national galleries.

In the second half of the century the exhibition became the focus of tensions that could no longer be contained by the RA. The legislative impulse of the Academy was undermined by the market and the capture of new audiences. New exhibitions and exhibiting societies (the Grosvenor Gallery founded in 1877, the New Gallery, the Grafton Gallery in 1892, the New English Art Club, the Allied Artists, the Camden Town Group) emerged to accommodate internal and external dissent from the RA. By the 1880s there was an anomic, kaleidescope character to the cultural field with manifestos, projects and institutions that sparked into life and fizzled out.

The Chantrey Bequest brought these problems to a head. The gift was predicated on a normative order in which the connection between art and power was patent. Its key terms (the RA's trusteeship and its high art aspirations) contained residues of a patrimonial-oriented collection code that prioritized high art over low commercial art. The problem emanated from the tensions of the late Victorian cultural field. It seems likely that the Bequest was an initiative aimed at securing the high art ambitions of academicians in the face of middle-class demand for low art. The Will was made in 1841 and matured in 1877. But it was not until 1897, with the foundation of the Tate, that its significance as a national collection was fully demonstrated.

Social integration

The tensions of the academic system matured as a sustained battle for control of the Chantrey Bequest. Identification of these tensions is a necessary but insufficient basis for an account of the gestation of the Tate as a museum of modern art. System contradictions opened up possibilities of declassification and reclassification for, as I have argued, the RA and its exhibition could no longer manage the field of art. However, if the RA and the Tate followed different trajectories of relative decline and ascent it was not that they had been shot out of the canon of system integration but that the officers of both institutions charted and recharted courses through the medium of cultural contradictions which tended to empower the professional class more generally.

The organizational problems of the Academy and its exhibition, which were deeply rooted in the nineteenth century, created opportunities for professionalizing strategies of distinction which took the symbolic revolution of modern art into the museum. The Chantrey dispute, as I argued in Chapter 7, was interwoven with upper-class structuration and particularly with that of the professional class. The balance of power shifted from the broader middle class and towards the professional class just as the decline of land drew the aristocracy into closer association with the cultural state. The Tate was not a creature of the professional class nor was the professional class a dominant class. Rather the Tate proposed a professional identity and interpreted the shifting balance of class power; along with other departments of state (including the Treasury), it converged on a language of distinction and public service which accommodated the identities of a declining landed aristocracy and an ascending professional class. The Tate was one site at which distinction materialized, a place at which a new upper-class identity grounded in the imperatives of cultural capital was proposed.

From patrimony to market

The Chantrey episode was one strand in a diverse reordering of knowledge/power that split the public sphere in the late nineteenth century. Before 1870 modernization had favoured an inclusive impulse in that fine art institutions enlisted the middle class within an estate system of cultural stratification founded on academic hierarchy. Social ordering was through a regime of strong classification and framing that domesticated the market, put newcomers in their place and reproduced the centred authority of Good Society. The relationship between art and power was patent; art illuminated the power of the sovereign and the upper circle, the museum received the judgements of the Academy.

By the 1900s the Academy could no longer contain the market and modernism had relaxed classification and framing, blurring the boundaries between art and the consumer culture and undermining the nostrums of high art. Art and artists had become fugitive, fleeting and uncertain. Modern art did not neccessarily appear at the exhibition, it could pop up anywhere. The Tate arrested declassification at the museum gate by reinstalling strong classification and framing. The official discourse of art sanctioned weak classification and framing in the market, but strong classification and framing in judging the market. Where modernism, arising at the intersection of the academy and the culture industry, had blurred the boundaries of art and life, it was now appropriated through strong classification and framing: strong classification between art and mere pictures, strong framing between curator and artist, curator and visitor.

It might appear that the Tate represented the universalism of art against the particularism of the academy. It is more correct to say that the

RA was made to appear as interested, selective and partial. The Tate was no less selective. It deleted Victorian popular art but it was also selective in relation to modern art. Its officials had formed their taste at a particular moment of European modernism, and as a British institution the Tate selected its European art. Thus, in 1915 the trustees of the National Gallery, establishing the Tate's mission as a gallery of modern art, asserted that in terms of acquistion: 'We have not in our minds any idea of experimentalising by rash purchase in the occasionally ill-disciplined productions of some contemporaneous continental schools, whose work might exercise a disturbing and even deleterious influence on our younger painters' (Curzon, 1914–16: 26).

Conclusion

Museums order the relationship between eye and mind; they socialize the eye, organize visual capacities and, in so doing, construct a point of viewing. As curators and visitors we may learn to see the requirements of our social structure as natural, as materialized in the acquisitions and arrangements of museums. Thus social change is change at the museum: change the social structure and you change the order of the museum; reorder the museum and you disrupt identities. Curation presupposes a social grammar; museums acquire artefacts, they select and combine objects to compose principled displays and exhibitions which are encodings of the social order.

Code refers to the tacitly acquired principles through which curators and directors obtain artefacts, order displays and invite the public to be visitors or through which visitors themselves appropriate exhibits. Classification and framing specify the rules through which museum discourses are structured and through which the symbolic violence of their abstraction is naturalized. Classification and framing focus attention on museum practices as they are oriented to diverse realities and as they bring particular identities into focus. The obverse of this is the disorganizing or blurring of those identities which are not permissible within a given ordering of art.

The problem is to provide an account of social change at the museum without treating the latter as a reflex of social structure or as an autonomous transparent communicator of the meanings of artefacts. Classification and framing, as relational concepts, point to the social embeddedness of the museum's point of view. The point of view of the museum is both an emergent possibility of system contradictions and the outcome of struggles for cultural power between groups. The concepts of code, classification and framing provide a theoretical basis for understanding how discourses may intersect at and be mediated by museums. Classification and framing at the museum refer to continuous processes of ordering that mediate power as it flows through the dimensions of modernization: system and social integration. In those respects the

museum was born out of the aporias of modernization. On the one hand, recontextualization yields systemic uncertainties: the rules of acquisition and display always require human action no matter how ritualized and habitual they may be. The question is to what extent are the rules of the museum compatible or incompatible with those institutions with which it has transactions, say, the academy, the state or the market. On the other hand, the museum is a relationship of social interdependence; its origins were in the compulsions of eighteenth-century integration and conflict.

The museum movement, as it is sometimes called, arose out of transactions between dominant and subordinate groups in the course of Western modernization. The visitor's eye was a locus of social reordering; at the museum the nineteeenth-century state permitted the gaze of the discriminating eye, the disciplined eye and the nationalized eye. The museum was not a creature of the state or, for that matter, of dominant classes; it was a relationship of cultural power focused on the eye. That relationship is a starting-point for decoding museum discourses.

Notes

1 One exception is Hooper-Greenhill's analysis of the National Portrait Gallery (Hooper-Greenhill, 1980).
2 Goethe, quoted in Holt (1979: 76–7). Delecluze and Shee quoted in Eitner (1970).
3 See Bernstein and Davies (1969) on the Plowden Report and child-centred schooling. On the parallels with Foucault see Atkinson (1985).
4 Lockwood's paper has generated a number of recent interpretations and developments of which I find Clegg (1989) and Mouzelis (1991, 1995) the most illuminating.

Bibliography

Abercrombie, N., Hill, S. and Turner, B. (1986) *Sovereign Individuals of Capitalism*. London: Allen & Unwin.

Adhemar, J. (1964) *Graphic Art of the Eighteenth Century*. London: Thames & Hudson.

Agnew's (1967) *Agnew's 1817–1967*. London: The Bradbury Press Ltd.

Albrecht, M. C., Barnett, J. H. and Griff, M. (1970) *The Sociology of Art and Literature*. London: Duckworth.

Alexander, J. C. (1995) *Fin de Siècle Social Theory: Relativism, Reduction and the Problem of Reason*. London: Verso Press.

Allen, B. (ed.) (1995) *Towards a Modern Art World*. New Haven and London: Yale University Press.

Alpers, S. (1983) *The Art of Describing*. London: John Murray.

Altick, R. (1978) *The Shows of London*. Cambridge, MA: Harvard University Press.

Ames, W. (1967) *Prince Albert and Victorian Taste*. London: Chapman and Hall Ltd.

Anon. (1770) *Sculptura Historico-Technica: or, the History and Art of Engraving* (4th edn). London: Printed for J. Marks.

Antal, F. (1948) *Florentine Painting and Its Social Background*. London: Routledge & Kegan Paul.

Art Treasure Examiner (1857) *A Pictorial, Critical, and Historical Record of the Art Treasures Exhibition at Manchester in 1857*. Manchester and London: Alexander Ireland & Co.; W. H. Smith & Son.

Atkinson, P. (1985) *Language, Structure & Reproduction: An Introduction to the Sociology of Basil Bernstein*. London: Methuen.

Atkinson, T. (1736) *A Conference Between a Painter and an Engraver*.

Bagehot, W. (1867/1963) *The English Constitution*. London: Fontana.

Banks, J. (1954) *Prosperity and Parenthood*. London: Routledge & Kegan Paul.

Barnes, B. (1977) *Interests and the Growth of Knowledge*. London: Routledge & Kegan Paul.

Barrell, J. (1992) *The Birth of Pandora and the Division of Knowledge*. London: Macmillan.

Baudelaire, C. (1965) *Art in Paris 1845–1862. Review of Salons and Other Exhibitions*. London: Phaidon Press.

Baudrillard, J. (1988) 'The trompe l'oeil', in N. Bryson (ed.), *Calligram*. Cambridge: Cambridge University Press.

Bauman, Z. (1987) *Legislators and Interpreters*. Cambridge: Polity Press.

Baxandall, M. (1972) *Painting and Experience in Fifteenth Century Italy*. Oxford: Clarendon Press.

Bayard, J. (1981) *Works of Splendor and Imagination*. New Haven: Yale Centre for British Art.

Bazin, G. (1968) *The Museum Age*. Desoer: Literary Services and Production.

Beard, M. and Henderson, J. (1995) 'The historicality of art: Royal Academy (1780–1836) and Courtauld Institute Galleries (1990–) at Somerset House', in S. Pearce (ed.), *Art in Museums*. New Research in Museum Studies, vol. 5. London: Athlone Press.

Becker, H. (1982) *Art Worlds*. Berkeley: University of California Press.

Beckett, R. B. (ed.) (1966) 'Patrons, dealers and fellow artists', in *John Constable's Correspondence*, vol. 4. Suffolk Records Society.

Bell, Q. (1959) 'Haydon versus Shee', *Journal of the Warburg and Courtauld Institutes*, 22: 347–58.

Bell, Q. (1963) *The Schools of Design*. London: Routledge & Kegan Paul.

Benjamin, W. (1970) 'The work of art in the age of mechanical reproduction', in *Illuminations*. London: Jonathan Cape.

Bennett, T. (1995) *The Birth of the Museum*. London: Routledge.

Benson, R. W. (1924) *The Holford Collection*. London: Burlington Fine Arts Club.

Berger, J. (1972) *Ways of Seeing*. London: BBC/Penguin Books.

Berman, M. (1983) *All That Is Solid Melts into Air*. London: Verso.

Bernstein, B. (1971) *Class, Codes and Control*, vol 1. London: Routledge & Kegan Paul.

Bernstein, B. (1975) *Class, Codes and Control*, vol. 3, *Theoretical Studies towards a Sociology of Language* (2nd edn). London: Routledge & Kegan Paul.

Bernstein, B. (1982) 'Codes, modalities and the process of cultural production in education', in M. W. Apple (ed.), *Cultural and Economic Reproduction in Education*. London: Routledge & Kegan Paul.

Bernstein, B. (1986) 'On pedagogic discourse', in J. G. Richardson (ed.), *Handbook of Theory and Research for the Sociology of Education*. London: Greenwood Press.

Bernstein, B. (1990) *Class Codes and Control: The Structure of Pedagogic Discourse*, vol. 4. London: Routledge.

Bernstein, B. (1996) *Pedagogy, Symbolic Control and Identity: Theory, Research, Critique*. London: Taylor & Francis.

Bernstein, B. and Davies, B. (1969) 'Some sociological comments on Plowden', in R. S. Peters (ed.), *Perspectives on Plowden*. London: Routledge & Kegan Paul.

Blake, W. (1810) 'Public Address', in Geoffrey Keynes (ed.), *The Complete Writings of William Blake*. London: Oxford University Press (1966).

Blomfield, R. (1932) *Memoirs of an Architect*. London: Macmillan.

Boime, A. (1971) *The Academy and French Painting in the Nineteenth Century*. London: Phaidon Press.

Booth, C. (1903) *Life and Labour of the People in London*. Second Series: *Industry*, vol. 4. London: Macmillan.

Bourdieu, P. (1968) 'Outline of a sociological theory of art perception', *International Social Science Journal*, 20.

Bourdieu, P. (1980) 'The production of belief: contribution to an economy of symbolic goods', *Media, Culture and Society*, 2(3).

Bourdieu, P. (1984) *Distinction: A Social Critique of the Judgement of Taste*. London: Routledge & Kegan Paul.

Bourdieu, P. (1990) *In Other Words: Essays Towards a Reflexive Sociology*. Oxford: Polity Press.

Bourdieu, P. (1993) *The Field of Cultural Production*. Oxford: Polity Press.

Bourdieu, P. (1996) *The State Nobility: Elite Schools in the Field of Power*. Oxford: Polity Press.

Bourdieu, P. and Darbel, A. (1991) *The Love of Art: European Art Museums and Their Public*. Oxford: Polity Press.

Bourdieu, P. and Wacquant, L. J. D. (1992) *An Invitation to Reflexive Sociology*. Oxford: Polity Press.

Bourne, J. M. (1986) *Patronage and Society in Nineteenth Century England*. London: Edward Arnold.

Brewer, J. (1997) *The Pleasures of the Imagination*. London: HarperCollins.

Brighton, A. (1977) 'Official art and the Tate Gallery', *Studio International*, 193.

Brown, O. (1968) *Exhibition: The Memoirs of Oliver Brown*. London: Evelyn, Adams & Mackay.

Bryson, N. (1983) *Vision and Painting: The Logic of the Gaze*. New Haven: Yale University Press.

Buckman, D. (1973) *James Bolivar Manson 1879–1975*. London: Maltzahn Gallery.

Bullen, J. B. (ed.) (1988) *Post-Impressionists in Britain: The Critical Reception*. London: Routledge.

Burger, P. (1984) *Theory of the Avant-Garde*. Manchester: Manchester University Press, and Minneapolis: University of Minnesota Press.

Burne-Jones, G. (1906/1912) *Memorials of Burne-Jones* (two vols), 2nd edn. London: Macmillan.

Burnet, J. (1850) 'Autobiography of John Burnet', *Art Journal*, 12: 275–7.

Callon, M. (1986) 'Some elements of a sociology of translation', in J. Law (ed.), *Power, Action and Belief: A New Sociology of Knowledge?* London: Routledge & Kegan Paul.

Campbell, R. (1747/1969) *The London Tradesman*. Newton Abbot: David & Charles.

Cannadine, D. (1990) *The Decline and Fall of the British Aristocracy*. New Haven and London: Yale University Press.

Cannadine, D. (1995) *Aspects of Aristocracy*. Harmondsworth: Penguin Books.

Carey, J. (1992) *The Intellectuals and the Masses*. London: Faber.

Carr, J. Comyns (1908) *Some Eminent Victorians: Personal Recollections in the World of Art and Letters*. London: Duckworth.

Carr, Mrs J. Comyns (1925) *Reminiscences*, edited by E. Adam. London: Hutchinson.

Caulfield, J. (1814) *Calographiana: The Print Sellers. Chronicle and Collector's Guide to the Knowledge and Value of Engraved British Portraits*. London: G. Smeeton.

Chadwick, W. (1996) *Women, Artists, and Society*. London: Thames & Hudson.

Chantrey and His Bequest: A Complete Illustrated Record of the Purchases of the Trustees, with a Biographical Note, Text of the Will etc. (1904) London: Cassell.

Cherry, D. (1993) *Painting Women: Victorian Women Artists*. London: Routledge.

Clark, T. J. (1974) 'The conditions of artistic creation', *Times Literary Supplement*, 24 May.

Clark, T. J. (1984) *The Painting of Modern Life: Paris in the Art of Manet and His Followers*. London: Thames & Hudson.

Clark, T. J. (1985) 'Arguments about modernism', in F. Frascina (ed.), *Pollock and After*. London: Harper & Row.

Clegg, S. R. (1989) *Frameworks of Power*. London: Sage.

Clemenson, H. A. (1982) *English Country Houses and Landed Estates*. London: Croom Helm.

Clifford, J. (1988) *The Predicament of Culture*. Cambridge, MA: Harvard University Press.

Clive, M. (1964) *The Day of Reckoning*. London: Macmillan.

Colley, E. (1996) *Britons: Forging the Nation 1707–1837*. London: Vintage.

Coombes, A. E. (1991) 'Ethnography and the formation of national identities', in S. Hiller (ed.), *The Myth of Primitivism*. London: Routledge.

Cooper, D. (1954) *The Courtauld Collection*. London: Athlone Press.

Corbett, P. C. (1997) *The Modernity of English Art*. Manchester: Manchester University Press.

Corrigan, P. and Sayer, D. (1985) *The Great Arch: English State Formation as Cultural Revolution*. Oxford: Basil Blackwell.

Cowdell, T. P. (1980) *The Role of the Royal Academy in English Art 1918–1930*. Ph.D. thesis, London University.

Crewe Inquiry (1904) *Chantrey Trust: Report, Proceedings and Minutes of Evidence*. Select Committee, House of Lords, UK Parliamentary Papers, 357, v.493.

Crimp, D. (1993) *On the Museum's Ruins*. Cambridge, MA: MIT Press.

Crookshank, A. and The Knight of Glin (1978) *The Painters of Ireland c. 1660–1920*. London: Barrie & Jenkins.

Crow, T. E. (1985) *Painters and Public Life in Eighteenth Century Paris*. New Haven and London: Yale University Press.

Cumberland, G. (1827) *An Essay on the Utility of Collecting the Best Works of the Ancient Engravers of the Italian School*. London: Nicol.

Curtis, J. (1972) 'The original print: an epitaph', *The Penrose Annual*.

Curzon, N. (1914–16) *Report*. National Gallery Inquiry, UK Parliamentary Papers, cmnd. 7878.

Dalziel, G. and Dalziel, E. (1901) *The Brothers Dalziel: A Record of Fifty Years' Work, 1840–1890* (2nd edn). London: Methuen.

Darcy, C. P. (1976) *The Encouragement of the Fine Arts in Lancashire 1760–1860*. Manchester: Manchester University Press.

Davidoff, L. (1986) *The Best Circles: Society Etiquette and the Season*. London: Hutchinson.

Davidoff, L. and Hall, C. (1987) *Family Fortunes: Men and Women of the English Middle Class, 1750–1850*. London: Hutchinson.

Davis, F. (1981) 'Lesson in tolerance: "Some Chantrey favourites" at the Royal Academy', *Country Life*, **169**(4368).

Dawson, J. (ed.) (1981) *The Complete Guide to Prints and Printmaking*. London: BCA.

Dennistoun, J. (1855) *Memoirs of Sir Robert Strange and Andrew Lumsden* (2 vols). London: Longman, Brown, Green & Longman.

Dickens, C. (1866) 'Engraved on steel', *All the Year Round*, 27 October: 372–6.

Dictionary of National Biography (1971) Oxford: Oxford University Press.

Dimaggio, P. (1982) 'Cultural entrepreneurship in nineteenth-century Boston', *Media, Culture & Society*, **4**(1): 33–50; **4**(4): 303–22.

Dimaggio, P. (1987) 'Classification in art', *American Sociological Review*, **52**: 440–55.

du Maurier, G. (1896) *Trilby: A Novel*. London: Osgood, MacIlvane.

Duncan, C. (1991) 'Art museums and the ritual of citizenship', in I. Karp and S. D. Lavine (eds), *Exhibiting Cultures: The Poetics and Politics of Museum Display*. Washington and London: The Smithsonian Institute.

Duncan, C. (1995) *Civilizing Rituals: Inside Public Art Museums*. London: Routledge.

Duncan, C. and Wallach, A. (1980) 'The Universal Survey Museum', *Art History*, **3**(4): 448–69.

Durkheim, E. (1893/1933) *The Division of Labor in Society*. London and New York: The Free Press/Collier Macmillan.

Eastlake, C. (1872) *Hints on Household Taste in Furniture, Upholstery and Other Details*.

Eastlake, C. (ed.) (1895) *Journals and Correspondence of Lady Eastlake* (2 vols). London: John Murray.

Eddy, A. J. (1904) *Recollections and Impressions of James McNeill Whistler* (2nd edn). Philadelphia: J. B. Lippincott.

Edwards, E. (1808) *Anecdotes of Painters*. Reprinted by Cornmarket Press, London, 1970.

Edwards E. (1840) *The Administrative Economy of the Fine Arts in England*. London.

Eisenstein, E. (1979) *The Printing Press as an Agent of Change* (2 vols). Cambridge: Cambridge University Press.

Eitner, L. (1970) *Neoclassicism and Romanticism 1750–1850: Sources and Documents*. Vol. 2: *Restoration/Twilight of Humanism*. Englewood Cliffs, NJ: Prentice Hall.

Elias, N. (1978) *The Civilizing Process*. Vol. 1: *The History of Manners*. Oxford: Blackwell.

Elias, N. (1982) *The Civilizing Process*. Vol. 2: *State Formation and Civilization*. Oxford: Blackwell.

Elias, N. (1983) *The Court Society*. Oxford: Blackwell.

Elias, N. (1985) *The Loneliness of the Dying*. Oxford: Blackwell.

Elias, N. (1987) 'The retreat of sociologists into the present', *Theory, Culture and Society*, 4(2–3): 223–47.

Elias N. and Dunning, E. (1986) *Quest for Excitement: Sport and Leisure in the Civilizing Process*. Oxford: Blackwell.

Escott, T. H. S. (1880) *England: Its People, Polity and Pursuits* (2 vols). London: Cassell, Petter, Galpin.

Escott, T. H. S. (1885) *Society in London: By a Foreign Resident*. London: Chatto & Windus.

Evelyn, J. (1905) *Sculptura; or the History and Art of Chalcography*. Oxford: Clarendon Press (first published 1662).

Fawcett, T. (1982) 'On reproductions', *Art Libraries Journal*, 7(1).

Fielding, T. H. (1841) *The Art of Engraving with the Various Modes of Operation*. London: Ackermann & Co.

Fisher, F. J. (1947) 'The development of London as a centre of conspicuous consumption in the sixteenth and seventeenth centuries', *Transactions of the Royal Historical Society*.

Fisher, P. (1991) *Making and Effacing Art*. London and Cambridge, MA: Harvard University Press.

Flint, K. (ed.) (1984) *Impressionists in England: The Critical Reception*. London: Routledge & Kegan Paul.

Foucault, M. (1998) 'What is an author?', in M. Foucault, *Aesthetics, Method and Epistemology*, ed. J. D. Faubion. Harmondsworth: Penguin Books.

Fowler, B. (1997) *Pierre Bourdieu and Cultural Theory: Critical Investigations*. London: Sage.

Fox, C. (1976) 'The engravers' battle for professional recognition in early nineteenth century London', *The London Journal*, 2(1).

Fox, C. (1977) 'Education, fine arts and design', in G. Sutherland *et al.*, *Education*. Dublin: Irish Academic Press.

Freitag, W. M. (1979) 'Early uses of photography in the history of art', *Art Journal*, 39(2).

Fussell, G. E. (1974) *James Ward RA*. London: Michael Joseph.

Fyfe, G. J. (1973) *The Social Context of English Engraving during the Nineteenth Century*. Unpublished M.Phil. thesis, University of Leicester.

Galerien, T. (1921) 'The renaissance of the Tate Gallery', *The Studio*, 82(344): 187–97.

Garlick, K. and MacIntyre, A. (1978–) *The Diary of Joseph Farington.* London and New Haven: Yale University Press.

Gascoigne, B. (1986) *How to Identify Prints.* London: Thames & Hudson.

Giddens, A. (1973) *The Class Structure of the Advanced Societies.* London: Hutchinson.

Giddens, A. (1990) *The Consequences of Modernity.* Oxford: Polity Press.

Giddens, A. (1994) 'Living in a post-traditional society', in U. Beck, A. Giddens and S. Lash, *Reflexive Modernization.* Oxford: Polity Press.

Gillett, P. (1990) *Worlds of Art: Painters in Victorian Society.* New Brunswick, NJ: Rutgers University Press.

Gilmour, P. (1978) *The Mechanised Image: An Historical Perspective on 20th Century Prints.* London: Arts Council of Great Britain.

Ginzburg, C. (1980) 'Morelli, Freud and Sherlock Holmes: clues and scientific method', *History Workshop*, 9.

Girouard, M. (1979) *The Victorian Country House.* London: Book Club Associates.

Goblot, E. (1973) 'Cultural education as a middle-class enclave', in E. Burns and T. Burns (eds), *Sociology of Literature and Drama.* Harmondsworth: Penguin Books.

Godfrey, R. T. (1978) *Printmaking in Britain.* London: Phaidon Press.

Goldsmith, O. (1809) *The History of Greece from the Earliest State to the Death of Alexander the Great* (two vols, 10th edn). London: R. Baldwin *et al.*

Grana, C. (1971) *Fact and Symbol.* New York: Oxford University Press.

Graves, A. (1901) *The Royal Academy of Arts: A Complete Dictionary of Contributors and Their Work from Its Foundation in 1769 to 1904* (5 vols). London: Henry Graves & George Bell. (Kingsmead Reprint 1970)

Gray, B. (1937) *The English Print.* London: Adam and Charles Black.

Greig, J. (ed.) (1922–28) *The Farington Diary*, 8 vols. (This edition consulted unless otherwise indicated.)

Gruetzner, A. (1979) 'Two reactions to French painting in Britain', in *Post Impressionism: Cross-currents in European Painting.* London: Royal Academy of Arts/Weidenfeld & Nicolson.

Guizot, F. (1862) *An Embassy to the Court of St. James's in 1840.* London: R. Bentley.

Habermas, J. (1989) *The Structural Transformation of the Public Sphere.* Cambridge: Polity Press.

Haden, F. S. (1890) 'The art of the painter etcher', *The Nineteenth Century*, 27 (May): 756–65.

Hall, C. (1992) *White, Male and Middle Class.* Oxford: Polity Press.

Hall, S. (1984) 'The rise of the representative/interventionist state', in G. Maclennan, D. Held and S. Hall (eds), *State and Society in Contemporary Britain.* Oxford: Polity Press.

Hallé, C. E. (1909) *Notes from a Painter's Life: Including the Founding of Two Galleries.* London: John Murray.

Hamerton, P. G. (1876) *Etching and Etchers* (2nd edn). London: Macmillan & Co.

Hamerton, P. G. (1882) *The Graphic Arts*. London: Seeley & Co.

Hamerton, P. G. (1889) *Thoughts about Art*. London: Macmillan.

Hamlyn, R. (1991) 'Tate Gallery', in G. Waterfield (ed.), *Palaces of Art: Art Galleries in Britain 1790–1990*. London: Dulwich Picture Gallery.

Hamlyn, R. (1993) *Robert Vernon's Gift: British Art for the Nation*. London: Tate Gallery.

Hardie, M. (1910) *Frederick Goulding: Master Printer of Copper Plates*. London: Eneas Mackay.

Hardie, M. (1968) *Watercolour Painting in Britain*. Vol. 3: *The Victorian Period*, ed. D. Snelgrove with J. Mayne and B. Taylor. London: Batsford.

Harris, E. M. (1968, 1969, 1970) 'Experimental graphic processes in England 1800–1859', *Journal of the Printing Historical Society*, 4, 5 and 6.

Harrison, C. (1981) *English Art and Modernism, 1900–1939*. London and Bloomington: Indiana University Press.

Haskell, F. (1976) *Rediscoveries in Art: Some Aspects of Taste, Fashion and Collecting in England and France*. Oxford: Phaidon.

Hauser, A. (1962) *The Social History of Art*, 4 vols. London: Routledge & Kegan Paul.

Hazlitt, W. (1830) *Conversations of James Northcote, Esq., RA*. London: Colburn & Bentley.

Heath, J. (1993) *The Heath Family of Engravers 1779–1878* (2 vols). Aldershot: Scolar Press.

Hennion, A. (1995) 'The history of art-lessons in mediation', *Reseaux: The French Journal of Communication*, 3(2).

Hermann, F. (1972) *The English as Collectors: A Documentary Chrestomathy*. London: Chatto & Windus.

High Roads of History (n.d.) Book VII, *High Roads of British History*. London: Thomas Nelson & Sons.

Hind, A. M. (1963) *A History of Engraving and Etching*. New York: Dover Publications. (First published 1923)

Hodgson, J. E. and Eaton, F. A. (1905) *The Royal Academy and Its Members 1768–1830*. London: John Murray.

Holme, C. (1906) *The Royal Institute of Painters in Watercolours*. London: The Studio.

Holmes, C. J. (1936) *Self and Partners (Mostly Self): Being the Reminiscences of C. J. Holmes*. New York: Macmillan.

Holst, N. von (1976) *Creators, Collectors and Connoisseurs*. London: Thames & Hudson/Book Club Associates.

Holt, E. G. (1957) *A Documentary History of Art*. Vol. 1: *The Middle Ages and the Renaissance*. New York: Doubleday.

Holt, E. G. (1979) *The Triumph of Art for the Public*. New York: Anchor Books.

Hooper-Greenhill, E. R. (1980) *The National Portrait Gallery: A Case Study in Cultural Reproduction*. Unpublished MA dissertation, London University, Institute of Education.

Huish, M. (1892) 'Whence comes this great multitude of painters?' *Nineteenth Century* (November), **32**: 720–32.

Hutchison, S. C. (1962) 'The Royal Academy Schools 1760–1830', *Walpole Society*, (1960–2) **43**: 123–83.

Hutchison, S. C. (1968) *The History of the Royal Academy*. London: Chapman and Hall.

Ingham, G. (1984) *Capitalism Divided? The City and Industry in British Development*. London: Macmillan Press.

Ivins, W. M., Jr. (1927) *Prints and Books: Informal Papers*. Cambridge, MA: Harvard University Press.

Ivins, W. M., Jr. (1953) *Prints and Visual Communication*. London: Routledge & Kegan Paul.

Jameson, F. (1991) *Postmodernism, or the Cultural Logic of Late Capitalism*. London: Polity Press.

Jenkins, R. (1992) *Pierre Bourdieu*. London: Routledge.

Johnson, T. (1982) 'The state and the professions: peculiarities of the British', in A. Giddens and G. Mackenzie (eds), *Social Class and the Division of Labour: Essays in Honour of Ilya Neustadt*. Cambridge: Cambridge University Press.

Jones, G. S. (1976) *Outcast London*. Harmondsworth: Peregrine Books.

Jones, T. (1960) *Henry Tate 1819–1899: A Biographical Sketch*. London: Tate & Lyle Ltd.

Jussim, E. (1988) *Visual Communication and the Graphic Arts*. New York and London: R.R. Bowker.

Kaufman, T. D. (1994) 'From Treasury to museum: the collections of the Austrian Habsburgs', in J. Elsner and R. Cardinal (eds), *The Cultures of Collecting*. London: Reaktion Books.

Keynes, G. (1966) *The Complete Writings of William Blake*. Oxford: Oxford University Press.

Krauss, R. E. (1986) *The Originality of the Avant-Garde and Other Modernist Myths*. Cambridge, MA: MIT Press.

Kristeller, P. O. (1951–2) 'The modern system of the arts: a study in the history of aesthetics', *Journal of the History of Ideas*, **12**: 496–527, and **13**: 17–46.

Laidlay, W. J. (1898) 'The Royal Academy: its uses and abuses', *Architectural Review*, **4**: 132–4.

Laidlay, W. J. (1907) *The Origins and First Two Years of the New English Art Club*. London: the author.

Lalanne, M. (1880) *A Treatise on Etching*, edited by S. R. Koehler. London: W. & G. Foyle.

Lamb, W. R. M. (1951) *The Royal Academy*. London: G. Bell & Sons.

Lambert, R. S. (ed.) (1938) *Art in London*. Harmondsworth: Penguin.

Landseer, J. (1807) *Lectures on the Art of Engraving*. London.

Lang, G. E. and Lang, K. (1990) *Etched in Memory: The Building and Survival of Reputations*. Chapel Hill and London: University of North Carolina Press.

Layder, D. (1994) *Understanding Social Theory*. London: Sage.

Leslie, G. D. (1914) *The Inner Life of the Royal Academy*. London: John Murray.

Levine, L. (1988) *Highbrow/Lowbrow*. Cambridge, MA: Harvard University Press.

Levis, H. C. (1912) *A Descriptive Bibliography of the Most Important Books in the English Language Relating to the Art and History of Engraving and the Collecting of Prints*. London: Ellis.

Lichtenstein, R. (1968) 'An interview', in *Roy Lichtenstein*. London: Tate Gallery.

Lilien, O. M. (1957) *History of Industrial Gravure Printing up to 1900*. London: Autotype Co.

Lippincot, L. (1983) *Selling Art in Georgian London*. London: Yale University Press.

Lockwood, D. (1956) 'Some remarks on the "social system"', *British Journal of Sociology*, 7(2): 134–46.

Lockwood, D. (1964) 'Social integration and system integration', in G. K. Zollschan and W. Hirsch (eds), *Explorations in Social Change*. London: Routledge & Kegan Paul.

Lucas, E. V. (1924) *A Wanderer among Pictures: A Companion to the Galleries of Europe*. London: Methuen.

Maberly, J. (1844) *The Print Collector: An Introduction to the Knowledge Necessary for Forming a Collection of Ancient Prints*. London: Saunders & Ottley.

MacColl, D. S. (1904) *The Administration of the Chantrey Bequest: Articles Reprinted from 'The Saturday Review', with Additional Matter, Including the Text of Chantrey's Will and a List of Purchases*. London: Grant Richards.

MacColl, D. S. (1931) *Confessions of a Keeper and Other Papers*. London: Maclehose.

McConkey, K. (1989) *British Impressionism*. London: Phaidon Press.

McKendrick, N., Brewer, J. and Plumb, J. H. (1982) *The Birth of a Consumer Society*. London: Europa Publications Ltd.

Macleod, D. S. (1987) 'Art collecting and Victorian middle class taste', *Art History*, 10(3): 328–50.

Macleod, D. S. (1996) *Art and the Victorian Middle Class*. Cambridge: Cambridge University Press.

Mainardi, P. (1993) *The End of the Salon*. Cambridge: Cambridge University Press.

Mallock, W. H. (1906) *The New Republic*. London: Chatto & Windus.

Malraux, A. (1954) *The Voices of Silence*. London: Secker & Warburg.

Malraux, A. (1967) *Museum Without Walls*. London: Secker & Warburg.

Marks, H. S. (1894) *Pen and Pencil Sketches* (2 vols). London: Chatto & Windus.

Martindale, A. (1972) *The Rise of the Artist*. London: Thames & Hudson.

Marx, K. and Engels, F. (1970) *The German Ideology* (part 1 with selections from parts 2 and 3, together with Marx's 'Introduction to a critique of political economy'). London: Lawrence & Wishart.

Meisel, M. (1983) *Realizations*. Princeton, NJ: Princeton University Press.

Men of the Time (1856) Biographical sketches of eminent living characters. London: Bogue.

Menpes, M. (1904) *Whistler as I Knew Him*. London: A. & C. Black.

Mills, A. R. (1967) *The Halls of Ravenswood: More Pages from the Journal of Emily and Ellen Hall*. London: Muller.

Minihan, J. (1977) *The Nationalization of Art*. London: Hamish Hamilton.

Mitchell, C. (1967) 'Benjamin West's "Death of Nelson"', in D. Fraser, H. Hibbard and M. J. Lewine (eds), *Essays in the History of Art Presented to Rudolf Wittkower*. London: Phaidon.

Morgan, H. C. (1969) 'The lost opportunity of the Royal Academy: an assessment of its position in the nineteenth century', *Journal of the Warburg and Courtauld Institute*, 32.

Morris, W. (1936) 'Artist and artisan: as an artist sees it', in M. Morris, *William Morris: Artist, Writer, Socialist* (2 vols). Oxford: Blackwell.

Mouzelis, N. P. (1991) *Back to Sociological Theory: The Construction of Social Orders*. London: Macmillan.

Mouzelis, N. P. (1995) *Sociological Theory – What Went Wrong? Diagnoses and Remedies*. London: Routledge.

Munnings, A. (1949) 'Chantrey Trust: academy reply to a challenge', *Daily Telegraph*, 27 January, p. 4.

Negrin, L. (1993) 'On the museum's ruins', *Theory, Culture & Society*, 10(1): 97–125.

Newbolt, F. (1930) *The History of the Royal Society of Painter-Etchers*. London: The Print Collectors' Club.

Nightingale, A. (n.d.) *Visual History: A Practical Method of Teaching Introductory History*. London: A. & C. Black.

Nunn, P. G. (ed.) (1986) *Canvassing: Recollections by Six Victorian Artists*. London: Camden Press.

Nunn, P. G. (1987) *Victorian Women Artists*. London: The Women's Press.

Papworth, J. W. and Papworth, W. (1853) *Museums, Libraries and Picture Galleries: Their Establishment, Formation, Arrangement and Architectural Construction*. London.

Parker, R. and Pollock, G. (1981) *Old Mistresses: Women, Art and Ideology*. London: Routledge & Kegan Paul.

Pearce, S. (1995) *Art in Museums*. London: Athlone Press.

Pears, I. (1988) *The Discovery of Painting: The Growth of Interest in the Arts in England 1680–1768*. New Haven: Centre for British Art.

Pennell, E. R. and Pennell, J. (1921) *The Whistler Journal*. Philadelphia: J. B. Lippincott.

PEP (1946) *The Visual Arts, a Report*. Sponsored by the Dartington Hall Trustees. London: Oxford University Press.

Perkin, H. (1972) *The Origins of Modern English Society*. London: Routledge & Kegan Paul.

Perkin, H. (1989) *The Rise of Professional Society Since 1980*. London: Routledge.

Pevsner, N. (1973) *Academies of Art, Past and Present*. Cambridge: Cambridge University Press.

Poggi, G. (1978) *The Development of the Modern State*. London: Hutchinson.

Pointon, M. (1994) *Art Apart: Art Institutions and Ideology across England and North America*. Manchester: Manchester University Press.

Pollock, G. (1980) 'Artists, mythologies and media – genius, madness and art history', *Screen*, **21**(3).

Prior, N. (1999) *Taste, Nations and Strangers: A Socio-Cultural History of National Art Galleries with Particular Reference to Scotland*. Ph.D. thesis, University of Edinburgh.

Pye, J. (n.d.) *A Collection of His Correspondence and Papers Relating to Turner and Other Artists*. The Associated Engravers and the Publication: Engravings from Pictures of the National Gallery, etc.

Pye, J. (1845) *Patronage of British Art*. London: Longman, Brown, Green, and Longmans.

Raimbach, M. T. S. (ed.) (1843) *Memoirs and Recollections of the Late Abraham Raimbach, Esq*, edited by M. T. S. Raimbach. London.

Ranciere, J. and Vauday, P. (1988) Going to the Expo: the worker, his wife and machines', in A. Rifkin and R. Thomas (eds), *Voices of the People*. London: Routledge & Kegan Paul.

Rawson, E. (1969) *The Spartan Tradition in European Thought*. Oxford: Clarendon Press.

Redgrave, F. M. (1891) *Richard Redgrave, a Memoir Compiled from His Diary*. London: Cassell & Co.

Redgrave, R. and Redgrave, S. (1890) *A Century of Painters of the English School* (2nd edn). London: Sampson, Low, Marston & Co.

Richardson, J. (1773) *The Theory of Painting*. London.

Roberts, H. (1973) 'Art reviewing in the early nineteenth century art periodicals', *Victorian Periodicals Newsletter*, **19**.

Robertson, D. (1978) *Sir Charles Eastlake and the Victorian Art World*. Princeton, NJ: Princeton University Press.

Roget, J. L. (1891/1972) *A History of the Old Water-Colour Society* (2 vols). Clopton: Antique Collectors Club, vol. 2: 125–31.

Rolfe, F. (1978) *Hadrian VII*. London: Picador. (First published 1903, London: Chatto & Windus).

Rosen, C. and Zirner, H. (1984) *Romanticism and Realism*. London: Faber and Faber.

Roseveare, H. (1969) *The Treasury: The Evolution of a British Institution.* London: Allen Lane.

Rothenstein, J. (1962) *The Tate Gallery.* London: Thames & Hudson.

Rothenstein, J. (1966) *Brave Day, Hideous Night.* London: Hamish Hamilton.

Rothenstein, W. (1932) *Men and Memories: Recollections of William Rothenstein 1900–1922.* London: Faber & Faber.

Rothenstein, W. (1939) *Men and Memories: Recollections of William Rothenstein 1922–1938.* London: Faber & Faber.

Royal Academy (1863) 'Position in relation to fine arts'. Royal Commission Report, Minutes of Evidence. *Parliamentary Papers* (3205): xxvii; Appendix, index (3205–1).

Rubinstein, W. D. (1981) *Men of Property.* London: Croom Helm.

Rubinstein, W. D. (1993) *Capitalism, Culture and Decline in Britain.* London: Routledge.

Ruskin, J. (1959) *The Lamp of Beauty.* London: Phaidon Press.

Ryder, J. and Silver, H. (1970) *Modern English Society* (1st edn). London: Methuen.

Salaman, M. C. (1912) *Whitman's Print-Collector's Handbook* (6th edn). London: G. Bell & Sons.

Sandby, W. (1862) *The History of the Royal Academy of Arts* (2 vols). London: Longman, Green, Longman, Roberts & Green.

Santaniello, A. E. (1979) *The Boydell Shakespeare Prints.* New York: Arno Press.

Savage, M., Barlow, J., Dickens, P. and Fielding, T. (1992) *Property, Bureaucracy and Culture: Middle-Class Formation in Contemporary Britain.* London: Routledge.

Scott, J. (1982) *The Upper Classes: Property and Privilege in Britain.* London: Macmillan.

Scott, J. (1991) *Who Rules Britain?* Oxford: Polity Press.

Sennett, R. (1976) *The Fall of Public Man.* Cambridge: Cambridge University Press.

Serota, N. (1997) *Experience or Interpretation: The Dilemma of Museums of Modern Art.* London: Thames & Hudson.

Shaw, G. B. (1931) *Immaturity.* London: Constable & Co.

Shee, M. A. (1809) *Rhymes on Art; or the Remonstrance of a Painter* (2 parts) (3rd edn). London.

Shee, M. A. (1837) *A Letter to Lord John Russell ... on the Alleged Claims of the Public to be Admitted Gratis to the Exhibition of the Royal Academy.* London.

Shee, M. A. (1838) *A Letter to Joseph Hume Esq., MP.* London.

Sherman, D. (1987) 'The bourgeoisie, cultural appropriation and the art museum in nineteenth century France', *Radical History Review*, **38**: 38–58.

Shils, E. (1981) *Tradition.* London: Faber & Faber.

Short, F. (1880) *On the Making of Etchings.* London: Dunthorne.

Skaife, T. (1854) *Exposé of the Royal Academy of Arts*. London: Piper, Stephenson & Spence.

Sloane, J. C. (1961) 'On the resources of non-objective art', *Journal of Aesthetics and Art Criticism*, **19**(4).

Smith, C. L. (ed.) (1895) *Journals and Correspondence of Lady Eastlake* (two vols). London.

Smith, C. S. (1986) 'The philosophy of museum display', *V & A Album*, 5: 31–8.

Smith, C. S. (1989) 'Artefacts and meanings', in P. Vergo (ed.), *The New Museology*. London: Reaktion Books.

Smith, D. (1982) *Conflict and Compromise. Class Formation in English Society: A Comparative Study of Birmingham and Sheffield*. London: Routledge & Kegan Paul.

Smith, F. B. (1973) *Radical Artisan: William James Linton 1812–97*. Manchester: Manchester University Press.

Solkin, D. H. (1992) *Painting and Money: The Visual Arts and the Public Sphere in Eighteenth Century England*. London and New Haven: Yale University Press.

Sombart, W. (1967) *Luxury and Capitalism*. Ann Arbor: University of Michigan.

Spender, S. (1952) *Learning Laughter*. London: Weidenfeld and Nicolson.

Steegman, J. (1936) *The Rule of Taste: From George I to IV*. London: Macmillan.

Stevens, A. (1897) *The Year's Art*. London: J.S. Virtue.

Stone, L. and Stone, J. C. F. (1984) *An Open Elite? England 1540–1880*. Oxford: Clarendon Press.

Story, A. T. (1892) *The Life of John Linnell* (2 vols). London: R. Bentley & Son.

Strong, R. (1978) *And When Did You Last See Your Father? The Victorian Painter and British History*. London: Thames & Hudson.

Strutt, J. (1785) *A Biographical Dictionary; Containing an Historical Account of All the Engravers, from the Earliest Period of the Art of Engraving to the Present Time* (2 vols). London: Robert Faulder.

Survey of London: Parish of St James Westminster (1963) pt. 2, vol. 32. London: Athlone Press.

Survey of London: The Museums Area of South Kensington and Westminster (1975) vol. 38. London: Athlone Press.

Tate Gallery (1946) *A Collection of Contemporary English Painting*. London: Tate Gallery.

Tate Gallery (1972) *Caspar David Friedrich*. London: Tate Gallery.

Thompson, E. P. (1968) *The Making of the English Working Class*. Harmondsworth: Penguin Books.

Thompson, E. P. (1978) *The Poverty of Theory*. London: Merlin Press.

Thompson, J. B. (1984) *Studies in the Theory of Ideology*. Oxford: Polity Press.

Thornton, A. (1938) *The Diary of an Art Student of the Nineties*. London: Isaac Pitman.

Tillyard, S. K. (1988) *The Impact of Modernism*. London: Routledge & Kegan Paul.

Tilson, J. (1970) 'Kelpra prints', in *Kelpra Prints*. London: Arts Council of Great Britain.

Torstendahl, R. (1990) 'Introduction: promotion and strategies of knowledge', in R. Torstendahl and M. Burrage, *The Formation of the Professions*. London: Sage.

Trodd, C. (1997) 'The authority of art: cultural criticism and the idea of the Royal Academy in mid-Victorian Britain', *Art History*, **20**(1): 3–22.

Vergo, P. (ed.) (1989) *The New Museology*. London: Reaktion Books.

Vertue, G. (1930–55) *Notebooks*. Volumes of the Walpole Society (Vols 18, 20, 24, 26, 30). Oxford: Walpole Society.

Vizetelly, H. (1893) *Glances Back through Seventy Years: Autobiographical and Other Reminiscences* (2 vols). London.

Waagen, G. F. (1853) 'Thoughts on the new building proposed for the National Gallery of England', *Art Journal*: 101–3, 121–5.

Waagen, G. F. (1854) *Treasures of Art in Great Britain* (3 vols). London: John Murray.

Wacquant, L. J. D. (1993) 'From ruling class to field of power: an interview with Pierre Bourdieu on La Noblesse d'Etat', *Theory, Culture and Society*, **10**(3): 19–44.

Walker, J. A. (1983) *Art in the Age of Mass Media*. London: Pluto Press.

Walpole, H. (1762) *Anecdotes of Painting in England*. London: Ward, Lock & Co.

Ward, E. M. (1924) *Memories of Ninety Years* (2nd edn). New York: Henry Hole & Co.

Waterfield, G. (1988) *Rich Summer of Art*. London: Dulwich Picture Gallery.

Wattenmaker, R. W. (1993) 'Dr. Albert C. Barnes and the Barnes Foundation', in *Great French Paintings from The Barnes Foundation: Impressionist, Post-Impressionist and Early Modern*. New York: Lincoln University Press/Alfred A. Knopf.

Watts, M. S. (1912) *George Frederick Watts: The Annals of an Artist's Life* (3 vols). London: Macmillan.

Webb, B. (1929) *My Apprenticeship*. London: Longmans.

West, S. (1990) 'Tom Taylor, William Powell Frith and the British School of Art', *Victorian Studies*, **33** (Winter): 307–26.

White, H. C. and White, C. A. (1965) *Canvases and Careers*. New York: John Wiley.

Whitley, W. T. (1928) *Art in England 1800–1820*. Cambridge: Cambridge University Press.

Whitley, W. T. (1930) *Art in England 1821–1837*. Cambridge: Cambridge University Press.

Whitman, A. (1907) *Charles Turner, Engraver*. London: George Bell & Sons.

Wiener, M. (1985) *English Culture and the Decline of the Industrial Spirit 1850–1980*. Harmondsworth: Penguin Books.

Williams, R. (1980) *Problems of Materialism and Culture*. London: Verso Press.

Wind, E. (1963) *Art and Anarchy*. London: Faber and Faber.

Wolff, J. (1981) *The Social Production of Art*. London: Macmillan.

Wolff, J. (1990) *Feminine Sentences: Essays on Women and Culture*. Oxford: Polity Press.

Wolff, J. and Seed, J. (eds) (1988) *The Culture of Capital: Art, Power and the Nineteenth-century Middle Class*. Manchester: Manchester University Press.

Wotton, W. (1694/1968) *Reflections upon Ancient and Modern Learning*. London: G. O. Verlagsbuchhandlung.

Zigrosser, C. (1975) *A World of Art and Museums*. Philadelphia: The Art Alliance Press.

Zolberg, V. (1981) 'Conflicting visions in American art museums', *Theory & Society*, **10**: 81–102.

Zolberg, V. (1995) 'The collection despite Barnes: from private preserve to blockbuster', in S. Pearce (ed.), *Art in Museums: New Research in Museum Studies*, vol. 5: 94–108. London: Athlone Press.

Index